PICTURING PEOPLE

Don Nibbelink,
F.R.P.S., F.P.S.A.

Edited by and published for
EASTMAN KODAK COMPANY

AMPHOTO
American Photographic Book Publishing Co., Inc.,
Garden City, New York

My many thanks to . . .

the print makers, the publishers, the editors, the typists, the proof readers, and the many other specialists who helped to produce this book.

LOU LANZI,
layout

KEN LASSITER,
project sponsor

AL GILBERT,
the cover photograph

the expert photographers whose works are featured in the shooting sessions and who are identified there.

Don Nibbelink

Library of Congress Catalog Card No. 75-27065

ISBN 0-8174-0576-3

Manufactured in the United States of America

To Monica

Come forth in the light of things
Let Nature be your teacher

Wordsworth—The Tables Turned

TABLE OF
CONTENTS

12 YESTERDAY

14 TODAY

16 TOMORROW

26 TOMORROW'S
 PICTURES TODAY
27 Aptitude Plus Attitude
27 Natural Results

30 PICTURING PEOPLE
 WHERE THEY ARE

32 EYE PHOTOGRAPHY
33 Lighting
34 Composition
34 Depth of Field
35 Inventive Eye Photography
35 Practicing Lighting Indoors

36 THE POWER OF RAPPORT

38 PORTRAIT LIGHTING
38 The Nature of Light
40 The Facial Lighting Target
43 Lighting Ratios
44 Establishing the Ratio
46 Outdoor Conditions
46 Subtractive Lighting

48 Sunlighting
50 Brightness Range
51 Reflectors
52 Fill-in Flash
54 Location Lighting
54 Single Flash
58 Two-light Flash
60 Portable Umbrellas
62 Window Lighting
64 Studio Lighting
64 Umbrella Lighting
66 Main Light Placement
66 Broad vs. Narrow
67 Fill-light Placement

68 PRACTICAL COMPOSITION
69 Color Use
70 Picture Shape
72 Foregrounds
73 Backgrounds
74 Background Hot-spot Control
76 Image Placement
78 Posing
80 Camera Angle
82 Props
84 Two Persons
85 Groups

86 LENS SELECTION
 FOR PORTRAITURE
86 Long Lenses
88 The Normal Lens
88 Wide-angle Lenses
90 Using the Lenses

 92 LENS ATTACHMENTS
 92 Diffusers
 95 The Vignetter
 96 The Matte Box
 99 The Skylight Filter
 99 Neutral Density Filters

100 FILM AND EXPOSURE
100 Film Selection
101 Exposure Determination
102 Negative vs. Positive
 Film Techniques
102 Processing
103 Density Evaluation

104 SHOOTING TECHNIQUES
104 The Invisible Camera
104 Expression
106 Shooting Tempo
110 Motor Drives
112 Sequences

114 AVAILABLE LIGHT
 CONSIDERATIONS
114 Exposure Determination
115 Exposure Bracketing
116 Filters for Available Light

118 SPECIAL EFFECTS
118 Multiple Exposure
120 Infrared
122 Special Lens Attachments
125 Matte Box and Other Masks
127 Posterization
128 Colored Light

130 THE SHOOTING SESSIONS

132 THE BABY

140 THE CHILD

150 THE SINGLE GIRL

160 THE BOY AND GIRL

164 WEDDINGS

178 THE FAMILY

192 GROUPS

196 PEOPLE AT WORK

202 PEOPLE IN MOTION

206 DARK FACES

210 OLDER PEOPLE

214 PROFESSIONAL MODELS

220 PEOPLE ON YOUR TRAVELS

238 THE STUDIO

254 THE VALUE OF CRITIQUE

256 INDEX

How will you photograph the interesting
people you meet in your travels? Will you
snap timidly from afar or take dramatic,
controlled closeups? Will you be only a
camera operator, or will you be a director
of photography?

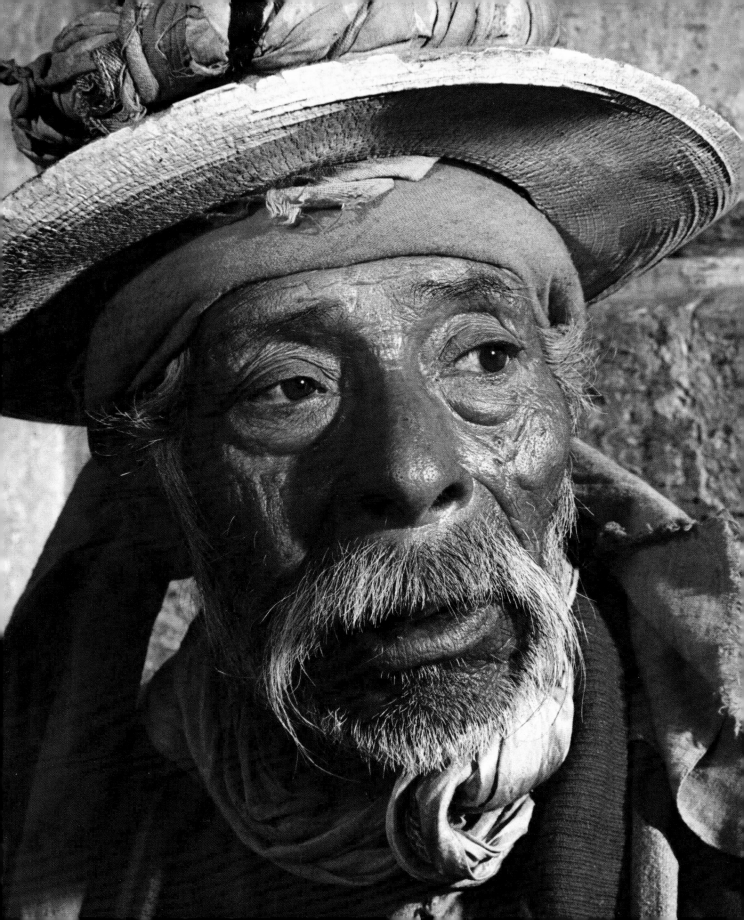

Picturing People

Let's Assume:

• You are *already* a good photographer. Full-time professional, part-time professional, or an advanced amateur—it doesn't matter. What does matter is that you know how to take technically good pictures most of the time.

• You own a versatile camera outfit that has interchangeable lens capabilities; probably 35mm, perhaps 120 roll-film size—this part doesn't matter.

• You are especially interested in color photography.

• Finally—and this matters very much—you would like to know how to take better pictures of people. That's what this book is all about!

Before you can improve anything— a machine, a performance, an artistic creation—you must first learn what's wrong with the existing one. Let's do that immediately.

11

YESTERDAY

For most of the last century, cameras were cumbersome and color photography an unthinkable dream.

But you must give our photographic forebears credit for trying to take good pictures of people. The illumination from north-facing skylights gave even shadow-filling soft light. No dazzle of multiple light sources with consequent multiple eye catchlights; no glaring highlights or unreal multidirectional shadows.

The main trouble was low photographic sensitivity. Daguerreotype exposures were measured in minutes. Even the new dry plates needed several seconds. So for fifty years, the head rest—the immobilizer—was a way of photographic life. Small wonder poses were stiff, with expressions ranging from pained to grim.

People were pictured *unnaturally*.

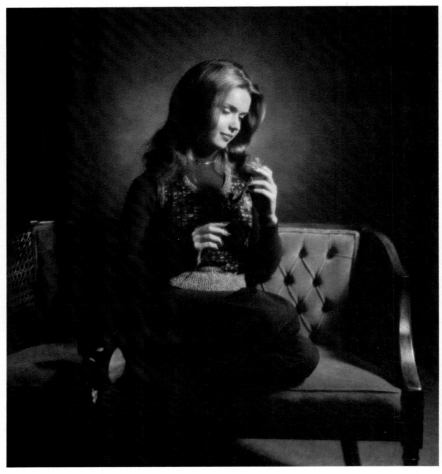

Technical masterpieces, but unnatural situations. How often does a real boy get dressed up like this? How long is he going to stay this way when he gets in his real element? And, honestly, have you ever seen a girl mope over a rose like this? NO! These are contrived pictures. CONTRIVED, CONTRIVED!

Today

Fast fine-grained emulsions. Breathtaking color. Zoom and interchangeable lenses for small versatile cameras. Automatic exposure controls. Indeed, everything needed to take any desired kind of people pictures. No longer can one rightly blame the tools of the trade for unnatural portraits.

Yet, there it is—too much of it, in fact—passport portraiture. Technical masterpieces but artistic failures. Still much of the stiffness of yesterday, still the unimaginative staring at the camera.

Sometimes you can actually count the number of light sources in a studio portrait by looking carefully at the subject highlights: main light, a fill light or two, side kicker, hair light, background light. Sometimes you can see weird or unbalanced lighting ratios. It often totals up to *unnatural* pictures.

Outdoors in the sunshine, it's harsh contrasts, squinty expressions, or as yesterday, the you-stand-over-there-and-I'll-take-your-stiff-and-*unnatural* picture.

How, then, should you take pictures of people?

Family albums have too many pictures in them like these. The fault lies with the unthinking photographer who didn't have enough imagination to pose his subjects in the shade and invent a bit of interesting action for them.

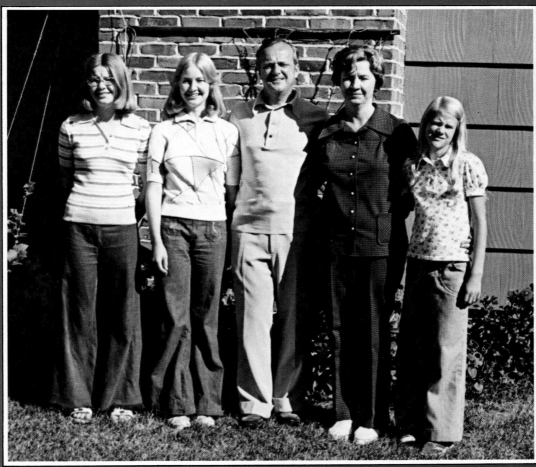

**Good pictures
are natural pictures.
And naturally means. . . .**

honestly
simply
cordially
ingenuously
frankly
openly
unaffectedly
spontaneously
naively
delightfully
suddenly
refreshingly
pleasantly
touchingly
wondrously
charmingly
graciously
youthfully

Tomorrow

These are "tomorrow" pictures.

Obviously, they were taken with today's wonderful tools. But we're calling them tomorrow pictures because these are the kind of people pictures we think you'd like to take from now on.

Why are they different and better? Because the people were photographed *naturally*. And what does that really mean?

Perhaps most important of all, they are better because the subjects themselves really like these pictures.

Ah, there's the goal, isn't it, to make pictures the subject will like? And what sort of pictures are these?

You can easily answer the question by asking what sort of pictures of yourself you would like. Of course they should present you in a pleasing, even flattering, way. They shouldn't be too dark or too light, and the colors should be right. They should, if possible, present you as personable, friendly, capable, intelligent, kind, courteous, and industrious. They should even minimize your wrinkles—if you have any.

Let's call the pictures you want, "natural, be-yourself pictures." (This may not be a consistently attainable goal—but would you really want pictures of yourself that would be anything less?)

16

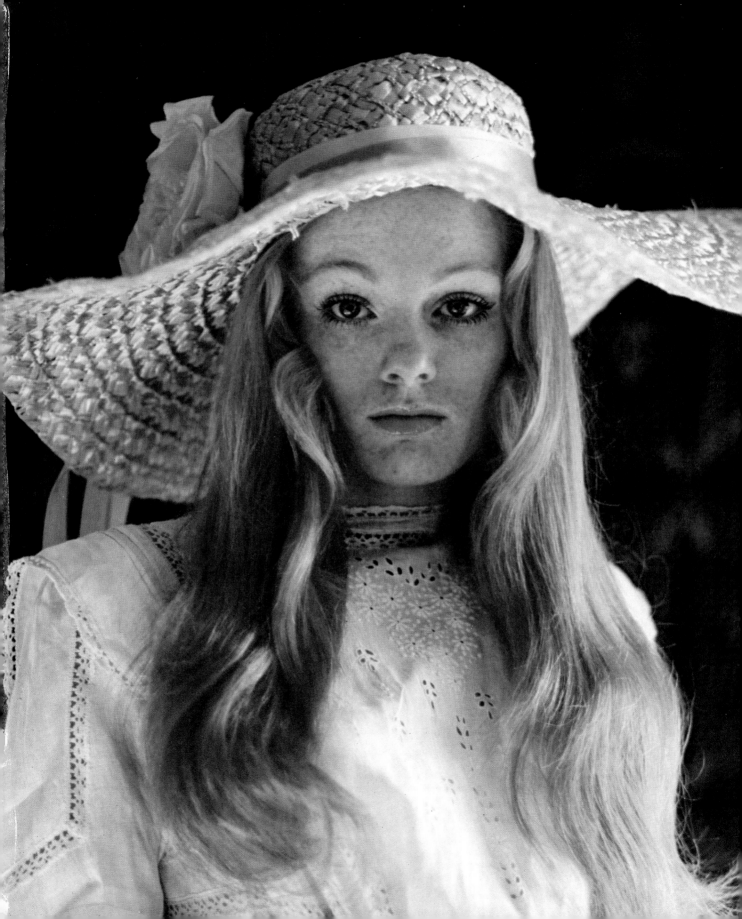

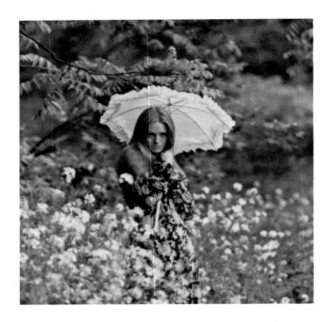

Relaxed, informal, diffused facial lighting, natural outdoor setting, pleasant expression—do your people pictures contain these attributes?

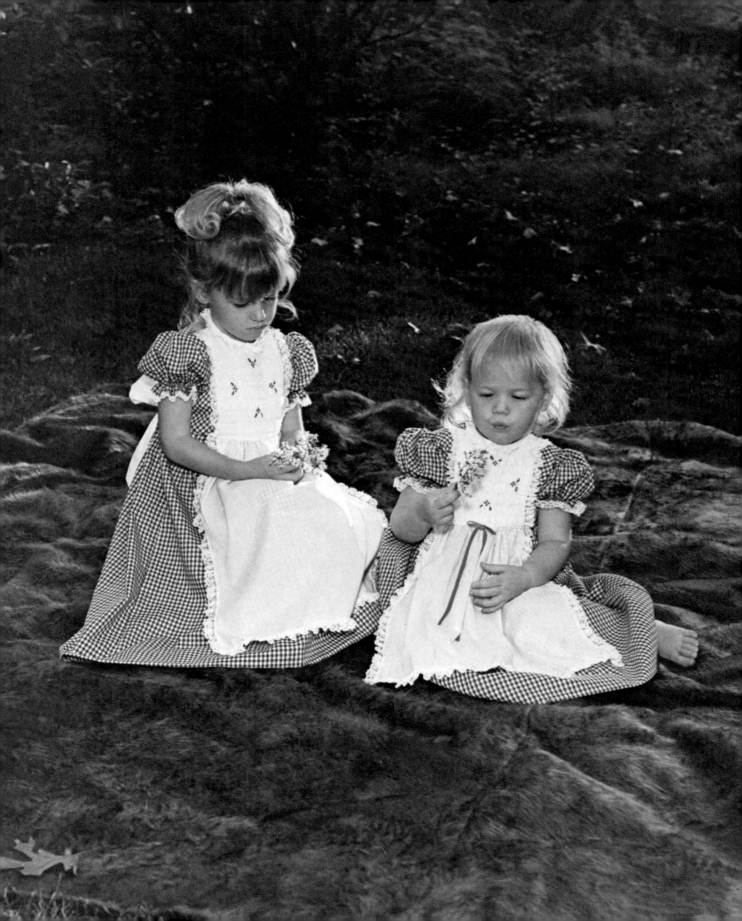

**Touchingly
Charmingly
Youthfully
Unaffectedly
Pleasantly**

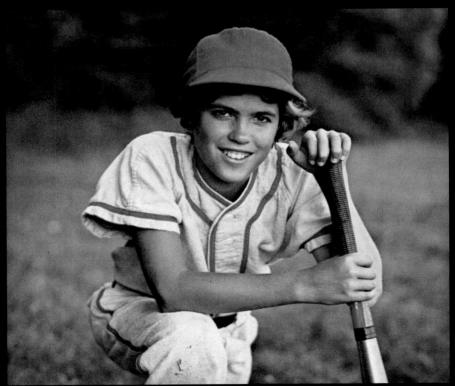

Wondrously
Suddenly
Delightfully
Spontaneously
Simply

So, now let's put the shoe on the other foot and have you take those kinds of pictures of other people. Quite an assignment, isn't it?

It can be done, and it's the job of this book to show you how to do it. There are, of course, many ingredients in a picture that will satisfy your subject, and these will be dealt with a chapter at a time.

But if just one word could be selected, which would help guide you best, it would probably be the word *natural*. Let's talk about this for a minute. Don't lose sight of the fact that *everything* that is natural is not necessarily desirable. Contrasty sunlight may be natural, but unmodified, it's a terrible type of portrait lighting. Soft shady lighting is no less natural, however, and it's wonderful for portraits. Sometimes you'll have to change unfortunate "natural things" into better "natural things." Yes, sometimes you'll find it desirable to manipulate nature a bit.

Let's see how to do this.

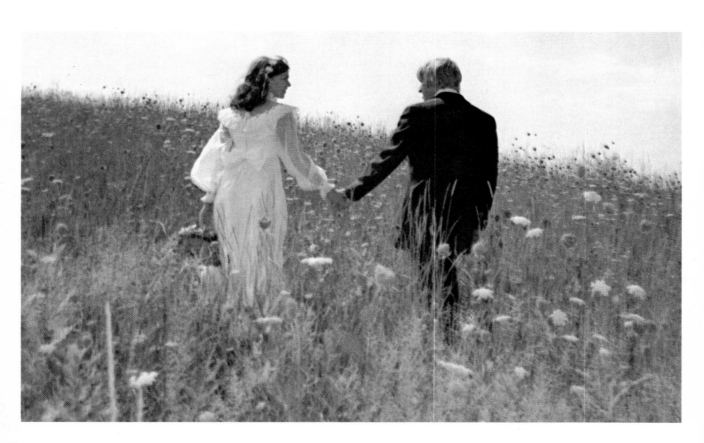

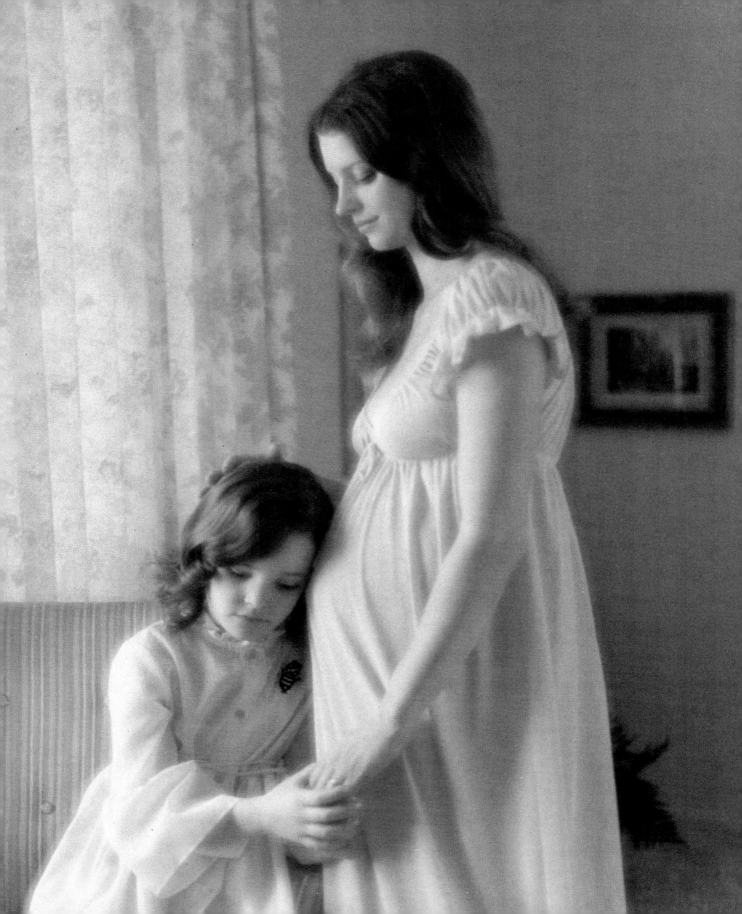

Tomorrow's Pictures Today

What is a photographer? One who makes pictures? Well, that's a weak way of thinking about it—a chimpanzee can push a shutter-release button. No, a good photographer is a person who thinks creatively, who plans artistically. He doesn't simply attack a subject with his camera, blazing away, hoping the law of averages will give him something good. No, first he decides, chooses, arranges, selects, rejects, illuminates, establishes rapport, invents the action, elicits the expression. Finally, finally, finally, after all this work has been done, he picks up his technical recording device and—this is the easy part—pushes the button.

What does it take to be a good people photographer? You may as well ask, What does it take to be a good carpenter? A good musician? A good lawyer? The answer is the same. First, one should be basically talented in the field in question. An opera star must have the right vocal chord configuration; a wood-carver must be manually dexterous. Second, one must train and develop these natural gifts or aptitudes to a level of excellence. This requires both recognition of the basic talent and a high degree of motivation. You can develop any ability. You can become as good as you want to be.

How, then, can you sharpen your photographic skills?

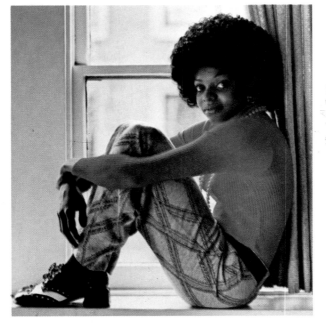

Aptitude Plus Attitude

Probably you were born a creative person—one who has the natural ability to see pictures where others don't. Hopefully, too, you were born withe the marvelous ability to like and understand people. You can find something of interest in every person you meet; your feelings about people are slanted positively rather than negatively. When you are really turned-off by a person at first contact, you take a second, more objective, look. When you travel into a foreign environment, you make yourself part of it. You can accept the differences in people, their ways, their thinking, their beliefs, and be in communion with them. When in Rome, you can become a Roman.

To identify is the name of the game when you are working with people, and being a photographer is working with people on a very interpersonal basis. You must have the ability to make "contact" with your subject in order for him to allow you really to see him. Only then will you be able to photograph him successfully.

Natural Results

Today the trend is toward the natural. A few years ago young people initiated a return-to-nature movement that has found wide acceptance. We are now urged to behave naturally (sans conventions), look natural (sans makeup), eat natural foods (sans preservatives), and sleep natural (sans pajamas). So no wonder the photographic world has also been seized by this new feeling, and all to the good at that! Wedding ceremonies and receptions are being held in the woods and in parks; barbecues and cookouts are held to celebrate graduations (after the *outdoor* ceremony); birthday and even cocktail parties are as often as not held on the patio.

Bird-watching is fast becoming a national pastime, and almost every family has someone in Little League baseball. At last, more and more pictures of people are being taken in the element natural to people—the outdoors. And this is a tremendous boon to the photographer because it's a wonderful, easy place to take pictures of people. You want natural results, and who can't agree that outdoors is a more natural place than indoors?

It comes as no surprise, then, that portrait photography is beginning to move away from studio sameness. The outdoor environment is both relaxing and natural. On a hazy day the colors are muted and pastel, the lighting is soft and easy to use artistically. In the shade, or when the sun goes behind a cloud, you don't have to worry about establishing exact lighting ratios, or that a hair light is too hot, or that someone might trip on an extension cord. You're free to concentrate on location selection, composition, and expression.

Outdoors you tend to adapt the camera to the subject, whereas indoors you tend to adapt the subject to the camera. Inside, especially in the formal studio situation, the subject loses his natural freedom. Confined to a posing chair and forced to be an exact distance from a domineering camera, he becomes strained. But outdoors the subject is free to move, to play, to work, to be himself. Your small unobtrusive camera can be just as mobile to capture these natural moments.

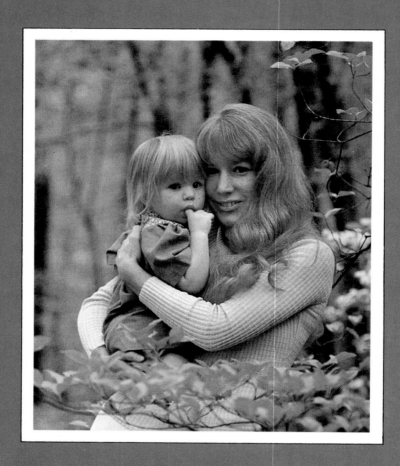

Perhaps you haven't thought of it this way, but an outdoor scene is generally composed of three areas or zones: the immediate foreground, the middle distance, and the far distant background. If it's outdoor portraiture with which we're concerned, the person often occupies the middle-distance area. The point is that *the scene has depth or dimensional planes.* It's realistic.

And what about taking good pictures of people indoors? Often it is more convenient to take portraits there. You don't have to go running through fields to take a passport photo, an identification picture for a calling card, or a mug shot for security files. Nor do you have to go outdoors for routine school photography, or for the picture taken in a shopping center's mechanized studio where a mother wheeling her child past will stop on impulse to have a picture taken, or for the average sitting-on-the-davenport type photo, or for an actual formal studio portrait.

Keep these picture types in mind and ask yourself, Where's the foreground? Where's the far distant background? There isn't any. You really can't call the wallpaper in back of the sofa *background* any more than you can call the gray studio wall just behind the subject *background.* Both of these portions of the scenes are truly within the confines of the middle-distance area. This means you usually take a flat one-zone picture indoors but a three-zone, more natural picure outdoors.

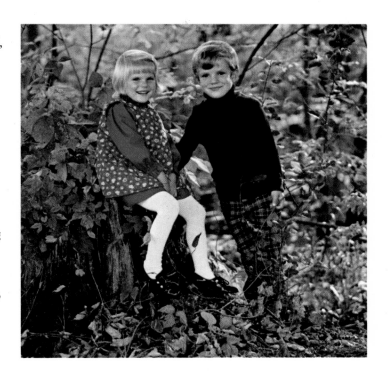

So what's wrong with taking natural pictures of people indoors? It's just difficult, that's all. Indoor studios are often too full of artificial backgrounds, enthusiastic retouchers, odd colors, and lots of artificial lights which all too often aren't used skillfully.

A list of lighting errors alone would be almost infinite. Included, for example, would be too much or too little fill light, undiffused fill lights perhaps causing multidirectional shadows, too strong or too many backlights, hair lights, and background lights. Outdoors you must admit (a) that the "set" or area included in your composition is illuminated evenly, and (b) the shadows, if there are any, are parallel. *These two natural conditions are nearly impossible to duplicate with artificial lights.*

Indoors versus outdoors is not really the thrust of this book. Of course you must also take pictures of people indoors, but the goal is to try to do it with outdoor naturalness. There are many aspects of taking good portraits, and these will all be discussed in the chapters to come.

Let's expand your horizons so that you can take better, more natural pictures of people wherever they are.

Picturing People Where They Are

"Got to get dressed up and go down to have my picture taken."

Imagine the mental state of the person who has uttered such words, and with a sigh, has resigned himself to his fate. He might as well have said, "Got to go down to the dentist and have a tooth pulled."

Why does this frame of mind exist?

To answer this question, let's suppose a friend asks you to show him your favorite picture of your wife. Do you march him to the piano and show him that formal, dressed-up picture of her staring at the camera?

Or does it happen like this:

"Say, I've got just the one!" And you dig out your wallet, search between the credit cards, and triumphantly hold aloft the shot of your wife gardening.

Why do you choose this shot as your favorite picture of your wife? It's a close-up shot of her kneeling in the flower bed in your backyard. The sun is shining through her bonnet rim, lighting her face. She's wearing her favorite gardening clothes and yellow gardening gloves. She has a geranium in one hand and a trowel in the other. There's a dirt smudge on her cheek, and you remember how she laughed when you told her her face was dirty after you snapped the picture.

Can you see why it's your favorite picture? It's a picture of your wife doing what she loves to do. She's being herself, being happy, and that's what makes it a terrific shot.

Let's ask a related question: How would *you* like to be remembered by your family and friends? By a "tooth-pulling" portrait, dressed up like you were going to a funeral? Or by a picture of you being yourself like the friendly, good-old-dad guy you know you really are?

When you put yourself in the subject's shoes, as you should, you realize there are two kinds of pictures that can be made. If you're human, your mind must be torn between the styles—hair combed, best suit, shoes shined, stiff and unnatural, or should I have the new informal kind? Think how much more you'd be inclined toward the "natural approach" *if you really had faith in the photographer.*

If you were a gentleman farmer, for example, and you knew a great, artistic, sympathetic, and congenial photographer who would take a superbly composed and artistically lighted shot of you aboard your pet tractor, doing what you enjoyed— the REAL you—well, wouldn't you really like such a picture?

Or suppose you were a woman with a gourmet flare for chinese cookery. See the sunlight slanting through your orange and brown kitchen-window curtains, a tip of the avocado sink contrasting against the pumpkin-colored countertop and the rust-brick wall, the flames toasting the wok, and you watching the savory steam with sparkling eyes in anticipation of a great meal.

Wouldn't your daughter like to have this picture of you?

Of course, examples like these can be carried through the complete gamut of vocations and avocations without end. It's simply the idea of picturing people as they are—naturally.

There are thousands of stiff, passport-type pictures taken *every* day. Yet there are millions of exposures made each day of people being pictured where they are and as they are. Snapshots? You can call them that, derisively, if you're a studio photographer with a large equipment inventory, but admit that these are pictures people love and try to take as best they can.

And now, enter the capable photographer—you. Perhaps it's trite, but remember the old adage: "If you can't beat 'em, join 'em." And why not, if these are the kinds of pictures people want!

Most snapshots leave a lot to be desired from an artistic standpoint, and indeed from other aspects that could turn the same situation into a memorably great photograph.

What can you offer? What can you bring to this situation? Surely more than a large equipment inventory! You have artistic ability, imagination, creativity, and a knowledge of light and how to control it. Perhaps most important of all, you're a practical psychologist—you know people. You know what they will like and you know how to manipulate them discreetly. And you can combine these aptitudes and attitudes to produce a superb, natural portrait.

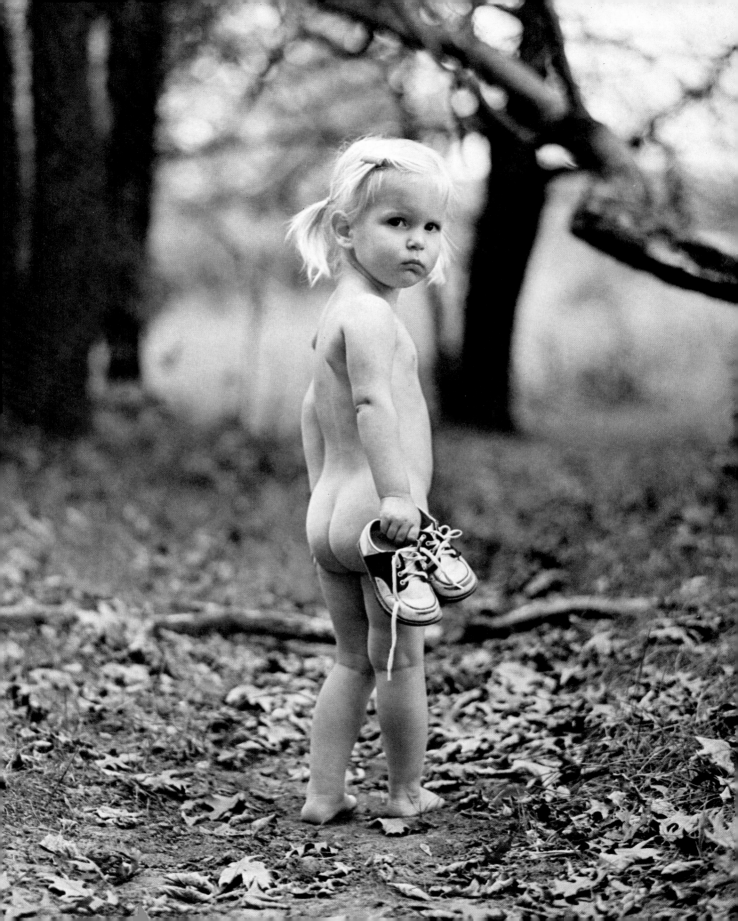

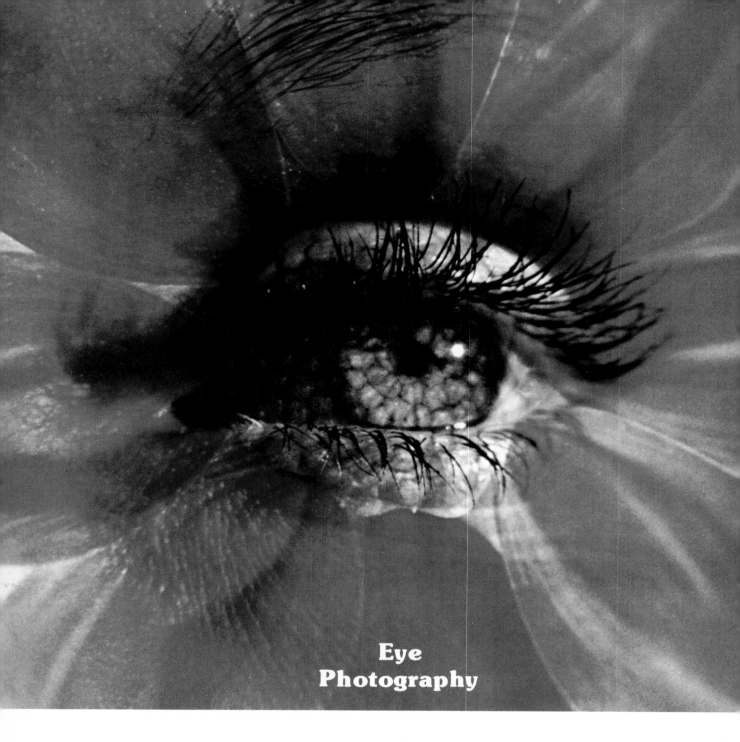

Eye
Photography

One of the significant differences between a mediocre photographer and a superior one is his level of development in the powers of observation. If you aspire to produce pictures of excellence, you must first be able to see them.

Seeing the effects of light is a preliminary step for using them in a well-planned photograph. In order to see them, you should cultivate the practice of "eye photography," that is, practicing picture-taking without a camera.

Let's begin: Put away your camera and take an early morning walk through the woods. Look at a single tree. See the striations in the bark, the texture, the color. Look at the leaves. See the variations in color from older leaves to the brighter greens of a new leaves. See how a single drop of dew tips a leaf. Notice how one color plays against another. See how the same foliage becomes gray in the distance. The magic word here is *see*, not *look*, but *see*. The lighting is soft and natural, the colors muted and easy on the eyes. Nature has much to teach the photographer who wants to learn.

Lighting

To know what you want and to be able to recognize it when you get it—this is the secret of good lighting. There are several ways you can develop your ability to see with a photographer's eye when you are "between pictures." While outdoors is unquestionably the best possible lighting classroom, don't limit your eye photography sessions to your outdoor hours. Wherever you are, in a restaurant or in your own living room, there are opportunities to study the action and reaction of light to subject. Never pass up a chance to study a lighting effect you like, whether it be an actual scene or in a photograph. For example, you are interested in portraits, so take a magazine or a book of pictures, such as a photographic annual, and try to imagine how the photographers placed their lights to achieve a certain effect. Look at the catchlights in the subject's eyes. How many catchlights are there? If it is the customary single catchlight in each eye, where was the light source.

How many lights were used for the subject and the background? If you can tell this easily, the lighting was probably arranged unskillfully.

Everywhere you go, whatever you do, the opportunity for taking eye pictures is unlimited. Look critically at the lighting effects in motion pictures, in a stage play, or in the downtown store windows. When riding to work on the bus, notice the lighting on your fellow passengers. See that man across the aisle reading a magazine? Watch the lighting on his face change as the bus passes under the shade of a tree or as it turns a corner. See how the shaft of sunlight striking the magazine he is reading is reflected back onto his face. Which of these lighting effects would make the best photograph?

If you can imagine the lighting setup in your mind's eye as you look at an excellent portrait, whether it be outdoors or indoors, you should be able to duplicate it yourself. You should develop the habit of making eye pictures so that you have all these occasions of experience to draw upon when using your camera. When you practice eye photography, you are really fine-tuning your visual perceptions so when the need arises, you will have your memory bank at hand to enable you to create a professional and artistic photographic interpretation.

Just for fun, let's use your outdoor studio to take an environmental portrait of a family. The father, who works in an office, is available only at noon, so the time is fixed. But wait! Isn't noontime an undesirable time of day for outdoor pictures because of the near vertical sun position? Which leads to the fact that you must be completely familiar with the areas in which you are

going to take the pictures. You must not only be familiar with the ingredients of the location—the gnarled tree trunk, the fallen log, the winding stream, the density of the overhead leaves—but you must also know the lighting conditions at different times of the day. Where is the sun coming up? When is it going to be high? When low? If you know the type of lighting effect you're after—sidelighting, backlighting, or whatever—you can arrive at your outdoor "studio" at the proper time.

Remember how you studied photography by walking through the park without a camera? Did you file these lighting conditions and compositional ingredients away in your mental file bank? Now is the time to bring them out and put them to use. Remember that spot in the nearby park at the fallen log? There's a good overhead leaf coverage so the sun won't be too contrasty. You can bring the family there and shoot in the shade and there will still be enough light because of the general openness of the area. You had that situation picked out long ago. Before the pictures were to be taken, the photographic problem had been solved. You knew exactly where you were going, what time was best, and what you were going to do.

Composition

At the same time you are searching for interesting lighting effects by eye photography exercises, you can also be studying composition. In fact, the two concepts should be inseparable. When you see a good subject lighting, draw the frame lines around it in your mind.

This valuable type of mental gymnastics can be carried past

lighting, into the realm of cropping, magnification, and perspective control. Ah, but this becomes the really difficult part—you must be able to *concentrate* on these aspects. It's difficult because your eye see things as "normal," and it's hard to imagine objects any other way—but you can with thought and practice.

Normal camera lenses have a focal length approximately equal to the diagonal of the film they're used with. They are classified as normal because they give an image ratio of approximately $1\times$, which is equal to what the eye sees at the same distance. In other words, the image size for a 35mm camera with a 50mm lens is equivalent to your retinal "camera" with your eye lens focal length of about 25mm.

But now let's put a 100mm lens on the camera for an image magnification of $2\times$. Can you imagine the difference in magnification and perspective with just your eyes? You should. If you can't, put the camera viewfinder up to your eye and look. Take it away, put it back, take it away. You must learn to imagine you are seeing telescopically.

It will help immensely if you cut out a rectangular film-shaped hole in a piece of cardboard and look through this as a practice viewfinder. You can actually correlate the eye-to-cardboard distances by comparing the field size with actual camera lenses of different focal lengths.

Use the following table to approximate the field of view of different lenses.

It may seem peculiar to your fellow passengers on an airplane if you're discovered examining them through a hole in a piece of cardboard. Just explain, if you must, that you are only practicing composition. Don't despair—eventually you will be able to see selectively without the cardboard crutch, and that's the point of the whole exercise.

You should become so experienced with this sort of selective seeing that you will be able to unfailingly predict which focal length lens will give you the desired magnification and perspective before you even take your camera out of the gadget bag.

 Depth of Field

Depth of field is simply the photographic term for zone of sharpness. You should place your portrait subjects within this zone by critical focusing. You should control the depth of field by selecting the lens aperture that will give you the desired artistic effect. A large aperture results in a small depth of field, for example.

So much for the basics. Now try this bit of *eye* photography:

There you are, sitting in a chair reading these words. Hold the book up at about face level and at normal reading distance. Focus your *eyes* on the book, and if you can, keep them focused for this distance. Now in your "mind's eye" only, look over the top of the book at the background. No, no, don't change your visual focus. It's difficult to look at the other side of the room and not have it appear in sharp focus instantly; your *eyes* do this so fast and so automatically all day long that you probably aren't aware it happens. But of course it does, so if you think you can get the book and the background sharp in only a single glance, you're mistaken. Try it again.

The point is that you should critically examine the background detail when it is in focus as compared with when it is out of focus. If you can successfully concentrate on the book, the background lines and shapes become blurred and indistinct, tones merge, highlights blend into middle tones, and specific objects become far less identifiable. But the shapes *are* there. The "lightnesses" and the "darknesses" *are* there. But now they have become subordinate to the subject. In other words, you have just taken an *eye* picture of the book in front of a room interior background. You had set your *eye* lens at $f/2$ to retain a shallow depth of field. *This is how to think of photographing people.*

Actually, with an average pupillary aperture of about 5mm, and an adult *eye* lens focal length of about 25mm, you are seeing objects with an aperture of about $f/5.6$. This gives a comparatively shallow depth of field, but you don't notice it because of the rapidity with which your *eye* changes focus.

Would you like to practice *eye* photography at a smaller-than-normal aperture, with an astounding increase in depth of field? You can! Simply poke a pinhole in a disc of aluminum foil, shut one *eye*, hold the disc very close to the other *eye*, and look through the tiny aperture. If you wear glasses, take them off for

With a frame of 2″ × 3″ (representing a 35mm frame)						
A lens with a focal length of (mm)	21	28	35	50	100	135
is represented by holding cardboard aperture this distance from your eye (inches mm)	63 2½	84 3¼	105 4⅛	50 5⅞	300 11¾	405 16

this experiment. Incidentally, the stronger your glasses, the more you will be amazed at the fantastic improvement of the image sharpness and increased depth of field that results. Your eye has now been "stopped down" to an aperture of about *f*/50!

While you're at it, try to see how close you can read fine printing. Also, hold a pencil about four inches from your eyes and observe how the pencil and objects at infinity are both in sharp focus!

This optical trick will provide an excellent opportunity for you to appraise the depth-of-field effects possible with a short focal length lens. It can also demonstrate the undesirable perspective distortions that are encountered if short focal length lenses are used for portraits at too close a camera-to-subject distance.

Inventive Eye Photography

So far, the matter of practicing without a camera has concerned itself with existing, obvious subjects and the imaginary recording of them. The person across the bus aisle *was there,* the lighting on his face *existed.* You decided how to frame the scene, what lens would be best, and similar matters.

But now let's go a difficult step further than the mere technical recording of the scene and be *inventive.* And in this vein you can give yourself all sorts of mental training assignments.

Imagine walking into a small bare room with only one draped window. The walls are a hideous green, there is no electricity, no furniture. Yet in five minutes you are going to have a

young woman celebrity walk in and you will be expected to take a superb portrait of her. How are you going to do it? Can you? Quick, check those drapes—can you take them down? Will one of them serve as a shoulder "evening cape" for your model? Is the drape lined so that the white side could be held up as an improvised reflector for a window-lighted head-and-shoulder picture? Were there flowers or plants or any kind of props in the rooms you passed on your way to this one? Think!

These and similar thoughts will stand you in good stead. So many times you'll walk into a strange room and someone will say, "Here's the photographer now. Tell us what to do." And everybody is going to stand around and watch you perform the miracle.

What miracle? The one where you instantly assume command, tell people where to stand, decide what props to use, and invent action that suits the occasion. *This is the essence of being a good photographer—this ability to invent, create, command, cajole, direct, suggest, and motivate.* Practicing these things *before* they're needed is the ultimate of eye photography.

Practicing Lighting Indoors

There is an excellent way you can practice lighting without taking a picture. The ideal practice area would be a small room with white or light-toned walls and ceiling. Place a small table in the center of the room, and on it put a white plaster bust, such as those used by art students to study the planes of the face. Don't use teacups, eggs, or water pitchers. Use a three-

dimensional face, even if it's a piece of airport gift-shop statuary or a bust of Beethoven from a music store. You'll need a 100-watt bulb in a small reflector on the end of a long extension cord that you can clamp to a lightweight stand. Now you can position it any given place and then walk back to the camera position to study the lighting effect. Do *not* look at the effect through your camera viewfinder or ground glass. Look with your eyes and evaluate the effect. You must learn to establish and recognize lighting visually—your camera is merely an unthinking device to record the scene only after you are satisfied with what you see.

There is a great variety of effects you can achieve. And when you think you have seen them all, add a reflector to your setup and practice with it. Then add light number two and three. Don't forget to try bouncing one or more of them from the walls or ceiling to see how the lighting effects can be varied. Measure the lighting ratios with your exposure meter and then learn to recognize them without measuring.

However, don't get so lost in these technical exercises that you lose sight of the desirability of taking relaxed, friendly, natural pictures of people.

The value of this lighting practice is, of course, that it will help you to arrange not only lights indoors, whatever type they are, but also arrange lights on location, wherever you are. It will help you to recognize good facial lighting even when the source is only existing room light. It will help you to position your subjects outdoors where the light direction is fixed. For example, repositioning your subject so that her chin is tilted up slightly to improve the rendition of the planes of her face.

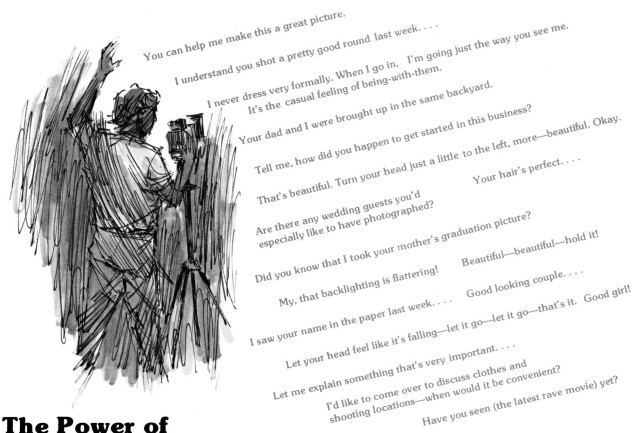

You can help me make this a great picture.

I understand you shot a pretty good round last week. . . .

I never dress very formally. When I go in, I'm going just the way you see me.

It's the casual feeling of being-with-them.

Your dad and I were brought up in the same backyard.

Tell me, how did you happen to get started in this business?

That's beautiful. Turn your head just a little to the left, more—beautiful. Okay.

Your hair's perfect. . . .

Are there any wedding guests you'd especially like to have photographed?

Did you know that I took your mother's graduation picture?

Beautiful—beautiful—hold it!

My, that backlighting is flattering!

Good looking couple. . . .

I saw your name in the paper last week. . . .

Let your head feel like it's falling—let it go—let it go—that's it. Good girl!

Let me explain something that's very important. . . .

I'd like to come over to discuss clothes and shooting locations—when would it be convenient?

Have you seen (the latest rave movie) yet?

The Power of Rapport

Are you familiar with the French term, *en rapport*? Literally, rapport means relation, tie, or connection. To be *en rapport* with someone means you are in mutual accord or have a sympathetic understanding. The definition of rapport, as used in hypnotism, is even more appropriate for our purposes: *The confidence of a subject in the operator with willingness to cooperate.* Substitute "photographer" for "operator" and you've got it!

What is the importance of rapport between the photographer and his subject? Briefly, the better the rapport, the better the pictures will be. With this strong mental bond between you and your subjects,

they will be more cooperative and pose more naturally. The subjects will understand what you want them to do. They'll realize you're not just someone who calls himself a photographer. They'll be pleased with you, and they will like the picture *even before you start shooting.*

It's important for the subjects to know what is happening; to involve them in the picture-taking situation. In fact, the aim should be to get your subjects to see the picture as clearly as you do, before it's taken.

Remember, many times you'll be photographing people who never before have worked with a competent photographer. They're not blasé professional models, they

don't understand anything about photography, they're stiff, tense, perhaps frightened, maybe embarrassed, or just generally uncomfortable.

You must make the subject feel that this is something that two people are doing *together*. You must not make them feel resentful. You must dispel that I-really-don't-want-to-have-my-picture-taken feeling. Don't make your subject feel like a victim!

Can you view the situation from your subject's viewpoint? Try. Did you know that many subjects you photograph secretly ask, "Do I really look that bad in pictures?" Most subjects know they are not movie stars and feel they are not good

enough (their self-image is not high enough) to want their picture taken.

Just a minute! These people are your friends, or perhaps customers; you are trying to please them. If you blindly persist in not sharing *their* viewpoint, you aren't going to do it very well.

It will help a lot if you explain what you're going to do. If you're taking environmental portraits outdoors, tell them about the desirability of backlighting, and about the trees in the background, and what role they're playing in the composition. Explain how your reflector softly illuminates the shadow side of their faces. They'll relax. If you are kind and gentle or enthusiastic, these emotions will be mirrored in their faces.

The same principle applies when you take pictures of an executive in an office, a secretary at a typewriter, a production worker on an assembly line, or friends and relatives at home. Just take a few minutes to talk with them so they won't feel they're just another subject to be ground into your camera. These subjects also must be made to feel an important part of what you are doing. Don't forget, they are doing it too—making the picture.

Obviously, the advantages of a good photographer-subject rapport are very worthwhile for picturing the person on the job. If you haven't had time to do your homework and are not familiar with your subject, take a few moments to chat before you start shooting. What are his responsibilities? How long has he had them? What are his interests outside of work? If you can't think of anything else to say, there is always one surefire question that will start your subject talking about himself. It goes like this: "Say, tell me, how did you ever happen to get started in this business?" But if you plan to ask this question, you'd better have the foresight to bring a picnic lunch!

On the other hand, you may be allowed only a very short time to take the picture. So you've got to be able to talk fast. You've got to be able to sell yourself right away. Even while you're shooting, you should be talking with your subjects to put them at ease. *Talk* for the sake of rapport; *think* photographically to ensure the technical success of your pictures.

How wrong it would be, at the same time, not to explain what you're going to do—to plunk the subject down in front of the camera and only say, "Bend this way, and turn your head this way, and hold your hand this way, and let your hair hang off your shoulder." Imagine a photographer arranging several lights around a three-year-old child and then, when all was ready, suddenly shouting in lion-taming tones, "OKAY KID, NOW SMILE!" There would be only tears.

It will help appreciably to quickly cement the relationship between you and your subject if you know a little about him beforehand. Does your subject play golf? Is he a hunter? If you know this person has written a book, have you at least browsed through it? Does he love to work in his garden? Can you talk to him about plants? If the subject is a woman, where does she buy her attractive clothes?

You can help to win people over this way. They'll feel more at ease because you have mutual interests, and it all helps to make picture-taking easier.

Obviously, rapport should also exist between the photographer and client, such as an art director who might have commissioned the pictures. The more clearly you understand the wishes and needs of the client, the more salable your services are. Some of these well-meaning, but perhaps inexperienced, people will tell you to take a picture *their* way when you know *your* way is better. Then what? Bend a little; shoot it both ways. Then comes the clever part: Make them feel, if you can, that your better way was really a version of their idea. That should sell them. The way to this sort of success is really a related aspect of rapport, isn't it?

When it happens, this stimulating meeting of the minds is an exciting thing. It's even contagious. On one occasion when a photographer was taking a slide sequence involving a production line, a few people stopped by to chat with the ad manager who was the client and to watch the photographer work. The whole group could see how the photographer was communicating with the subjects and they knew as well as he did, the sort of picture he wanted. They had never seen a photographer work this way, and they became so enthusiastic that they marched around with him for more than an hour. Afterward, one of these spectators said he felt as if he could grab a camera and do exactly what the photographer did.

But the payoff was that the client asked right then and there if the photographer would take some additional pictures for him the next week, to which the photographer replied that the client hadn't even seen the results of the first series. "No matter," said the man with the money, "I can tell exactly how they are going to turn out—they'll be terrific."

You'll have to agree, that's powerful rapport!

Portrait Lighting

The Nature of Light

Light, of course, is the tool that gives shape and color and texture to all things, including people, and it's up to you, the photographer, to manipulate it. If you control the light, you can broaden, shorten, eliminate, flatter, subdue, or emphasize; you can change values, hues, and saturations. What power lies in your hands!

For example, let's look at saturation—the extent to which a color departs from a neutral gray of the same brightness. Suppose you photographed a piece of bright red cloth, illuminated from the side with an undiffused spotlight. Then you replaced the spotlight with two umbrella lights, one from each side, and took the picture again. The red cloth would look entirely different in the comparison photographs. The specular—parallel-ray—illumination of the spotlight would result in high color saturation. The diffuse—scattered-ray—illumination of the umbrella lights would result in a much lower saturation and the red would be far less red.

The same changes would be seen between pictures taken outdoors in bright sunlight and others taken in overcast daylight.

Texture too! The texture of clothing and skin is controlled by the direction, the specularity, and the lighting ratio.

Let's find out how to control this image-former—control its direction, its intensity, its diffusion, its color.

First, the Target.

The Facial Lighting Target

What is good portrait lighting? When and why is it pleasing? And when and why is it not? When you're striving to achieve an artistic goal, it's best to have that target clearly in mind rather than shoving the lights about aimlessly, hoping to hit upon something good, or accepting unartistic available light without modifying it properly.

First, consider that for millenniums we and our ancestors have viewed objects outdoors with the sun as a single dominant light source and skylight adding diffuse light to the shadows. On gray or overcast days, there is a soft overhead illumination. These conditions and intermediate variations are what we have come to know as *natural* lighting.

To these conditions, let's now add a human head, and on one side of this round oval object, let's add a face. The forehead, both cheeks, nose bridge, and chin are the five principal planes. These planes should predominate in a representation of a face.

Now let's try to make an artistic, realistic-as-possible representation of this three-dimensional oval object on a two-dimensional plane—a flat sheet of photographic paper. Light areas seem nearer to the observer's eye and also more important than darker, receding areas. Direct the brightest light on these facial planes and you're off to a good start. (You could do it wrong, you realize. Too much light on the ears or the neck and you'll wreck it.)

Look again at these five facial planes—they're not flat. They have delicate curves, contours, and textures. Can you position your main "sun" light to bring these out? Remember, a three-dimensional object will probably look three-dimensional in frontal light, but the illusion of depth will be heightened with sidelight. Think of your main light as a contour light. From its position at about 45 degrees to one side of the subject, move it up so that it shines *down* at about 45 degrees, giving further shape and roundness to the cheekbones and chin.

Don't move it up too high or around too far to the side so that it no longer puts a bright catchlight in the subject's eyes. Even a bit too high, and a slight downward sag of the subject's face results. You'll have deep, void eye sockets—the skeleton lighting effect.

Now! With the main light in its idealizing, artistic, and natural "sun" position, add enough "skylight" fill to soften the lighting contrast and you have done it!

This, in effect, is what conventional portrait lighting is all about—this is your basic goal, your target.

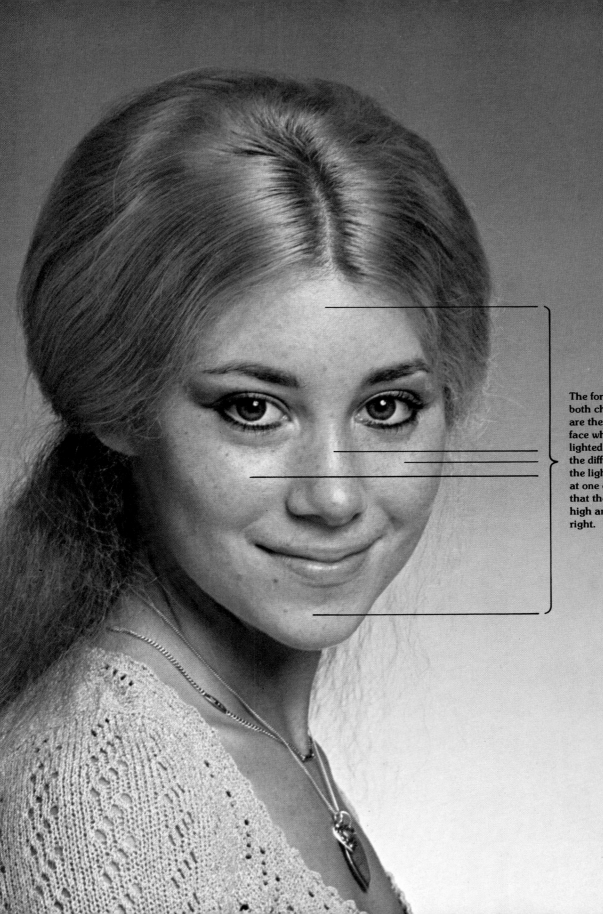

The forehead, the nose, both cheeks, and the chin are the five planes of the face which should be lighted to dominate. Note the diffused, soft nature of the light. Eye catchlights at one o'clock indicate that the main light was high and slightly to the right.

Look critically at this progression of lighting ratios. They range from a flat 1-to-1 ratio (in which the main light and the fill light were of equal intensity at the subject position) to an excessively contrasty 10-to-1 ratio. Somewhere in between, depending on your preference and the mood and style of the picture, is the right ratio. Soft ratios of about 2-to-1 or 3-to-1 are generally desirable for portraits.

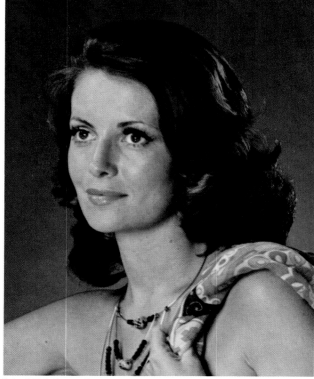

1-to-1 lighting ratio

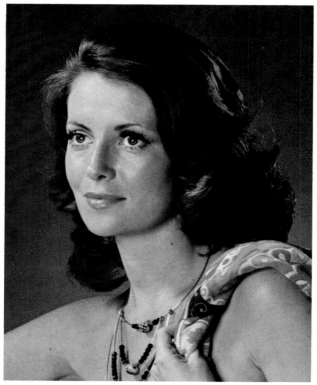

2-to-1 lighting ratio

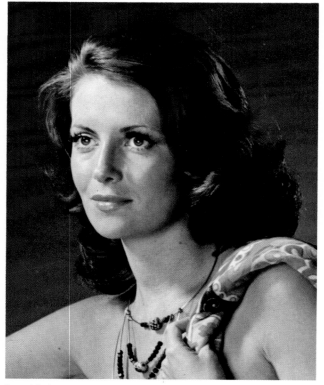

3-to-1 lighting ratio

Lighting Ratios

You can take good pictures of people if you don't know a thing about lighting ratios. But photographers who do so are either vastly experienced or lucky. Every competent photographer should know what lighting ratios are, how to establish and control them, and how to use them for different subjects and different lighting moods.

Lighting ratio is simply the relationship between the highlight and shadow illumination on a subject's face. Outdoors it refers to the sunlighted areas as compared with the shadow areas. Indoors it refers to the relative intensities at the subject position of the main light (representing the sun) and the fill-in light (representing the diffuse sky illumination).

Most recommendations concur that the ratio between these two lights should be in the neighborhood of 3-to-1. And it really makes no appreciable difference as to the type of film being used. A 3-to-1 ratio will produce pleasing, salable results that are also easy to handle from a printing contrast standpoint.

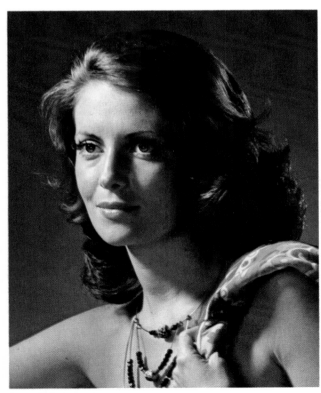

6-to-1 lighting ratio

10-to-1 lighting ratio

Do you want to know another reason why low lighting ratios are popular commercially? Because they are safe ratios from an exposure latitude standpoint. Low lighting ratios result in low subject brightness ranges. A low or ''flat'' brightness range can be placed with considerable latitude up or down upon the film's reproduction curve and be easily printed to compensate for the negative's density difference. Conversely, high lighting ratios result in high subject brightness ranges that must be precisely exposed. If underexposed, the shadows are immediately in reproduction trouble in the toe of the curve; if overexposed, the highlights are in the same type of trouble in the shoulder of the film's response curve.

Obviously, it is permissible to deviate from a basic 3-to-1 standard ratio and indeed on many occasions you should. For example, a low (2-to-1) lighting ratio minimizes facial wrinkles; a high lighting ratio (8-to-1) can be used for a dramatic effect. Babies and children usually are best portrayed with low ratios, older men, such as the bearded-prospector salon-type portrait, with high ratios. And you can even go beyond these extremes with artistic taste. You don't believe it? Well, imagine a closeup of a movie-star face with classical high cheekbones, a finely chiseled nose, slightly parted sensuous lips, uplifted long-lashed eyes, face turned slightly off a low camera viewpoint. Now illuminate this face with a single undiffused spotlight from the exact direction that the subject is looking. The pictorial lighting effect would be terrific. The lighting ratio could be 100-to-1!

The point, of course, is that lighting ratio is related to subject type, pose, and desired effect, and all of these factors should fit together artistically.

But back to basics and the 3-to-1 ratio. This is achieved when, as measured at the subject, the main light is twice as bright as the fill-in light when the fill-in light is used close to the camera lens. This is because the fill light from the front places one unit of light over the entire face, while the main light from the side (being twice as intense) places two units of light on only the main lighted areas of the face. Thus, there is only one unit of light in the shadows, but one plus two (that is, three) on the main lighted areas.

Establishing the Ratio

There are several simple methods of establishing a 3-to-1 ratio. These methods include using:

1. Both the main light and the fill light at equal distances from the subject, with the main light at twice the fill-light intensity. For example, with variable-power electronic flash units, the main light could be used at 200 watt-seconds, with the fill light at 100 watt-seconds.

2. Two identical lights, but with the main light closer to the subject. The specific distance for each light can be determined quickly by thinking of the lens f/stop openings as a distance scale. With this system, a 3-to-1 ratio is achieved if the main light is ''1 stop closer'' to the subject than the fill light. For example, if the light-to-subject distance for the main light is 4 feet, the fill-in light should be placed 5.6 feet from the subject; if the main light is at 8 feet, the fill light should be at 11 feet, and so on.

3. An exposure meter. This device can easily be used for measuring or establishing any desired lighting ratio indoors or out. Further, any artificial lights employed can be ''feathered'' (aimed somewhat off axis), baffled with barn doors (partially shielded to reduce light), or used as umbrella lights, thus not inhibiting any desired technique of lighting control for the most artistic effect.

What kind of a meter do you have?

An Averaging, Reflected-Light Meter? Measure the main plus fill-in illuminance by holding a KODAK Neutral Test Card vertically at the subject position and aiming the surface of the card halfway between the camera and the sun (main light) position, and by measuring it with the meter. Then aim the card at the camera, shading it from the sun but not the skylight (fill light), and measure again. Compute the exposure for each reading and determine the number of stops difference between the two computed exposures. The lighting ratio can be found in the following table.

LIGHTING RATIO TABLE

Stops Difference	Lighting Ratio
2/3	1.5:1
1	2:1
1 1/3	2.5:1
1 2/3	3:1
2	4:1
2 1/3	5:1
2 2/3	6:1
3	8:1
3 1/3	10:1
3 2/3	13:1
4	16:1
5	32:1

A Spot Meter? A spot meter can be used in the same manner as the averaging meter in the method described. To make it easy for you to measure, ask your subject to temporarily turn her face so that half of it receives both sunlight plus skylight (main light plus fill-in) and the other half has only skylight illumination (fill-in). Direct reflected-light readings can be made of each side of her face and compared, as in the first method, to find the lighting ratio.

An Incident Meter? From the subject's position, aim the meter at the sun (main light) and compute the exposure. Then aim the meter at the camera and shade the integrating diffuser from the direct sun, but do not block the skylight (fill-in light). Compute this exposure and compare it with the first to determine the ratio.

Remember, the most important aspect of lighting ratios is to control them and to use them artistically for different subjects and different lighting moods. Also important is to be able to accurately recognize lighting-ratio values when you see them. You must not be fussing with the lights and an exposure meter, trying to establish a 3-to-1 ratio, for example, when you're losing rapport with your subject. With practice and experience, you should be able to arrange, without measuring, whatever lights you are working with to very closely approximate a desired lighting ratio.

Note that ratios are not the complete answer to facial lighting control; it's the total effect of the lights on the face that is important. Another element to consider is lighting contrast. A 3-to-1 ratio with the main light at 45 degrees to the subject's face will result in a certain lighting contrast. Move the main light further around, say, to 60 degrees, and the lighting contrast will be increased even though the lighting ratio remains the same. This is because the degree of specularity of the main light highlights has intensified due to the change of angle at which the highlights bounce off the subject's skin into the lens.

A dark, moist skin will result in a higher lighting contrast than will a white, dry skin, even with the light placement remaining constant.

The point is, you should be cognizant of these lighting subtleties and modify your light placements with a careful, artistic eye.

Outdoor Conditions

In general, the very best lighting for taking portraits outdoors occurs mid-morning or mid-afternoon under hazy sunlight conditions. There is just enough light cloud cover or atmospheric haze so that definite shadows are just barely discernible. Yet shadows are there; there is direction to the light. This means it's the kind of soft lighting that won't cause your subject to squint if he faces the light, nor will you have to supplement the shadows with a reflector or fill-in flash if the subject is back- or side lighted. Shoot quickly; these ideal illumination conditions are sometimes fleeting.

With this hazy lighting, the sky is not going to be blue. So if that's an important consideration to your picture, pose your subject in front of tall foliage or try in some other way to hide the sky.

Hazy sunlighting is best for outdoor portraiture—but what if the day is *completely* overcast and gray? How can you supply a little direction to the light? There are two answers. The obvious first one is to add a bit of sparkle with a weak flash. The flash unit should be held high and somewhat to one side of the camera to serve as the hazy sun. Be careful not to overdo this highlight effect—a little bit goes a long way. Be sure to diffuse the flash, even if it's only with a thickness of handkerchief over the lamp housing. Even better, use the flash in conjunction with a small portable umbrella reflector.

Subtractive Lighting

The other solution to giving some direction to the light is with a technique known as *subtractive lighting*. Simply, this consists of shielding the side of the subject's face with a black umbrella or a head screen called a gobo. In a sense, this "subtracts" light from that side if positioned properly. You should not try to subtract light from the frontal planes of the subject's face. You'll probably need an assistant to hold the screen, or at least some portable stand on which to clamp it, but the technique is worth the effort. It does work, and lovely soft-lighting effects can be obtained. Of course this technique is only feasible for fairly close-up pictures of a single person.

Shade lighting can be more directional than you might believe. It's not flat. You must observe carefully the direction of the light on your subject's face and position him accordingly. The illumination under a tree or on the shadow side of a building is ideal for portraiture. It does away with squinting and is softly flattering.

Sunlighting

Sometimes you can't help it. Sometimes you must take a picture of a person outdoors on a clear, sunny day. Of course we're referring to professional-quality, artistic, natural portraits, not tourist pictures like the this-is-father-standing-in-front-of-Old-Faithful-Geyser snapshots.

When you must shoot in the direct sunlight, try to schedule the shooting time in the morning or afternoon when the sun angle is about 30 degrees from the horizon. Try not to shoot around noon when the sun is high; this will cause nose and eye shadows to be very uncomplimentary. There is a rather cumbersome way of partially overcoming the harsh lighting contrast of an overhead sun, and that is with a larger diffuser or "scrim." This is a gauze or mesh panel held over the subject's head by an assistant in order to diffuse the harsh light. Obviously, its use is rather limited to close-up work on windless days.

The most important piece of advice that can be given now is this: When you must shoot in bright sunlight, *turn your subject away from the sun so that his face is in shadow.* Presto! You've created a nice rim or backlight effect that is very pleasing to the eye. It's pleasing to the eye, but not to the film. The eye can tolerate as normal a scene with a wide range of brightness, but the film would record the scene as far too contrasty. The eye shifts sensitivity very rapidly too; it increases sensitivity when looking into a dark place. This effect is related to the rather slow change of pupil size. Thus brilliant highlights don't appear too brilliant and fairly dark shadows don't appear too dark. The eye tends to see in terms of an object's reflecting power, whereas the camera sees the same object by the amount of light it actually reflects.

Is a piece of white paper *always* white? Or a white shirt? Or a white dress? Your mind says it is. Yet if the paper is in a shadow of a scene that is predominantly sunlighted, and if your exposure is based on the

Same children, same time, same clothing, same place. The difference, of course, is that the picture at the right was taken with the children turned around so that they would be illuminated only by soft skylight. Be careful not to underexpose a scene like this since the relatively bright background can strongly affect an exposure meter.

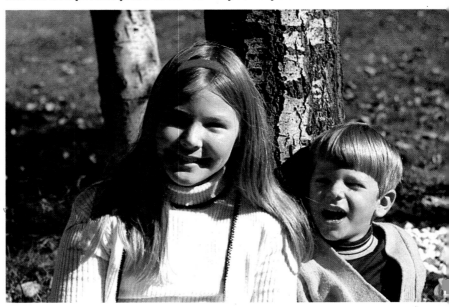

highlighted areas, the camera will see the paper as gray. However, if the paper is in the shadow area of a scene that is predominantly in the shade, and if your exposure is based on the shadows, the camera will see the paper as white.

The object lesson here is to compose your portrait subjects so that the scene is either essentially sunlighted *or* essentially in the shade. Don't mix these far-apart lighting situations—keep the film's recording capability in mind.

Ah, the film! Never forget it has a fixed sensitivity, and therefore you, the photographer, have to reduce the natural high brightness range to a lower one within the film's capability for a pleasing recording. By pleasing, we mean without loss of important highlights and shadows. You should keep in mind the differences between your vision and the film's recording capability when you are practicing "eye photography."

To be strictly accurate, it is not the film's brightness range that is important, but the brightness range of the projection screen or the printing paper. This is more limiting than you at first imagine. The scene's tremendous brightness range must be compressed down to where it can be recorded satisfactorily by the film. But the tonal range of a transparency material, of perhaps 1000-to-1, must be further reduced to about 100-to-1 on a piece of photographic paper. To be sure you don't lose important shadow or highlight detail along the way, the scene's brightness range must be first compressed by illuminating the shadows adequately. This means more shadow illumination than the photographically untrained eye would expect.

At this point you have three choices regarding a sunny, high-contrast brightness range:

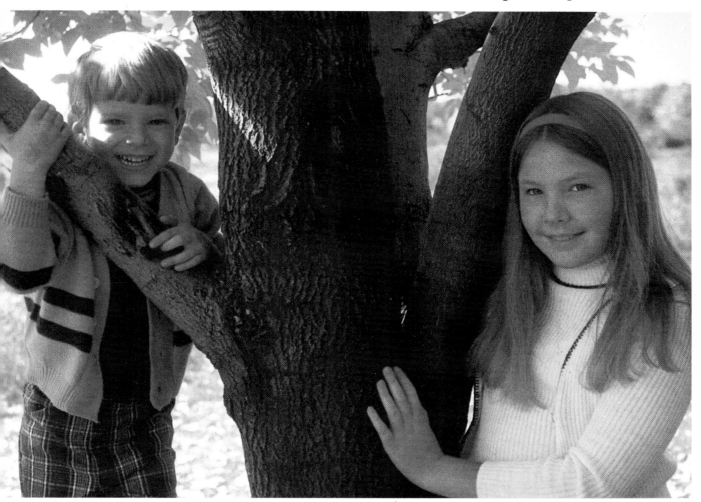

Brightness Range

One—Leave It Alone

You can leave the brightness range alone and record it as it naturally exists. In this instance, *expose for the face.* The background, and the foreground if any is included, will usually be somewhat overexposed. Sometimes this will result in an interesting pictorial effect; you might wish to try one exposure made this way. But chances are you won't like it very much. Of course if it's a dark foilage background, it won't be overexposed. However, the overall effect will be of excessive contrast. In addition, the subject could be missing the usually desirable eye catchlights.

Unaltered late afternoon back sunlighting. Two additional factors contributed to the success of this picture: The exposure was based on the shadow side of the subjects and the background in shadow kept that area dark, placing the emphasis on the figures.

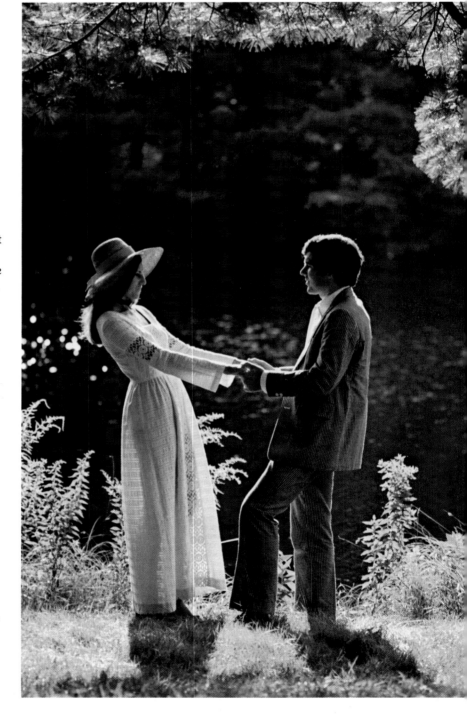

Two—Use Reflectors

The contrast of a backlighted outdoor portrait can be easily reduced by using a large reflector near the subject to bounce back some of the sunlight into the subject's face. Be sure the reflector is not included (not even its edge) in the camera's field of view. This obvious advice is given because some cameras include a bit more area of the subject than is seen through the viewfinder.

The reflector itself deserves some consideration. You can improvise one from a large sheet of white cardboard or stiff white paper. About a 36-inch square should be adequate for head-and-shoulder and even three-quarter portraits. There are also commercially available reflectors, such as the Reflectasol reflectors manufactured by Larson Enterprises, Inc. (18170 Euclid Street, P. O. Box 8705, Fountain Valley, California 92708), or the Ascor/Tiffany Bouncelight Umbrellas manufactured by Tiffany Enterprises (34 West 38th Street, New York, N.Y. 10018). Your camera shop probably has a variety of fabrics that can be used for reflectors, including super silver, silver, soft white, silver blue, blue, and gold. The super silver is the most efficient reflector and thus can be used the greatest distance from the subject. Don't use it too close; it's so bright that it will cause many subjects to squint.

White would be the universal, all-around choice for a reflector. Gold can be employed if you want to warm up the bluish color of

shadow illumination. On the other hand, if you are taking direct sunlight pictures, early in the morning or late in the afternoon when the light is objectionably yellow, you can use a blue reflector to cool it down somewhat.
A word of caution: *Don't overfill.* That is, don't use the reflector so close to the subject's face that the lighting effect becomes unnatural. Better too little fill light than too much.

A reflector, depending somewhat on its size and composition, has a rather limited range of usefulness. Beyond about 12 feet from the subject, even a large reflector will have little effect. Beyond this distance, the solution to reducing lighting contrast is with fill-in flash.

Sure, it's a little extra trouble to take a picture with a reflector. But it's worth it if you're quality conscious, especially if prints are your end product. Slides, with a greater density range available, can better tolerate a great range of subject brightness than can prints.

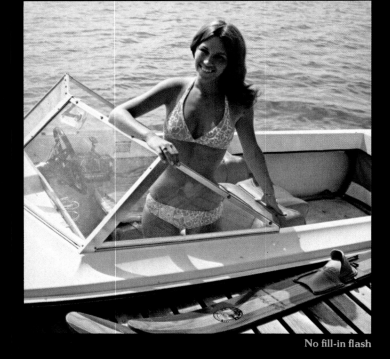

No fill-in flash

Three—Use Fill-in Flash

The high contrast of back sunlighting and shadow on a person's face can also be reduced with a flash used from the camera position. Again, the main problem is not to allow too much of the flash illumination to cause unnatural lighting. Usually, the trouble is that the flash is simply too strong, which means that it would best be used at a 12-to 20-foot camera-to-subject distance. For closer use it should be heavily diffused.

The important thing is that *the flash should lighten the shadows, not eliminate them.* The degree of fill-in flash can and should be controlled. Just use the following table, which works for any film. (The camera settings are based on the ratio of flash to sunlight and not on the film speed.)

SUBJECT DISTANCES FOR FILL-IN FLASH WITH ELECTRONIC FLASH (Distance in Feet)			
Output of Unit BCPS	Shutter Speed with X Synchronization		
	1 / 30	1 / 60	1 / 125
350	1½-2-3½	2-3-4½	3-4-7
500	2-3-4	2½-3½-5½	3½-5-8
700	2-3-4½	2½-3½-6	4-5½-9
1000	2½-3½-5½	3½-5-8	5-7-11
1400	3-4-7	4-5½-9	6-8-13
2000	3½-5-8	5-7-11	7-10-15
2800	4-5½-10	6-8-13	8-11-18
4000	5-7-11	7-10-15	10-14-20
5600	6-8-13	8-11-18	12-17-25
8000	7-10-15	10-14-20	15-21-30

Note: Some focal-plane shutters will not synchronize at speeds faster than 1/60 sec., so be sure to check your camera's instruction book.

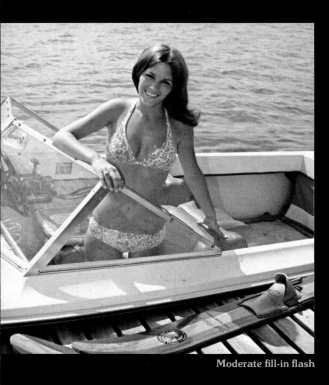
Moderate fill-in flash

Excessive fill-in flash

Let's assume that you have an interchangeable lens camera that has a focal-plane shutter and X-synchronization for electronic flash. Just locate the output of your unit on the table and read to the right to locate the distance range your subject should be within, for a good fill-in-flash shot. You'll get full fill (2-to-1 lighting ratio) when your subject is at the near distance, average fill (3-to-1 lighting ratio) when your subject is at the middle distance, and slight fill (6-to-1 lighting ratio) when your subject is at the far distance.

An example may be worthwhile: With a film rated at ASA 100, your basic exposure for a normal sunlighted subject would be 1/125 sec. at $f/16$. Let's say you have a 1000 BCPS electronic flash unit and you want to shoot a weak fill-in flash shot. If your subject is 11 feet from the camera, you're all set. But don't let this particular set of conditions limit your camera-to-subject distance. Suppose you wanted the subject at a 5- to 6-foot range with the same shutter speed and weak flash fill? Three solutions are possible.

Use the flash on an extension cord 11 feet from the subject and then the camera can be moved anywhere freely, while still maintaining this lighting ratio.

Use one thickness of handkerchief over the flash. This cuts the amount of flash illumination approximately in half.

Change to a lens of twice the focal length and shoot from the same 11-foot camera-to-subject distance. Again a word of caution: Don't

overfill—better too little than too much. In fact, aim for the 3-to-1 or 6-to-1 ratios; there's good "viewer acceptability" in this range, but far less at a 2-to-1 ratio.

The trouble with most flash units is that they put out too much light to be used conveniently for fill-in flash outdoors. One answer to this problem is to own a second, small unit with a minimum output for fill-in work. Call it a "wink" light if you wish. A little practice with this unit and you will quickly learn a camera-to-subject shooting distance zone in which a desirable degree of flash fill will result.

For the newer automatic flash units, increase the film speed (ASA) on the unit for less light. Doubling the film speed (ASA) will give you half the light.

Location Lighting

There are two obvious approaches to handling lighting in homes, offices, or other interior locations. One is to shoot with the available light (exposure determination and filter use are discussed on page 116), but there are limitations under some circumstances. First, there simply may not be *enough* light to do the job properly. Even with high-speed film, a low level of illumination, plus the additional speed loss from a light-balancing filter, will force you to accept a more shallow depth of field and/or a slower shutter speed than you desire.

For example, consider the man-in-the-office portrait. You want a relaxed, informal pose—not a Napoleonic one! One way to achieve this is to have the subject chat with someone out of camera range in a relaxed way. You're looking for the intriguing expression, the meaningful gesture, and the interesting tilt of the head, all movement-oriented shooting moments. But you'll get only blurred images at 1/10 sec. or slower shutter speeds. Or perhaps the subject will "drift" imperceptibly forward just out of the very shallow zone of sharp focus available when using wide lens openings.

Besides insufficient light, the color balance and the distribution of the available light may be undesirable. Let's use the man-in-the-office example again. Behind him there is a large window, and overhead there are fluorescent ceiling fixtures. If he faces into the room, there's not going to be much available light on the frontal planes of his face. If you expose for the face, as you should, the background may flare badly. Also, what light-balancing filter are you going to use for this mixture of bluish window illumination and minus-red fluorescent illumination? No one can outguess these situations every time!

The second obvious answer to the location-lighting dilemma is to use portable electronic flash. And as with every tool, there are right and wrong ways of using it.

Single Flash

For a natural lighting effect, the wrong way to use flash is to attach it to the camera. Surely you care more about the lighting than merely that there be enough to make an adequate exposure!

Using a single flash directed at the subject is artistically worse than aiming high-contrast sunlight directly at a person, if you could—worse because you are using it at comparatively short distances. The light from a single-point flash source diminishes very rapidly—the degree of falloff is inversely proportional to the square of the distance, if you want to be technical about it. Practically, this means that if you have one subject 6 feet from the flash and another at 12 feet, the farther one does not receive half as much illumination, it receives only one quarter—two full stops less. Of course you can imagine what this poor lighting distribution would do to formal groups, parties, or

Bounce is a flash trick used by most good location photographers. It's especially helpful in providing soft, even illumination for wide-angle lenses.

receptions. Flash, held high and at arm's length on an extension cord, will help to somewhat distribute the light more evenly.

A word of caution about using flash with wide-angle lenses: Most flash units are designed to give an adequate field coverage when using a normal focal length lens. This coverage angle is about 35 degrees (for the short dimension of the negative) by about 45 degrees (for the long dimension of the negative). But a wide-angle lens, because of its greater angular coverage, sees more than the flash illuminates. Consequently, if you are taking groups of people indoors with flash and you are using a wide-angle lens, the persons at the ends of the rows (imaged at the edges of the film) are going to be considerably underexposed when compared with those in the center.

To counteract this "hot-spotting" tendency, be sure to orientate your flash reflector in the same manner as your film format. That is, if you are taking a horizontal picture, be sure your flash reflector is also positioned horizontally—especially with extra-wide-angle lenses, such as a 21mm or even a 28mm lens for a 35mm camera. This may still not provide an adequate answer to the problem.

An easy solution is to use bounce or umbrella flash, if it is possible. This will broaden the light source considerably. A good technique used by location photographers is to fasten with a rubber band, a small white cardboard, such as a 3″ x 5″ file card, to the top back edge of your electronic flash unit. The flash is then aimed toward the ceiling in a bounce-light position, but the card, which should be bent forward slightly, catches some of the illumination and directs it forward toward the subject. Thus you would be using a combination of bounce plus direct light. The small portion of direct light is widely diffused, but it helps to illuminate facial shadows, as well as to put a tiny catchlight in the subject's eyes.

Don't forget: Using the flash in this manner will necessitate opening the lens up approximately two stops more than with the direct flash exposure.

There are additional evils of flash-on-the-camera, such as flat lighting for any particular subject in the scene. Then, too, you may encounter a possible "red-eye" effect (caused by having the light source so close to the lens that it sees the flash reflected from the reddish retinal lining of the subject's eyes; this occurs most frequently in children).

However, there are always exceptions to the rule, aren't there? For example, sometimes even professional photographers take a vacation from rigid, exacting photography. They leave their big cameras—or at least their expensive and versatile 35mm cameras with several lenses—at home and take off for sunny climes.

Without a camera? No, no. With a so-called snapshot camera, probably a <u>Kodak</u> Pocket <u>Instamatic</u> Camera and a hatful of flashcubes or ten-flash bars. Vacation! Fun! And pictures that they and their friends will enjoy later.

What would someone like this—a knowledgeable, artistic pro—do with his single flash-on-the-camera to get better pictures than someone else? There's no guarantee he would, but he'd probably pay attention to these things:

 —He wouldn't take pictures closer or farther than the recommended range of the flash. For simple, fixed-focus cameras, this camera-to-subject distance is about 6 –12 feet.

 —He'd be especially careful about the arrangement of groups of people—not letting someone be appreciably closer to the camera or farther away than the majority in order to be sure of even lighting.

 —He might even be so careful as to make a white-shirted person in the foreground put on a dark jacket. Or else move him to the rear of the group, so as not to "burn him up" with the flash.

 —But most of all, he'd be an imaginative director, an extroverted crowd controller, an inventor of an interesting bit of action that would unify a group and spontaneously create some great natural expressions.

And now hear this: It is not the camera equipment or the bagful of lenses and accessories that makes a good photographer. No, it is the person himself, his creative thoughts, his imagination, and his ability to direct and control his subjects. Of much less importance is how much was spent on the devices that record the wonderful scenes.

This represents the Flash Fall-off Syndrome. One of the most common mistakes in flash-on-the-camera photography is to accept groups of people as they are found, rather than to rearrange them so they'll be easier to illuminate evenly.

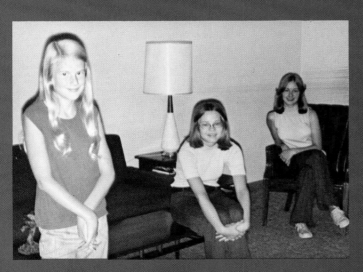

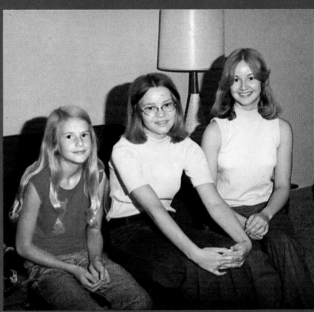

Two-Light Flash

If you really must use direct flash, try a two-light technique. These should be two identical electronic flash units, each with its own power supply. The remote, or "slave," light should be outfitted with a photoelectric cell which, of course, is triggered by the light from the on-camera unit.

Why two lights? Consider that you are trying to achieve a "natural" lighting effect. In other words, you should attempt to duplicate the strong directional sunlight, with the weaker skylight filling in and softening the shadows. Consequently, you should regard the slave light as the "sun" and use it high, off to one side, and closer to the subject than the fill light (representing the skylight), which is the on-camera flash.

The two identical flash units can be used interchangeably to create the desired lighting ratios—about 3-to-1 will give normal, pleasing results, and 4- or 5-to-1 will produce more contrasty, dramatic results. There are several easy-to-remember systems of positioning these lights for normal results.

Put the side (main) light about one-third closer than the fill light. The specific distances can be established by thinking of the f/stop lens openings as a distance scale. Thus a 3-to-1 ratio is achieved if the side (main) light is "1 stop closer" to the subject than the fill light on the camera. As an example, if you find you obtain the right composition when standing 11 feet from the subject, have someone hold the main light 8 feet from the subject, high and somewhat to the side.

If your flash units have a half-power switch, use both lights equidistant from the subject with the sidelight

on full power and the camera light on half power.

If there is no half-power switch, use the lights equidistant from the subject and cover half of the reflector with your fingers or put one thickness of white handkerchief over it.

For slide films, the exposure determination is based on the side (main) light-to-subject distance, using ordinary guide number procedures. The fill light (on the camera) simply does not enter into the calculations. However, for negative films, the exposure should be based on the important shadow areas of the face.

Let's be specific about the advantages of this two-light system compared with a single flash at the camera.

- Your portrait subjects will be illuminated far more artistically. They will look rounder, more three-dimensional, with the dominant light coming from high and to one side.

- Subject textures—their skin, the features of their faces, the texture of their clothing—will all be better delineated.

- Subjects will be separated better from the background.

- The underlighted-background and overlighted-foreground problem is largely eliminated.

- You'll have wonderful creative flexibility with two lights. For example, the slave light can be used only as a top hair light, or just as a light for the background, or just to increase the lighting coverage for a sizable group of people.

In general, be sure that the main light (this is the slave light held in

place by an assistant or else placed on a light stand) is fairly high, off to one side of the subject, and that it illuminates the frontal planes of the subject's face.

One obvious thing to watch for when "two-teaming" it this way at weddings, parties, or places where several other people are also taking flash pictures is that their flash will trigger your slave unit unless its photocell is covered until just before you want to use it yourself.

The main flash was positioned to the left and slightly behind the subject. It was triggered by a photoelectric cell that was activated by the fill-in light at the camera. Although the two lights were identical units, two-thirds of the camera light was covered to reduce its output to obtain this dramatic lighting effect.

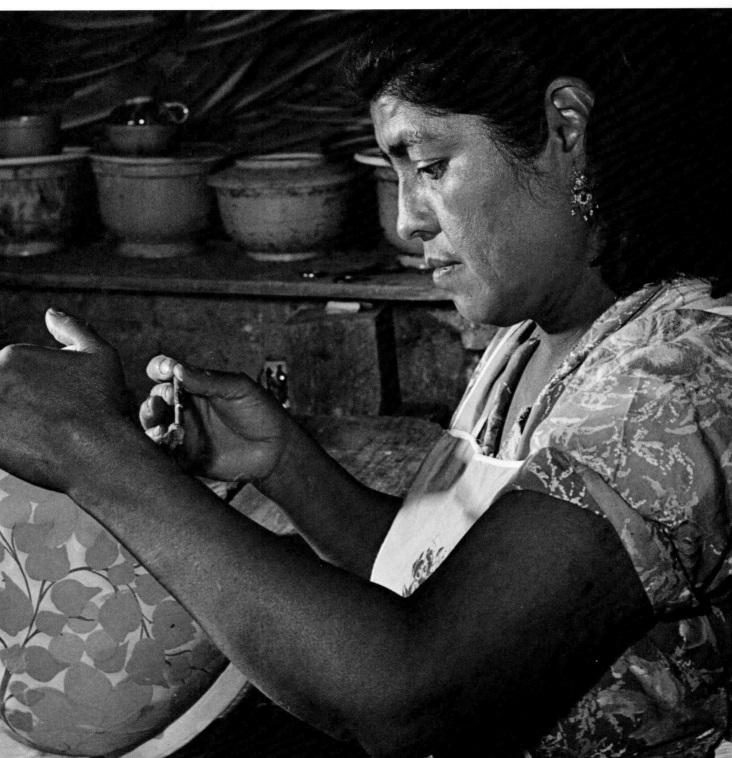

Portable Umbrellas

Remember that an overcast or hazy-sun day is one of the best natural types of lighting for people. It's impossible to duplicate exactly with artificial lighting equipment, but you should try. You can take a big step in this direction if you diffuse your electronic flash units by using them in conjunction with umbrella-type reflectors.

Really, you should broaden and diffuse your "point-source" flash units for several reasons:

- A sharp shadow from the main light is not as flattering nor as desirable in portraiture as it is in commercial product photography.

- Diffuse lighting minimizes facial textures and blemishes. It therefore eliminates some of the need for retouching.

- A diffused light covers the subject more evenly; it helps to eliminate hot-spotting.

- A broad source of light is far less subject to the inverse-square law of light falloff. People in a group will be illuminated more evenly.

One well-known way to diffuse light is to bounce the flash illumination off a white wall or ceiling. In an average room or office, this means an exposure increase of two or more stops. There are automatic flash units with which it is possible to keep the subject light-reflectance sensor pointing forward while tipping the lamp head upward. However, the trouble found by most bounce flash users is that rooms in which they take pictures vary in size, and exact exposure determination is often difficult to ascertain consistently. Then, too, bounce lighting is obviously not practical where the walls and ceiling are not near-white, or in large indoor areas, such as churches, auditoriums, gymnasiums, banquet halls, or other places where the ceiling is 20 feet high or higher. In these places, the flash aimed upward would go up, get lost in the rafters, and never come down again! Better to improvise in these situations and bounce the flash off a large white cardboard.

Certainly the most convenient and effective flash diffuser is a bounce flash umbrella. Lightweight, collapsible, versatile, and portable, an umbrella reflector is the answer to many otherwise difficult location portrait problems. You'll find this tool helpful in nearly every situation where you would normally use flash—wedding candids, fashion candids, at banquets, night clubs, receptions, sporting events, people-at-work situations, and just natural pictures of people at home or engaged in indoor hobby activities.

No longer do you have to worry about the color-contaminating influence of a green wall or which light-balancing filter to use where there is a mixture of different types of illumination. Exposure determination is now simple. Use ordinary guide number techniques and add 1½ stops. If you think the light loss is too great, you can mount two small electronic flash units on the umbrella, fitting one of them with a photoelectric triggering cell to use it as a slave light.

Umbrella reflectors are designed so that the reflecting fabric is interchangeable and reversible. A silver Mylar surface is a most useful all-around choice. But if you want to add a degree of warmth to your portraits, you have the option of changing to a gold fabric.

Better practice around home with an umbrella reflector before you take pictures with it on location. Also, watch out going through doors!

Use it flat for outdoor fill flash. Use it curved for indoor flash. Use it flat as a sun reflector.

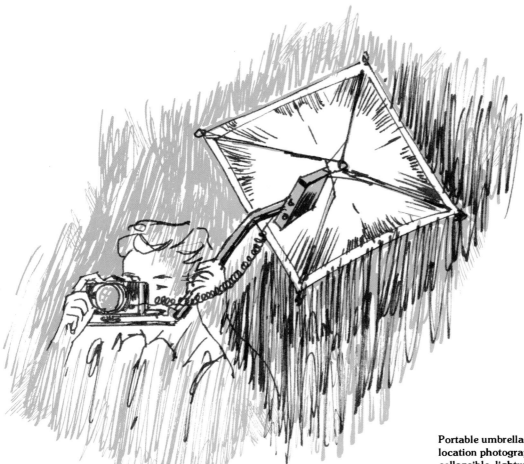

Portable umbrellas are a must for good location photography. They are adjustable, collapsible, lightweight, and available in different sizes. They provide a soft, even illumination and they can spread light over 120 degrees. Many models convert to a flat shape for fill lighting indoors or outdoors.

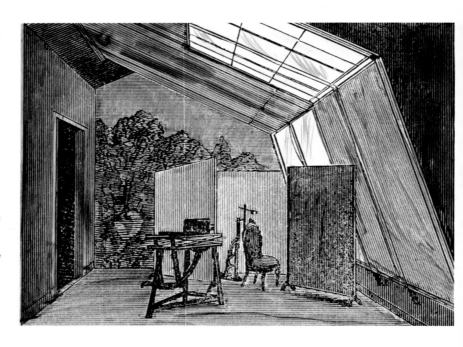

This studio skylight illustration was reproduced from the *Philadelphia Photographer* published in 1876. (We added the color tints to help separate the planes of the room.) The editors at that time said, "The style of light is used by the leading artists in this country and is the style that we feel we can recommend without risk even to those who have a very limited knowledge of photography. The main body of the light enters at about an angle of 45 degrees, which is the proper direction for giving a good light on the sitter."

Window Lighting

Let's go back a hundred years to the north skylight illumination of our photographic forebears. The light was softly directional, controllable, flattering, natural—it still has these qualities today!

First, there's nothing mystical about the light emanating from the northern quadrant of the sky. It's no better for photographic purposes than the light from the eastern sky. It's just that in the northern hemisphere, there is far less chance of the sun shining directly through a skylight that is facing north- than if the skylight were facing in any other direction. This is particularly true in winter when the sun's orbit traverses only the southern portion of the sky and sunlight never enters a north facing skylight directly. Can't have that contrasty lighting wrecking the

soft, beautiful skylight effect!

Today, to recreate the effect of north light, simply substitute a large window for a skylight and you have it made. And there are so many instances when this is a very good idea. Raining? Too cold? Snowing? Or sun shining brightly and there is no convenient shade available? Bring your subject inside and position her close to a window.

It would be very difficult, if not impossible, to match the soft, directional aspect of window light with artificial light. So accept it, use it, and be grateful. However, the color quality will vary from a gray overcast day to a sunny, clear day when the window will admit very bluish light. In this latter case, it's best to take window-light pictures with a skylight filter on the camera lens

An effective position for the subject would be to have her shoulders turned away from the window with her face toward the incoming light. There are two valid reasons for this suggestion. First, it is a graceful position to have the shoulders facing one way and the head another—it gets away from the "everything-stiff-at-attention" pose. Second, with the shoulders turned away from the window, the shoulder-chest area of the subject will reflect far less light than the face, which is turned toward the light. And this is how it should be, artistically.

In most instances you will want to add some fill light to the shadow side (the room side) of the subject's face. There are three easy ways of doing this: with a large reflector, with a weak fill-in flash, or with a blue floodlight in a reflector. Of course, you must balance this fill light so as not to overpower the daylight; just enough so that the fill provides adequate shadow illumination.

Here is where an exposure meter can be a valuable tool. Let's say that you are using the blue floodlight method of balancing. First, measure the window-light intensity. Then gradually increase the shadow illumination, measuring with your meter as you do, until you have achieved the desired lighting ratio. If the window frame is going to show as a part of the scene, you'll want a fairly high ratio, say 8-to-1, to preserve a natural lighting effect. Psychologically, we expect to see this high lighting ratio for any subject at a window, so don't disappoint the viewers with anything else.

Studio Lighting

For modern studio lighting, there really can be only one logical choice—electronic flash. Units are available with sufficient light output so that they can be heavily diffused or bounced and still have enough lens-stopping-down power to make picture-taking of wiggly children easy. The exposures are short enough to freeze even sudden and rapid movements. The color quality of the light is close to daylight and no filter is required for a color negative film, such as Kodak Vericolor II Professional Film, Type S.

The most common errors in using any indoor illuminant are: (a) they are usually not sufficiently diffused, and (b) the placement is not done skillfully. You are a long way toward correcting both errors if you turn the studio lights away from the subject and bounce them against sizable white umbrella-type reflectors. This effectively and dramatically increases the size of the light source, making it simulate hazy sunlight— the ideal portrait light for general use.

You should become familiar with the customary conventions of portrait light placement. Just because you are bouncing the lights doesn't necessarily mean that you are also positioning them artistically.

For example, you could bounce the main light at the ceiling directly over the subject's head, but this would cause too much light on the hair and excessively dark eye shadows like a noontime sun, the worst possible outdoor lighting. Better to bounce the main light off a white wall behind you so it illuminates the eyes properly. When aiming bounce lights, there's really no need to wonder what the effect will be if you keep in mind that the angle of incidence equals the angle of reflection. Perhaps you'd remember better if you think of it in terms of handball bounce angles or of bank shots when playing pool—it's the same law of physics that governs all of these situations.

Light placement principles are essentially the same regardless of the type of illuminant—flood, flash, fluorescent, electronic flash, daylight, or what have you. The basic idea is to reproduce natural outdoor hazy sunlighting. This lighting consists of the hazy sunlight, diffused but just strong enough to cause discernible shadows, *and* the fill light that comes from the rest of the sky area. Remember, *two* sources: one slightly directional, the other completely diffused and coming from *everywhere* overhead. Recall that the best *time* of day for portraits was early morning or late afternoon (on such a hazy day) when the sun angle was about 30 degrees from the horizon. To

duplicate this condition, you now know how high to position your main (diffused) light to simulate the hazy sun.

Umbrella Lighting

It's interesting to consider that in the past century, studio portrait lighting has completed a circular evolution. It started with soft, diffuse skylight. It went through several stages of glamor spotlighting—tungsten floodlighting, banks of fluorescents, and various kinds of electronic flash lighting. And now it's back to natural lighting, using diffuse skylight from a large window, or trying to create this effect with the help of small electronic flash units bounced off reflecting umbrellas.

Umbrella lights are used in conventional light placement positions, that is, main modeling light, frontal fill light, and usually one or two backlights to provide hair detail and background-subject separation.

To this arrangement can be added a huge umbrella light suspended from the ceiling, about halfway between the subject and the camera. This can be angled down at the subject at about 40 degrees. If you think this recreates an indoor approximation of outdoor hazy sunlighting, you are exactly right. In fact, it's correct to call this the main light since it provides the basic general illumination. On it the actual exposure is based. The smaller

The large umbrella suspended from the ceiling provides the overall illumination and determines the exposure level. The mobile umbrella unit at the right is the main, or modeling, light. The two smaller umbrellas are backlights to illuminate the hair and to help separate the subject from the background. Consult the studio shooting session on page 238 for examples of umbrella lighted portraits.

movable floor units provide slight directional emphasis for this principal light.

The large overhead umbrella technique has another bonus: It's high enough, and it can be angled down enough, so that the shadow caused by the subject is low enough not to be seen by the camera, even on a fairly close background. And, since the falloff from such a large source is so slight, the background receives sufficient illumination so that it does not require lighting separately.

This is different! It used to be an almost universally accepted studio procedure to place a separate light on the background. This was often hidden behind the subject, and by today's natural light standards, created a somewhat phony effect, to say the least.

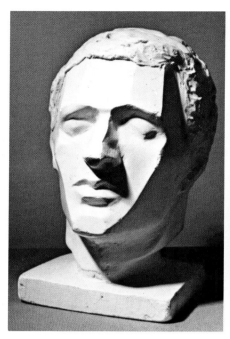 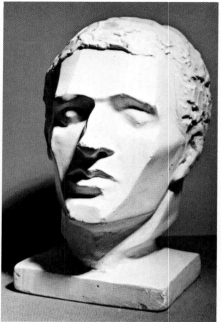 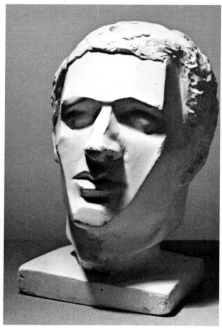

The main light is in the narrow, or "short," lighting position. It is the most generally used position. Note that it illuminates the eyes and casts a 45 degree angle nose shadow *toward* the camera.

The main light is in the broad lighting position. This position is sometimes used to broaden a narrow face. Note that it illuminates the eyes and casts a 45 degree angle nose shadow *away* from the camera.

Mistake! The main light is almost directly over the model causing uncomplimentary deep shadow pockets under the eyes. Use plenty of fill light at the camera if the main light is like this.

Main Light Placement

This is a generalization. Actually, main light positioning can be quite an art, but here are the basic principles:

1. Generally, this light should be higher than the subject's head and approximately at 45 degrees to one side of the camera-subject axis. Position the height of this light so it will create catchlights in the subject's eyes. As seen from the camera position, these catchlights should be either in the 1 o'clock or the 11 o'clock position in the subject's eyes, depending on the direction the subject is facing.

2. Use the main light lower for babies, small children, or old people when you desire to minimize facial wrinkles and textures.

3. Use the main light higher for increased texture emphasis, such as in character portraits.

4. To a limited extent, you can alter apparent facial contours by careful positioning of the main light. For example, a narrow face can be made to appear slightly broader if the main light is moved closer to the camera-subject axis. Also, a thin face appears wider if the nose shadow is shortened; easily done by lowering the main light.

Broad vs. Narrow

Most normal-shaped faces are artistically portrayed with a slight turn of the head and with the main light positioned high and on the far side of the subject. This places the primary highlight area on the far side, with the near cheek and ear in shadow.

This so-called narrow, or short, placement of the main light actually creates an illusion of far more three-dimensional roundness than it would if it were placed on the near side of the face in a broad placement. The reason is that any photographic subject looks rounder with side- and/or backlighting than it does with flat frontal lighting. Lighting from the side creates shadows that aid the observer's mind in depth perception.

To achieve the conventional narrow lighting effect, place the main light just high enough and just far enough to the side so that it casts a triangular highlight on the near cheek.

To idealize your subjects, reduce the size of this triangle for broad faces, widen it slightly for narrow faces, lengthen it for wide faces, and

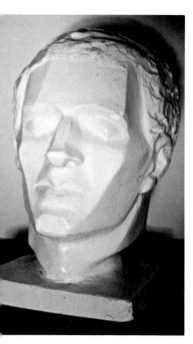

Mistake! The main light is too low. It's below the level of the face, in fact. This positioning should be reserved for unusual fireside or horror effects. Use it sparingly.

shorten it for long faces. This delicate positioning of the main light is very closely related to the positioning of the subject's head since a slight tilt one way or another can alter the effect.

With large studio-type electronic flash units, you can use the built-in tungsten modeling lights to observe these main light positioning subtleties. With portable flash units there is no way to do this. But better to estimate these positionings intelligently than to guess blindly, right?

Fill Light Placement

Like the main light, the fill light should be heavily diffused. If it isn't, it can cast shadows of its own and cause double eye catchlights—both of which shriek of unnaturalness.

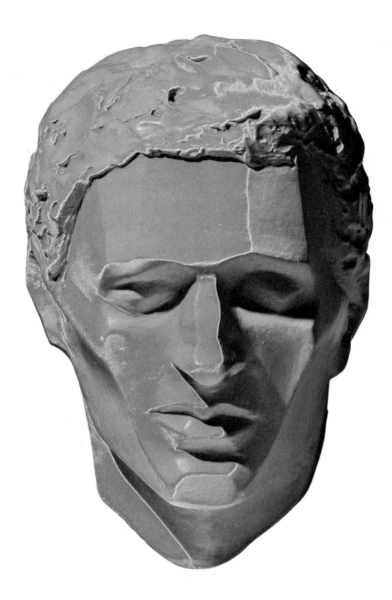

The fill light should be about three or four times weaker in effect than the main light. If not, the lighting ratio will be contrasty—higher than the hazy sun ratio. The several methods of establishing this ratio were given previously under the heading of *Two-Light Flash.*

The fill light should be at about camera level or slightly higher; not lower or else the effect will be unnatural.

Most conventional portraits are illuminated by two light sources: The main light, 45 degrees above and to one side (represented by yellow), and the fill light, near the camera position (represented by blue). Consult pages 42-45 for methods of establishing and controlling the ratio of these two sources. If you arrange the main light high, so that it doesn't illuminate the eyes like this, the lighting ratio should be low—not more than 2 to 1—or else the eyes will be too dark.

Practical Composition

Let's get the customary definition out of the way first. Composition is the arrangement of all the lines, shapes, tones, and colors that form the picture. As someone said, "As soon as you look in your camera viewfinder, you have composition!"

For centuries, attempts have been made to analyze the composition of famous pictures to find out if there were governing artistic principles that could be applied to future pictures. And yes, there have evolved some general compositional conventions. You can hear weighty words about them, such as the desirability of rhythmical repeat patterns, the action thrust of diagonal lines, and good old dynamic symmetry.

Then, too, there are analytical devotees who superimpose various geometrical figures—triangles, ovals, S-curves—onto prints to "prove" why they are good.

Familiarity with these concepts will do you no harm! The problem is that they are probably more applicable to landscape, commercial, and industrial photography than they are to portraiture.

One of the bases of photographic compositional problems is that the sharp-eyed camera sees too much. It sees distracting things in front of, beside, and behind the subject. Don't look only at your subjects in the viewfinder; the camera is going to also record distracting and unrelated objects around them.

Artistic faults like this are easily solved by taking pictures analytically and not emotionally. As the creator, you are obligated to recognize whether or not the arrangement of the subject matter needs improvement. Should you add a subject ingredient? Subtract something? Rearrange objects? Move your camera to the left or right? Higher or lower? Change focal length?

With increased experience, you'll learn that there should be one primary center of interest, that simplicity solves a lot of compositional problems, and that close-ups are a good way of keeping it simple.

You should be relentlessly analytical every time you look at a picture, be it yours or someone else's. And even when you have a camera in your hand, *look* more than you take.

Color Use

Color is an integral part of the total mood of the picture! If you have control over this compositional aspect—as you should—you can use muted colors to convey a quiet, peaceful, or restful mood and bright colors to convey a more lively feeling. For special effects, a blaze orange, neon red, arc yellow, or aurora pink literally shout THEATRICAL, don't they?

Color itself should not be considered an isolated tool, but rather a member of the compositional team to help portray the theme you're trying to establish.

Use color with a critical eye. Too many colors are not tasteful in a portrait, neither are heavily patterned colors. Background color should not overpower subject color. Earth tones are in—subdued browns, blacks, and off-whites blend with contemporary sophistication. To keep this from trending toward drabness, add brightening accent notes of sharp blues or other bright, appropriate hues.

A trend in modern portraiture is the use of subdued "earth" tones—low values (brightness) and low chromas (saturation) of essentially warm hues (color), to use Munsell System terminology. With clothes and backgrounds composed of these colors, the face is bound to predominate. See page 246 for an example.

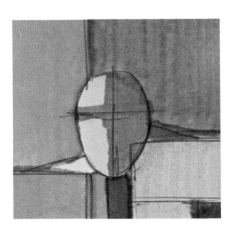

Another suggestion for suitable color schemes would be to group several middle-value, low-chroma colors for clothing and surroundings, but to add a small high-chroma accent, perhaps in the form of a clothing accessory or a prop. See page 241 for an example.

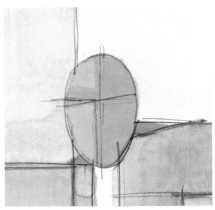

High-key pictures have a comparatively large proportion of the area composed of high values of any color. A low-value, but high-chroma, color can often be used with success as a small accent. See page 250 for an example.

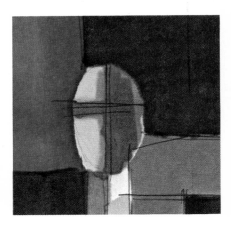

A low-key picture—one with a comparatively large proportion of the area composed of low values (and it doesn't matter how many hues are involved)—can use an off-white or a light gray as a small accent area. These are often "strong statement" or mood pictures. See page 212 for an example.

Picture Shape

Fill the space properly with your subject and what will be the shape of your composition? If it is a single person, about 90 percent of the time it should be a vertical picture. Two people offer more possibilities for a horizontal format. And groups are almost 100 percent horizontally oriented.

But perhaps the creatively exciting possibility here is that the final print doesn't always have to be the convenient (and tired?) conventional 8″ × 10″ rectangle. Why shouldn't it be a daringly long vertical or horizontal strip? Or a graceful oval? Raphael's great "Madonna and Child" was painted on the end of a wooden barrel, and it's perfect as a circular composition. A very successful wedding photographer offers his clients an album of 10-inch square pictures. It helps set him apart from his competition and he feels he can charge more because the prints look impressively larger than the usual 8″ × 10″ prints. The key to this success is that the pictures are shot with a square-format camera and composed to fill the frame.

This should give you the helpful clue: *You should consider the print shape as you look through the viewfinder, and compose your subject accordingly.*

Foregrounds

What is between the subject and your camera? Sometimes nothing if the shot is a close-up. But often there is some compositional element there, and surely there should be, if you can incorporate it as a natural element in the scene. An overhanging tree branch? An archway? There are an infinite variety of foreground frames that will help to give a desirable depth perspective to your middle-distance people pictures.

Of course you can carry suitable props with you when you venture forth on assignment. A selection of small colorful scarves to add to a fashion-type portrait might be an example. One of these could be dangled at arm's length, partially in front of the lens, to create the desired effect.

However, be wary of adding something that will only look false or funny in the scene. Far better to take no foreground props with you, but to find them at the location where they are natural and relate to the scene. In other words, use only "indigenous" objects, and use them sparingly and artistically. For example, you're shooting a lawn reception for a bride and groom—the table centerpiece bouquet is an ideal colorful object to shoot through. The same for the clock or desk set on the executive's desk. Use a handful of grass in front of the lens if you are doing a fashion shot of a model in a grassy field. Frame a fall outdoor picture with some out-of-focus autumn leaves. The idea list is endless, and it's easy to train your eyes to find these framing opportunities the instant you arrive at the shooting location. A word of advice: Take the picture two ways, with and without the foreground objects. It's always nice for your subject to have a choice of treatments.

Artistically, it really doesn't matter if the foreground is sharp as long as your middle-zone subjects are in critical focus.

Backgrounds

Keep them simple!

Now don't pass this statement off as unnecessarily self-evident. Yes, it should be, but all too many pictures of people are taken with confusing or overpowering backgrounds.

Why should a background be simple? Let's think about the desired artistic effect of a good photograph of a person. In a portrait, the face should command the most attention. The face should be *positioned* in the composition so that it commands attention; it should be *posed* so that it commands attention; it should be *lighted* so that it commands attention. And since the eye invariably seeks out the lightest tones on which to concentrate, the face should be artistically and psychologically the lightest-toned object in the picture.

What does this have to do with backgrounds? If left to themselves, backgrounds would often have lighter tones than the subject. As the light-controlling master of the situation, you should prevent or change this. It's better to underlight than overlight the background for an indoor portrait.

Outdoors, a few steps to the right or the left might improve the background. Or, reposition your subject somewhat to the left or right. Consider it! Fill-in flash, or the use of a reflector, will let you record the shadow side of a subject's face with *less* exposure than if you didn't use them. This lessened exposure will drop the background tones *down* the tonal scale to help subordinate them to the subject.

The camera-handling technique of selective focus can also help subdue background importance. You should consider this foremost of your outdoor people pictures.

The busy-street background at the left could never be eliminated by cropping. Note how the background was simplified by changing camera location, moving in closer, and using a lower camera angle.

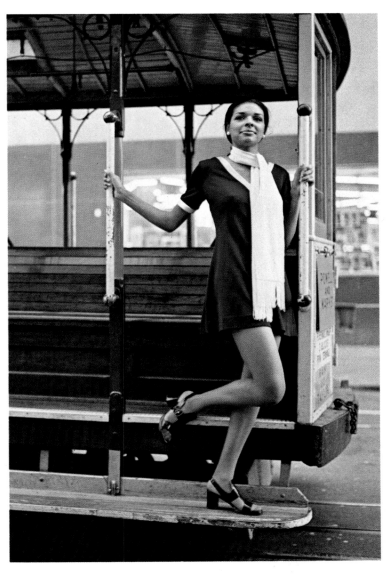

Background
Hot-spot Control

You're not going to believe the following technique works, but have faith, learn the trick, and try it out for yourself.

Here's the situation: It's a sunny day and you are taking a picture of a girl in a shaded grove of trees. The soft skylight on her face is lovely. You've decided on an exposure of 1/125 sec. at $f/2.8$—the wide aperture especially selected to provide a minimum depth of field so that the distracting background will be as out of focus as possible.

Let's consider that background for just a moment. Yes, it's a blurred mass of highlights and shadows, but the sun-illuminated patches of leaves and grass are overly brilliant blobs of circular light—really too bright and artistically distracting for the lower light level of the shadow-illuminated face. Can you control and subdue the background more? Yes, you can.

Place a strip of black tape, about ¼-inch wide, across the middle of a skylight filter and put this attachment on the lens. Magic! The bright, out-of-focus blobs are now much darker and they seem to have been elongated at the same time. Watch this effect carefully in your viewfinder or on your ground glass as you rotate the lens attachment so that the black strip comes to a diagonal position. Whether the elongated blobs should lean to the left or the right, and how much they should lean, is your decision. Try to fit them in with the lines of the foreground composition. Incidentally, you will be able to observe and evaluate this *effect* much more accurately if your view screen is actually ground glass and not composed of microprisms.

There is no black, well-defined strip across the picture because *every* portion of the lens acts as a separate lens in forming the total image. In other words, there won't be a bandit-like mask across the subject's face, because each point of the uncovered lens is also imaging the entire subject's face to the respective point on the film. You have lost some lens speed in the process, the amount depending on the width of the black strip, but this should not amount to more than about one stop.

The technique works because you have divided your circular lens into two D-shaped lenses *that only affect out-of-focus areas.* Each bright-toned, out-of-focus object is divided in half (with a blurry dark line between them), moves to a slightly different position on the film plane, and is rendered with less than half of its original brightness.

Perhaps this is a strange phenomenon to you, but you can understand the optics of it better if you perform the following simple experiment. Image a ceiling light fixture onto a sheet of white paper with a magnifying glass. Move the glass up and down over the paper until the image of the light is as sharp as possible. Now lay a pencil across the lens. There will be no difference in the image sharpness; it will be only barely darker. While holding the pencil in the same place, move the lens vertically so that the image is out of focus. Note that the image has now divided into two D-shaped halves, each of which is less than half as bright as the intact sharp image. Any elongation is only an apparent effect.

Try this in-and-out focus effect several times to see how varying degrees of unsharpness affect the character of the split image.

The fact that you used a skylight filter as a vehicle for the tape strip is not important. It was suggested only so that you don't "gunk-up" your valuable camera lens with the tape. Any optically flat piece of glass would serve as well. It is important, however, to position the tape as close to the lens as possible.

A strip of black masking tape placed on a skylight filter over the lens can provide the type of background hot-spot control seen below. It will not affect the sharpness of the subject image. It only reduces the brightness of the out-of-focus blobs of light in the background.

The single strip of tape can take other forms for slightly different variations of background control. You can use a cross, double tape strips, or a circular piece of tape.

The circular piece of tape is something you'll want to try because it performs the two related functions of reducing the brightness of background hot-spots and decreasing the depth of field.

It is the central area of the lens, where the object rays are deflected least, that gives the greatest depth of field. The black disc on the lens takes out that central core of sharpness from the out-of-focus hot-spot, leaving only a gray circle of light representing the spot.

The rule is: The larger the disc, the grayer the hot-spots and the less the depth of field. Note that the disc will not affect the foreground image sharpness, but it will affect the lens speed. How much? Well, if the disc is one half the diameter of a given aperture, it will block one quarter of the transmitted light, or in other words, half a stop. This loss isn't very much, but certainly you should compensate for it manually if your camera does not do it automatically.

Obviously the subject's head has been positioned too high, too close to the center, too low, and too far to one side. Of these compositional errors, an image too close to the center is by far the most common. It results from taking pictures emotionally and unthinkingly, rather than artistically. Try using the rule-of-thirds grid system shown at the right to eliminate these faults.

Image Placement

As you look at your subject in the camera viewfinder, your compositional goal should be to (a) select the camera-to-subject distance and (b) aim the camera so that no cropping in the print-making stage could improve the picture whatsoever. Difficult to do every time? Nevertheless, you should try to crop as you shoot every time!

There are more ways to err in placing the image within the picture borders than ways of doing it artistically. Don't bump your subject's head on the top of the frame, don't put it exactly in the middle, don't have it too low or too far to one side.

Where then? Let's briefly consider one compositional guide often referred to as the Rule of Thirds. Divide a rectangle into thirds, both horizontally and vertically, like this:

For close-up head-and-shoulder portraits, put the subject's eyes about on the upper line. For middle-distance shots where the image size is considerably smaller, place the subject at any one of the four points where the horizontal and vertical lines intersect. Leave more space in the direction the subject is facing than behind him.

To be sure, this compositional crutch doesn't always work—but just look at many well-composed people pictures—it works more often than not.

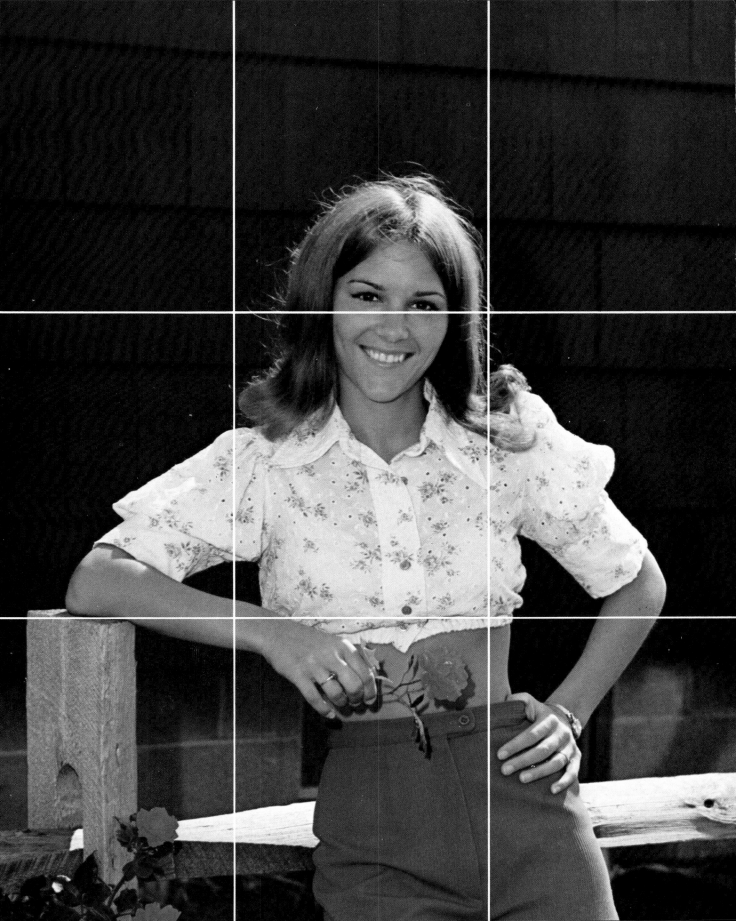

Posing

What a terrible word, "pose." Know what it really means? To place in a fixed or sustained posture. Pose is related to the French word *poseur*, meaning a person who habitually pretends to be what he is not.

Well, a studied stiffness is exactly what you do not want from a subject. You want him to be relaxed, interesting, free, graceful, believable, and natural.

How do you achieve this from your subjects? Sometimes you're lucky and your subject will naturally fall into relaxed, easy-looking positions.

This is, in fact, the forte of a good professional model, who should present so many graceful or appropriate body positions and facial expressions, that you barely have time to capture them on film. This will not happen often with people who seldom have their picture taken. They usually have a tendency toward stiffness if they do not actually freeze up.

With your artistic eye, you'll recognize "posiness" when you see it and you'll have to correct it with suggestions, directions, or examples. In other words, *try to pose them so they don't look posed.*

Same girl, same camera position, same lighting. Now you decide: Which hand positions are the most graceful? Which body position do you prefer? Did you notice the right-angle elbow in the picture at the right? In which version do her legs appear longer? Why? Does she look more slender in the first or the third picture.

The posing aspect of the composition should actually start long before you make exposures. If this is the first time you've met your subject, talk first. Explain to him the kind of picture you'd like to take and the style you want to use. Or ask him how the picture will be used. All this will help relax your subject. While you're doing this, you will have a chance to survey your surroundings and pick out places where you can position your subject with a sympathetic background. Your lightning mind should be racing ahead of the conversation, inventing a natural bit of activity on which to base the picture-taking.

Of course many times you'll have to say, "turn your right shoulder more toward the camera," or "lift your chin a little," or "put all your weight on your right leg and bend your left one." But don't just say it, *make the same body movement yourself.* This will help your subject understand your directive and its degree.

The subject still doesn't quite understand what you wish of him? Demonstrate! Let him come back to your camera and look in the viewfinder while you pretend to be him. Show him the approximate position, the suggested bit of action, and chances are, he surely will get the idea.

Maybe you'll have to refine the composition even at this point, so be alert to the little things someone could object to—the wrinkled coat or the handkerchief that was a little too far out of the pocket. You know how people are; you can create a pictorial masterpiece and the subject may say he doesn't like it because of a wisp of hair that came down on his forehead at the last moment. And you didn't notice it. Keep alert for that kind of thing.

There's more to a person than a face!

First, hands: If it's a close up, try to keep the subject's hands close together, or at least in the same vertical plane. This will help prevent one of them (the one nearer the camera) from appearing larger than the other. The shorter the focal length of the lens being used, the more important this advice becomes.

Hands should be relaxed. Wrists should be bent slightly, usually upward, to help relieve stiffness. Fingers should be curved naturally. No hand position should look as if some of the fingers are missing. But, hands can get too "posey." It would be wrong, wrong, wrong, to adjust each finger so that it looks exquisitely artistic, because now you're going too far. Somewhere between this and a fist is what you want; hands should look natural.

Elbows should not be bent at a stiff 90-degree angle; a curved arm is much more graceful and natural.

Feet should never be planted in parallel pairs. One should be ahead of the other and at a different angle. Or try having your subject cross his knees or ankles for a more relaxed pose.

Camera Angle

You must remember that the lens of the camera represents the eyes or viewpoint of the person seeing the resultant print. If the camera is at eye level with the subject, then so is the eventual observer. In general, two people view each other at eye level, and therefore a subject should be photographed at eye level for the most natural effect. It would create an awkward subject-viewer relationship if the camera were considerably above or below usual viewing angles.

There are exceptions to this generality of course—to create an unusual effect, for example. If the camera is low and looking upward, it can add dominance or impressiveness to the subject. It gives a feeling of a king on a throne, or a father as seen from a child's viewpoint. On the other hand, you wouldn't normally look up at a child, would you, so here a slight higher-than-the-eyes camera viewpoint would be natural.

There are also some minor corrective measures that can be effected by judicious selection of camera viewpoint. Corrective? Well, let's frankly admit that every person you picture wants to be idealized—flattered is a better word. So, keep in mind that a lower-than-eye-level camera viewpoint can help minimize a prominent forehead, a long nose, or baldness. A higher-than-normal camera viewpoint, on the other hand, can help hide a double chin or slightly slenderize a broad face.

These camera-angle generalities apply, of course, whether indoors or out, in the studio or on location, or for informal pictures of friends or family.

Generally speaking, the camera should be about at the subject's eye level. However, *always* consider if a somewhat higher or lower camera angle would result in a better picture. Here, an exception to the rule, a lower-than-normal angle has provided a truly wonderful result. Notice the increased feeling of regality in the portrait at the right.

Most of the time, a prop should be a secondary center of interest—the person's face is most important. You can help achieve this goal with appropriate posing and careful lighting. The face should receive more light than the prop. If you can't, or don't, control the lighting during the shooting session, consider darkening the prop when the print is made.

Props

Every time you take an environmental portrait, ask yourself if a prop would make it better. An appropriate prop of course—that is, the little girl with a doll, the baby with a bottle, a boy with a baseball mitt, granny with reading glasses, the minister with a bible, a golfer with clubs.

Props solve a lot of pose, expression, and compositional problems for the photographer. They give the subject something to look at and they can solve otherwise awkward hand positions. They can also symbolize or identify the subject's interests, hobbies, or vocation. There's the composer and his music, the artist and her easel, the doctor and his stethoscope, the lawyer and her law books, the musician and his instrument, and on and on.

Don't forget—would a prop make the picture better?

Two Persons

Interaction is probably the key to success here. What is the relationship between these two or three people? The answer will often give you the idea for the picture situation, the subject arrangement, and of course, the desired expression. Is it child-to-parent? Supervisor-to-employee? Is it an award situation? Or is it three little sisters playing dress-up?

What about pictorial balance? Should the balance be formal, or symmetrical, with both sides of the scene equal in importance? Or should one person dominate the scene?

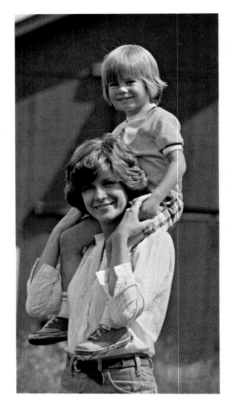

Generally, it is compositionally more interesting to create informal, or asymmetrical balance, with an adult, for example, at one side of a picture to balance two children at the other side.

You can also control dominance by positioning and lighting. The higher the person is in the frame, the more dominant he becomes. The less you see of a person's face, the less dominant he becomes. You can also emphasize dominance by lighting one person more dramatically than the other.

How many times have you seen a picture of two people side-by-side, just staring at the camera? Such pictures literally shout that an unimaginative photographer took them. Surely you can invent something more interesting, can't you? Do these two illustrations give you any ideas?

Of course as with larger groups, try to keep any two heads from being in the same horizontal plane.

Your compositional thinking must now also consider the possibilities of composing in *depth*. With this added dimension, the arrangement possibilities between a single person and two or three persons are like the differences between ordinary tic-tac-toe and the three-dimensional version of the game. Think in terms of depth. Put on a wide-angle lens, and you'll have an entirely new, exciting world to conquer.

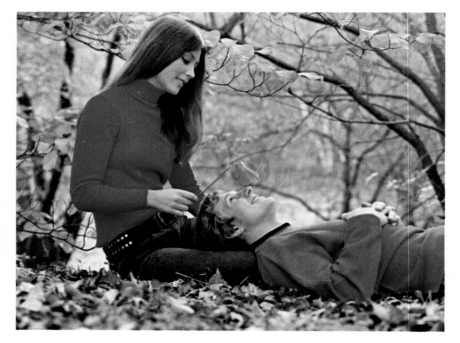

Groups

Groups of people are probably the most awkward, difficult situations a photographer has to cope with. Too often the solution is the easy-out, line-'em-up-like-a-firing-squad-and-shoot picture. The problem is really one of crowd control; it can be solved by the imaginative, extroverted photographer. You must take over. You must be the director on the set.

Now what? One of the best ways to unify a composition is to invent a bit of action. If it's a four-generation family grouping, have everybody look at the baby. For wedding principals, have everybody watch the bride throw the bouquet. If it's a picnic, have everybody watch the smallest boy eating the biggest slice of watermelon. If it's a children's party, games can be a good answer. And how about grandfather reading a bedtime story to three grandchildren in their pajamas?

Call these corny examples if you will, but at least consider some appropriate bit of business that will help arrange the group naturally and direct its attention to the center of interest. If left to themselves, people in a group will sort of line themselves up in a row. Artistically, that is the worst sort of arrangement. The main objection is that all the heads are at the same level, like a row of bowling balls on a rack. You must break up this arrangement with inventive directions so that, ideally, no two heads are in the same horizontal or vertical plane.

Watch out for someone sneaking a look at the camera just at the last moment—there's one in every group!

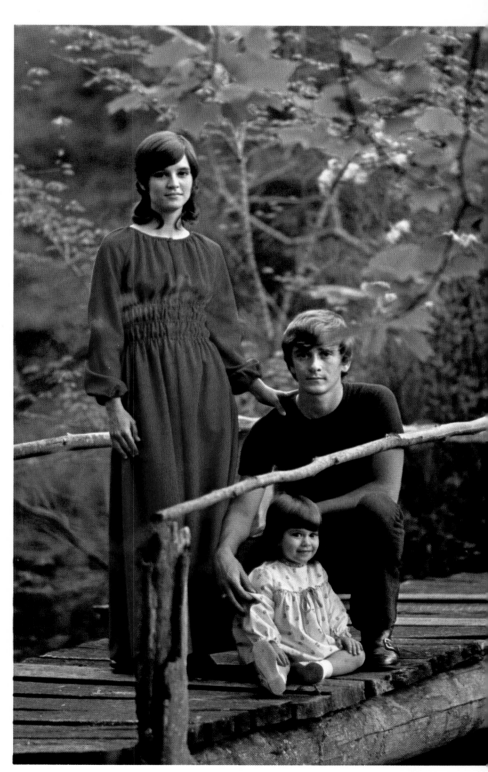

These two pictures were taken from the same camera position—the upper one with a 28mm wide-angle lens and the lower one with a 135mm telephoto lens. In general, larger-than-normal lenses are preferred for picturing people, for improved perspective, and for getting large images at a convenient working distance from the subject.

Lens Selection for Portraiture

Of course all photographers know there are short, normal, and long focal length lenses. They know that the longer the focal length, the larger the image of the subject becomes. And that a long focal length lens is a handy way for bringing the subject closer. Similarly, a wide-angle lens is good to use in a small space because it includes a lot of area. These things are true, and this thinking is fine for tourists and bird photographers, but *not* for serious portrait photographers. If this includes you, you must not really regard different focal length lenses as "image magnifiers"; think of them, instead, as "perspective controllers."

It would be shortsighted to recommend here a particular focal length for a specific application, such as a 28mm lens for a wedding group of 12 people to be shot in a working space of 15 feet. Rather, let's discuss a preference of focal length to fit a working style, because it is this factor, more than anything else, that suggests which lens to use and how to use it.

Long Lenses

Lenses with a longer-than-normal focal length have traditionally been recommended for portraiture. Let's see why this is good advice.

You should avoid, as much as possible, the type of perspective distortion commonly referred to as "foreshortening." You've noticed this effect—the nose of a subject is disproportionately large or a hand that is closer to the camera than the face is much larger than normal. This distortion is independent of lens design or focal length. It would occur even if you used a pinhole aperture instead of a lens! It is merely a result of using a camera position too close to the subject. Close objects are, of course, rendered larger than far objects. In the example mentioned, the nose is *relatively* much closer to the lens than the rest of the face, with the short camera-to-subject distance. Too small a room is often the culprit; outdoors you can easily get as far away from the subject as you wish, and the nose-to-camera distance is more nearly the same as the eyes-to-camera distance. Thus, this important difference is about 1/36th of a 3-foot camera-to-subject distance (where you might use a 28mm lens), but only 1/164th of a 12-foot camera-to-subject distance (where you might use a 105mm lens to achieve the same image size).

Another variation of perspective distortion occurs in wide-angle photography where three-dimensional objects at the edge of the scene appear wider than similar objects in the center of the scene. This is most commonly evident in the "lineup" pictures of the principals at a wedding. If a very short focal length (wide angle) lens is used for this shot, the unfortunate

people at each end of the row are rendered with a head size that's about 50 percent larger than normal! Again, do not blame lens design; this is also due to the geometry of working too close to the subject. A head distortion of about 10 percent can be tolerated before the subjects notice and object. This degree of distortion is obtained at about 23 degrees from the axis of the lens. So you can use this acceptance or tolerance angle as a rule-of-thumb when you photograph such subjects so as not to encounter the problem. If you have enough room to back away from a large group, even a normal focal length lens can practically correct the problem.

In outdoor portraiture, you'll find it helpful to have a selection of different focal length lenses from which to select. And you'll find that you will also tend toward larger lenses *in order to simplify the background.* Long lenses, with their narrower angle of view, see *less* of the scene behind the subject. For example, suppose you are outdoors and your subject is standing 50 feet in front of a lateral row of trees. *At the same subject image size,* a 50mm lens will see six trees behind the subject, whereas a 105mm lens will see only three of them. In other words, *lens selection is a way to control the composition of your backgrounds.* Another way it does this is to control the "compression" of the background objects. The longer the focal length of the lens, the closer together those background objects will appear that are in line with the lens axis. For example, a receding row of trees can be made to appear to be growing much closer together than they actually are.

Similarly, any given background object will appear nearer to the subject. For example, a mountain, a building, or a tree in the background can be made much more prominent in relation to the person in the foreground, if a long focal length lens is used.

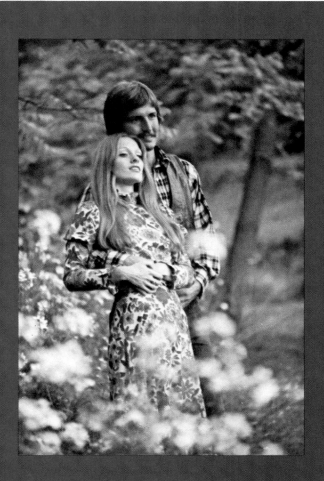

A glance should tell you that these pictures were taken with a telephoto lens. You should also deduce that they were taken at a high shutter speed and at a wide lens aperture because of the out-of-focus foreground and background.

The Normal Lenses

Lens manufacturers often refer to the normal focal length lens (about 50mm for a 35mm camera; about 85mm for a 2¼" x 2¼" camera) as the workhorse. They are compact, easy to use, give a moderately wide angle of view, and have a normal image ratio, about equal to the eye. They usually have excellent sharpness and they are available with high-speed apertures. But from the viewpoint of the discriminating portrait photographer, the normal focal length lens is probably the last choice for picturing people. In fact, for decades the conventional advice has been to select a lens not less than twice the film diagonal for purposes of improved facial perspective.

However, the normal focal length has several uses in portraiture. One of these is speed. For low-light-level photography, where the last available photon of light must reach the film plane, a normal focal length $f/1.2$ lens may be the only feasible tool. Or suppose you desired a shallow depth of field. Again a wide aperture is needed.

Wide-angle lenses are indispensable tools. They make it possible to include a lot of subject area at a close distance and they create interesting subject perspectives. But take care not to have any one portion of the subject's body closer to the camera than the rest, or else an unfortunate enlargement-type distortion of these features can occur.

Wide-angle Lenses

Wide-angle photography of people is a completely different style than long focal length lens photography. Let's briefly contrast these styles.

Long focal length lenses are aptly used in a one-person-at-a-time sort of portraiture. It's usually desirable to use them wide open to achieve artistically shallow depth of field. On the other hand, wide-angle lenses are exactly the right tool to include a lot in a confined space—great for parties and receptions. Wide-angle photography is get-everything-sharp photography. Overall sharpness is easy because of the astounding depth of field encountered even with fairly close-up pictures of people.

Look at the statistics: For a 28mm lens (used on a 35mm camera, of course) focused at 8 feet and the diaphragm operating at $f/4$, the depth of field would extend from 6 feet to 10 feet. Set at $f/11$, as might be the case for an outdoor or electronic flash exposure, the sharpness zone would extend from 3.5 feet to infinity! In other words, *everything* would be in focus.

The way *not* to use a wide-angle lens is for the single person closeup. Instead, think of it as being best for photographing several people, especially where the subjects are different distances from the camera and each is to be rendered sharp. Most important, from a style standpoint, is not to overlook the wonderful opportunity to arrange your subjects specifically for dramatic wide-angle perspective.

You must preplan your composition in *depth*. Remember that the foreground objects will be abnormally large and will dominate. You should choose the camera viewpoint, then set the focus and the diaphragm so that these foreground objects will be sharp.

For example, let's suppose you wish to photograph a person editing motion picture film. Go around to the other side of the clips of film hanging up on the editing board and part them so you see the face of the editor through the opening. Keep the light off the film clips, but illuminate the subject's face— perhaps with an umbrella bounced flash used on an extension cord. You will have a very unusual, dramatic shot that can only be taken with a wide-angle lens.

Or, when photographing a child, place a tricycle in the immediate foreground and stoop down for a low shot through the wheel. Or, at a picnic, put a huge slice of cake on the edge of the table, with your subject on the opposite side. Maneuver around so that the cake fills about a third of the image area in your viewfinder, framing the subject. These, and limitless other examples, take artistic advantage of the degree of perspective distortion available with abnormally short focal length lenses. But it does require wide-angle thinking to execute the effect properly.

Before leaving the subject of perspective, let's briefly admit, to satisfy the optical purists, that with the exception of the 180-degree fisheye lens, there is no such thing as perspective distortion. Lenses do not distort, they only image and record the subject lines accurately as presented to them. Distortion occurs only when you view the resulting photograph differently than when it was taken by the camera.

Suppose you took a close-up portrait taken with a 21mm lens, which shows the subject's hand extended toward the camera. Would this hand be rendered abnormally large?

Don't say yes quite so fast!

The answer is yes, the hand would appear too large when you hold this print at normal viewing distances.

But suppose you could view this print from the center of perspective. This would be with one eye centered, and at a distance equal to the focal length of the lens times the degree of enlargement—for a 3× enlargement in this example, that would be a little less than 3 inches. Meet these print-viewing conditions and the hand would appear perfectly normal!

Lenses don't distort—only viewers do!

Ah, here is the forte of the wide-angle lens—it gets even the objects in the immediate foreground *and* those in the background all in wire-sharp focus. This, of course, is a planned wide-angle shot, using a 28mm lens on a 35mm camera.

Using the Lenses

Increasingly, the trend for natural pictures of people is for a very shallow depth of field. For closeups—and this means from head and shoulders to a three-quarter view—this narrow zone of sharpness includes the front part of the subject's face—the eyes, the nose, and the mouth. This is the most photographically critical part of a person; it's where the attention of the print viewer should be.

The obvious exception to using a narrow depth of field is when photographing babies and small children, or people in motion outdoors where it is often nearly impossible to confine them to one spot. In those cases you simply must use as great a depth of field as feasible to ensure sharp results.

A very shallow depth is also desirable for picturing people in image sizes ranging from full figure down to where they are the "figure in the foreground" of a landscape scene. The reason is, of course, to concentrate the print observer's attention on the subject by keeping the person as sharp as possible with the background and foreground being rendered in soft focus.

You'll find one of the most useful 35mm lenses for outdoor pictures of people is an f/2.8 of 105mm focal length. Try using this lens at its maximum aperture with the highest shutter speed that the lighting conditions dictate to yield the correct exposure. This technique not only

gives the desirable shallow depth of field at the subject's face, but has an added bonus. The high shutter speed helps to assure sharpness because the longer the focal length of the lens, the more difficult it is to hand-hold for consistently sharp pictures.

For a given image size, the longer the focal length, the farther away from the subject you'll be shooting. But it would be unwise to use a lens of excessive focal length. A 200mm lens on a 35mm camera can really "flatten out" a face. With a 105mm lens, you're not right on top of the subjects and its rendition is pleasing. Your subjects will have a little freedom to move around, and so will you. Both for indoor and outdoor portraits, a "generous" camera-to-subject distance means that you'll have many more opportunities to shoot through something to frame your subject. Or you'll have the chance to add a bit of out-of-focus color in an otherwise empty corner of your composition.

Nine out of ten photographers who use a variety of focal lengths would now also add, "Why not use an even longer lens, such as 135mm,

Below you see the ordinary normal-lens picture. But that's just the trouble with it—it's too ordinary, too normal, too all-inclusive. Put on a medium telephoto lens, step a bit to the right and include the red taillight of the car, as an intentional out-of-focus object in the foreground, and a more dramatic version results.

because the depth of field is shallower than it is for a 105mm lens?" This idea is a popular misconception. Let's set the matter straight once and for all, since it is important to your picture-taking for you to understand these basic optical principles.

Read the following statement carefully: *For the same image size on the film, at the same lens aperture, the depth of field is the SAME for any lens, regardless of its focal length.*

There are, as you have seen, other valid reasons for using a relatively long focal length lens for portraiture, but—let's say it again— NOT for

reducing depth of field for the same image size.

To achieve the shallowest possible depth of field, just use the lens at its maximum aperture and pick the shutter speed that will give the correct exposure for that setting. However, with a bit of optical trickery, it is possible to reduce this zone of sharpness even further than the lens manufacturer ever dreamed. This can be accomplished with the black-disc technique described in the preceding chapter under Background Hot-spot Control. The black disc, placed exactly over the central area of the lens, blocks out all the image rays

that are close to being on axis, and which contribute most to depth sharpness. Thus you would be using only the rim rays—the ones which contribute least to the depth of field.

There are two practical aspects for using this depth-compression effect. First, you can decrease the depth of field even beyond that provided by the maximum aperture of the lens. Second, you can obtain any degree of lessened depth of field, say, the equivalent of $f/4$ depth of field, even when you are forced to shoot at $f/11$ because of a high-speed film and intense sunlight combination. In other words, with the appropriate

size disc in place, you can open the lens to $f/5.6$, get an $f/11$ exposure, and have an $f/4$ depth of field! The zone of sharpness is even less than you would expect because of the elimination of the central rays that contribute to the depth sharpness even at wide apertures.

You must experiment with different size discs and their photographic effect on different lenses. The closer the disc is to the lens diaphragm, the more uniform the effect will be. Since it obviously isn't practical, or advisable, to take a lens apart, try to use a lens that has the diaphragm located as close as possible to the front element.

Lens Attachments

Diffusers

Fortunately, the sharpness fad has subsided. There used to be an attitude about midway between the pictorial haze of the turn of the century and the interpretive freedom of today, that only razor-sharp pictures were good pictures. The most reasonable stand should be to do anything to your pictures that will intensify or heighten the mood you wish to portray. If starkness be your goal, use sharp-as-a-tack techniques. On the other hand, if a dreamy, ethereal quality best fits your subject, surely a degree of controlled diffusion will help.

Diffusion in a photograph is by far best introduced during the taking rather than during the print-making stage. A diffuser (purchased as a lens accessory or made from a piece of plastic) used in front of the camera lens spreads the highlights of a scene proportionally more than the shadows. It is especially effective in portraits employing a considerable degree of backlighting. A child looking dreamily out of a window, the backlighted veil of a bride, the highlights of the hair of a kindly grandmother, or an engaged couple walking down a backlighted path in the woods or standing on the bank of a backlighted stream— these are prime examples of good diffusion opportunities.

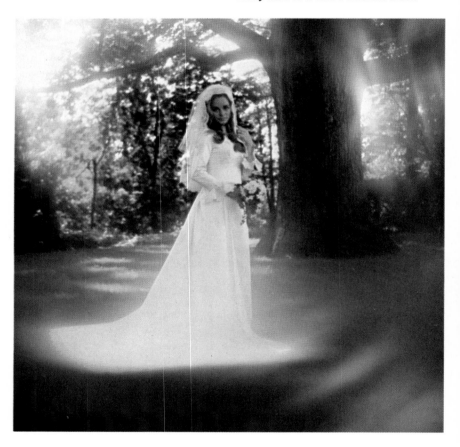

Smeared highlights resulting from spreading petroleum jelly on a skylight filter. Use this effect sparingly—when you really want to create a different effect.

Diffusion discs need no exposure compensation. They also have the advantage of softening facial lines and wrinkles, thus minimizing the need for retouching. Better not to overdo this effect; better too little than too much. Best of all, when you use the technique, take the subject both with and also without diffusion, then you'll have the opportunity to make a selection afterward.

A very interesting diffusion effect can be produced as follows: Carefully smear some petroleum jelly on the peripheral area of a skylight filter, leaving the center clear. The central area, which is for your subject, will be sharper than the surroundings. It's sort of a "vignetted" diffusion that may require a little familiarity on your part to use effectively.

**The straight,
non-diffused version.**

**Diffused version.
Which do you prefer?**

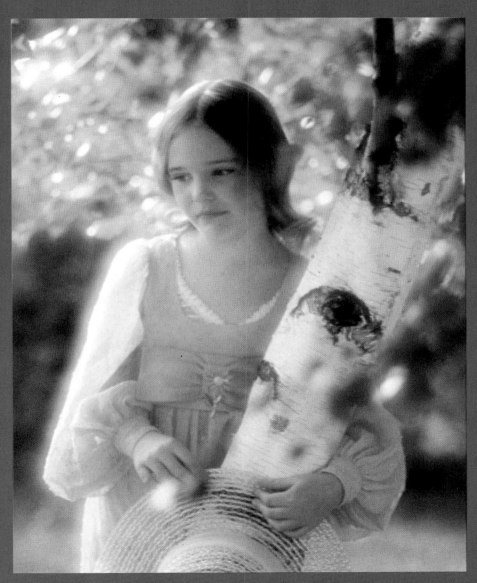

The Vignetter

The most widely used form of vignetter is a sheet of translucent plastic with a serrated oval opening. This is held in position a few inches in front of the lens by a lens shade. Its purpose is to obliterate or obscure the detail surrounding the subject, and by so doing, to focus the print observer's attention on the center of interest. If used correctly, the vignetter will produce a beautiful blend from the sharp central area to the diffused detail at the edges of the picture.

It is easy to vary the effect by smearing transparent colors on the vignetter, by vignetting only the bottom half of the scene, or by varying the translucency of the vignetting material selected.

Carefully observe the vignetted effect in your camera viewfinder to be sure it is what you wish, and modify it if necessary. View the effect at the actual aperture you will use to make the exposure. Be sure to shield the vignetter from direct rays of the sun, which could cause an undesirable flare effect. The vignetter seems to work best with a lens of about twice the normal focal length.

Although vignetting can be accomplished during printing, the effect is somewhat more artistic when made in the camera.

The Matte Box

Surely you have seen motion pictures, or perhaps television commercials, where one person is presented as twins, talking and interacting with himself. One of the common ways of accomplishing this trickery is with a device called a *matte box*. This is simply an extended lens hood which terminates in a slotted frame capable of holding black opaque masks in a fixed position in front of the lens so that only one portion of the film is exposed at a time.

In the example, one half of the film is blocked while the other half is used to record the actor. The actor then changes costume and moves to the opposite side of the set. The film is rewound to the starting point, the mask is reversed, and the interphasing action is shot on the remaining unexposed half of the film. If the mask is positioned properly, the blend between the two halves is practically undetectable.

This same technique has been recently improved by creative still photographers, particularly those specializing in wedding photography. Appropriately, these pictures are called "fantasies." Common examples would include an extreme closeup of the hands of the bride and groom forming a framing archway for a long shot of the bride and groom standing in front of the altar. Or, a diminutive bride and groom apparently *inside* a wine goblet.

Such trick effects can be produced in the darkroom by double printing or by combining two suitable negatives as a printing sandwich. However, the easiest way to create these results is by careful preplanning and through skillful use of a matte box.

Let's further examine the couple-in-the-wine-glass effect. This involves using a registered pair of plastic masks—an opaque center oval with a clear surround, and the exact opposite of this, a clear center oval with an opaque surround.

Simply photograph the couple through the transparent oval, change masks, and then double-expose the same piece of film, photographing the wine glass through the second mask.

If you are using a 2¼″ × 2¼″ camera with interchangeable backs, these two exposures can be made hours or days apart at your convenience. Just insert the dark slide and note which frames are concerned, and put aside this negative for the subsequent exposure. Various shaped masks are commercially available. You can also imaginatively make your own with Kodalith film.

There is a fairly critical lens aperture that will give you a pleasing "blurred blend" of the two images. What exact aperture this is depends somewhat on the focal length of the lens and the distance the matte box mask is in front of the lens. Try an aperture of *f*/5.6 or *f*/8 for a start. Smaller apertures will result in a line of demarcation that is too sharp; larger apertures will cause this line to be excessively broad and blurry.

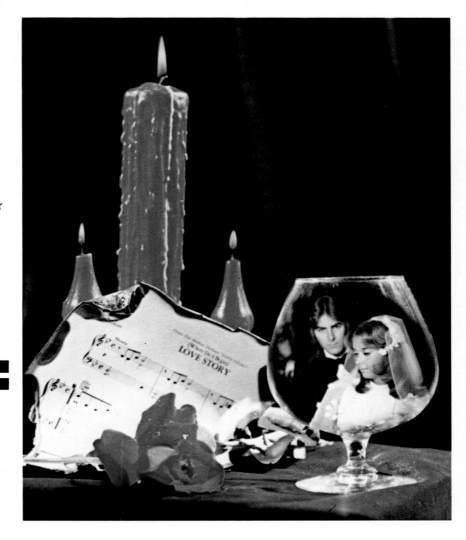

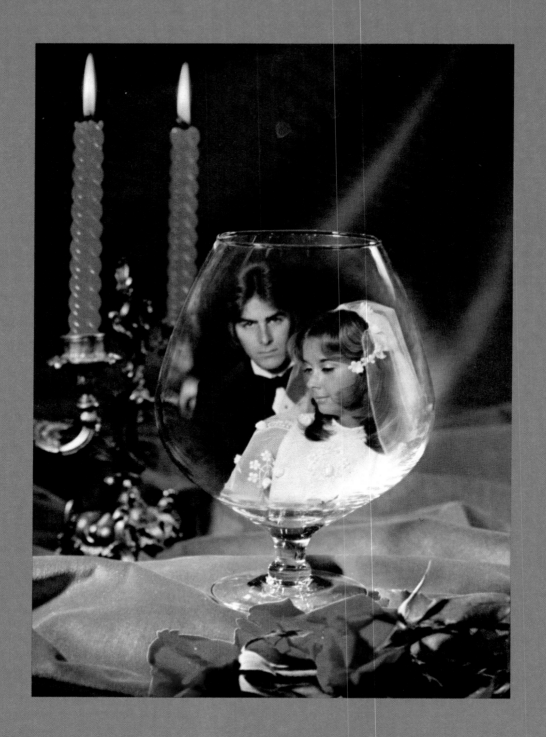

◀ Or, do you prefer this version of the same original-image ingredients? Matte-box-like effects can also be produced in the darkroom by skillful double printing.

The Skylight Filter

When you take pictures of people outdoors on an overcast day, or when the subjects are in open shade, you should use an ultraviolet absorbing filter, such as the Kodak Skylight Filter, 1A. In fact, it would generally do more good than harm if you just put it on your camera lens and left it there all the time. It has no filter factor and it will help protect your lens from fingerprints and even physical damage.

Ultraviolet radiation is normally present in all sunlight, but it comprises proportionally more of the radiation of skylight and overcast-day illumination than for sunlighting. Of course your eye cannot see the ultraviolet radiations, but any color film can. It is recorded in the blue-sensitive layer, which is also sensitive to ultraviolet light.

This "insidious" illuminant makes its presence known in objectionable bluish hair highlights and on the tops of shoulders. The lighter and the glossier the subject tones, the more this bluish top lighting defect becomes apparent. This two-tone hair effect is not correctable in printing, so best eliminate it in the taking with an ultraviolet absorbing filter.

For portraits taken in the shade on a blue-sky sunny day, the skylight filter, which is slightly pinkish, will have a beneficial warming effect on the general color balance. This is very helpful when exposing transparency films where the film in the camera is the film in the projector, and it's too late to alter the color balance. Even negative

films will benefit from this warming, however, since they will print much closer to a normal-balance negative without requiring heavy cyan filtration in the enlarger.

Neutral Density Filters

The most practical application of neutral density filters in taking pictures of people is that you can increase the size of the lens aperture to achieve less depth of field. Let's say, for example, that your exposure for a subject on a sunlit beach with Kodak High Speed Ektachrome film was 1/500 sec. at f/16. To isolate the subject from the background, you really want to use an aperture of about f/2. This is 6 stops less and would require a 2.0 neutral density filter.

These filters are available in a variety of densities and they do not affect the rendering of colors.

Another lens attachment you'll want to keep handy in your gadget bag for outdoor people pictures is a polarizing filter. It can dramatically darken the blue sky on a clear day, placing more emphasis on the foreground people. Its exposure factor is about 1½ f/stops.

ND	% Transmission	Filter Factor	Stop Increase
0.1	80	1¼	⅓
0.2	63	1½	⅔
0.3	50	2	1
0.4	40	2½	1⅓
0.5	32	3	1⅔
0.6	25	4	2
0.7	20	5	2⅓
0.8	16	6	2⅔
0.9	12.5	8	3
1.0	10	10	3⅓
2.0	1	100	6⅔
3.0	0.1	1000	10

NOTE: If you use two filters together to achieve an effect between those given above, multiply the factors together to get the combined factor.

Film and Exposure

Film Selection

Obviously you have your own personal preference for portrait films. Perhaps the job calls for a fine-grain transparency; you'd select a film such as Kodachrome 25. Or, because of the low level of illumination for an available light series of pictures, you must choose a high-speed film with the exposure range necessary for low-light conditions.

However, if the primary objective is prints—and for people pictures this would include about 99 percent of the situations—then you should select a color negative film. Keep in mind that excellent transparencies can be made from the negative, if needed.

You could choose Kodak Vericolor II Professional Film 5025, Type S, for portraiture, indoors or out, with daylight-balance types of illuminants. Think of the "S" in the designation as meaning "short" because the film is intended for exposures of 1/10 sec. or less. For longer exposures, such as those used for studio-type commercial photography, Kodak Vericolor II Professional Film 6013, Type L (for "long") is recommended.

These color negative films possess considerably finer grain and sharpness characteristics than their predecessors. A fully acceptable 8" × 10" color print can be made from a 35mm negative. Gray tones as well as colors are rendered with remarkable accuracy, and the flesh tones are very pleasing.

It's important to note that the film contrast of the Type S is slightly less than previously available color negative films. The film has increased exposure latitude in addition to softer highlight-to-shadow renditions—especially helpful in pictures of people taken outdoors in strong sunlight. Type L was not designed for portraiture, since it has higher contrast than Type S to meet the needs of commercial photographers for product photography where higher contrast is needed.

It may help you to think correctly about flash guide numbers if you consider this: Just as camera exposure varies with the square of the f/stop used, so the light energy of a flash lamp varies with the square of the flash guide number. For example, an electronic flash unit having a guide number of 70 has approximately twice the light output of a unit having a flash guide number of 50, since the square of 70 is 4900 while the square of 50 is about half that value (2500).

There are reliable meters for measuring flash exposures. If you

ILLUMINATION AND EXPOSURE INFORMATION

Kodak Vericolor II Professional Film, Type S, is designed for exposure with electronic flash, daylight, or blue flash illumination at exposure times of 1/10 sec. and less. Other light sources (see table below) can be used with the designated filter if the exposure time is no longer than 1/10 sec.

Light Source	ASA Speed*	Filter Required
Daylight	100	None
Photolamp (3400 K)	32	No. 80B
Tungsten (3200 K)	25	No. 80A

*Recommended for meters marked for ASA Speeds or Exposure Indexes. Also note that the ASA Speed contains a safety factor of about 1.25, which is about ⅓ stop.

ELECTRONIC FLASH GUIDE NUMBERS

Output of Unit (BCPS or ECPS)	500	700	1000	1400	2000	2800	4000	5600	8000
Guide Number for Test	50	60	70	85	100	120	140	170	200

Flashbulbs:

No filter is necessary for exposures with blue flashbulbs. Guide numbers are calculated on the basis of the film speed for daylight, ASA 100. With most clear flashbulbs, put a No. 80C filter over the camera lens. With zirconium-filled clear flashbulbs, such as an M-3, use a No. 80D filter.

Daylight Exposure Table:

Lens opening with shutter at 1/125 sec. (For the hours from 2 hours after sunrise to 2 hours before sunset.)

Bright or Hazy Sun on Light Sand or Snow	Bright or Hazy Sun (Distinct Shadows)	Cloudy Bright (No Shadows)	Open Shade* or Heavy Overcast
f/22	f/16†	f/8	f/5.6

*Subject shaded from the sun but lighted by a large area of sky.
†For backlighted close-up subjects use f/8.

don't have one, you should make a practical test before trying to photograph people seriously. Calculate your exposure first from the published guide number for the light-and-film combination. Then make a series of exposures at ½ stop intervals larger and smaller than this. As a working rule for color negative film, pick an exposure level ½ stop more than the exposure in which inadequate shadow details are beginning to evidence themselves.

Exposure Determination

Of course wonderful color renditions and pleasing subject reproduction, and even to some extent sharpness and fine grain, are predicated on your being able to expose the film properly. Fortunately, there is considerable exposure latitude with color negative films, much more than with a transparency material where there is actually little if any exposure latitude (but this depends somewhat on the brightness range and nature of the subject).

You probably have a reflected-light type of exposure meter, either as a separate piece of equipment or as an integral part of your camera. But are you certain you are using it properly to determine your portrait exposures? The difficulty is that exposure meters are unthinking instruments; they tend to average out subject reflections. They will underexpose a high-key subject and overexpose a low-key subject every time if you take the reading back from the subject at the camera position. (An incident-type exposure meter is not generally used outdoors because it does not take subject reflectance into account.)

Many of the usual exposure-determination problems can be

solved through the use of a Kodak Neutral Test Card—a simple accessory that should be in every competent photographer's gadget bag. It's worth taking just a moment to describe the functions of this card since it can be your path to consistently accurate exposure. Briefly, it is designed to provide (a) a reference of known reflectance for making exposure meter readings in scenes, or (b) for inclusion in pictures as an aid in controlling their reproduction.

For use with artificial light indoors, hold the card straight up and down with the gray side facing halfway between the camera and the main light. Hold your exposure meter not more than six inches from the card. Don't allow any shadow to affect the reading. The meter reading will be the same as a reflected-light reading of an average indoor scene, taken from the camera position. Why not

read the scene itself directly? Because it may *not* be an average indoor scene from a tonal standpoint. To *place* it properly on the accurate reproduction portion of the film's sensitivity curve, you want to give it an *average* exposure.

Incidentally, for fairly dim available light work, turn the card over and take the reading from the white side, which will better deflect the meter needle. Then because the white side is five times as reflective as the gray side, divide the reading by five to calculate the correct exposure.

Outdoors—and remember, the portrait lighting recommendation is for shade, for an overcast day, or for backlight—hold the Neutral Test Card straight up and down with the gray side facing directly toward the camera. Adjust your calculated exposure to the following table:

Lighting	Exposure Adjustment
Backlighting: Close-up scenes	Reduce exposure ½ stop
Backlighting: Subject at medium distance with sunlit background	Reduce exposure 1½ stops
Shade	None
Overcast Day	None

A Kodak Neutral Test Card can be used as a reliable exposure determination device. It has an 18 percent reflectance and is the "middle gray" tone against which many exposure meters are calibrated to expose an average scene correctly. The card can also serve as a means of color accuracy control. Some photographers include a gray card on one frame of each roll of color film when color control is important.

Obviously, the Neutral Test Card reading takes no account of subject material that differs in reflectance from the average. Therefore, you must *decrease* the calculated exposure by ½ – 1 stop if the subjects is unusually *light,* and you must *increase* the exposure by ½ – 1 stop if the subject is unusually *dark.*

But now let's zero right in on the matter of correct exposure for a face. Should your meter read just the face and should you expose the film accordingly? NO! The reflectance of the average Caucasian face is about 35 percent, whereas the reflectance of the <u>Kodak</u> Neutral Test Card is 18 percent. Thus there is a discrepancy factor of about two between them. *You should expose the film one more stop than a facial meter reading would indicate.* In other words, you would underexpose the film by about one stop if you based the exposure on a close-up reading of the subject's face.

Negative vs. Positive Film Techniques

If you do not have an 18 percent reflectance gray card, and you are using color transparency materials, average the highlight and shadow side of the face. For color negative films, base the exposure on the shadow side of the face.

Is there value to the old adage, "For negative films, expose for the shadows; for transparency films, expose for the highlights"? Most certainly there is. Further, this exposure advice is related to the lighting approaches that best apply to these two types of materials.

For transparency films it is preferable to first establish the main, or modeling, light; then add sufficient fill light to the shadows to bring the lighting ratio up to the desired level, say, 3-to-1. Exposure would be calculated on the basis of the main light illumination. The reason for this is that the camera exposure alone establishes the density level of the transparency. The observer is very critical of highlight density—these light areas of the face should not be rendered too light or too dark, but with an expected amount of detail and texture.

For negative films, it is preferable to first establish the fill light placement and intensity level. Base the exposure on this illumination. Then add the side modeling lights to give form and texture to the face as necessary. The density of the highlights is completely readjustable when the print exposure is made, so that end of the tonal scale is not the worrisome part. In a negative film, your chief concerns should be (a) that the important shadow areas receive adequate exposure, and (b) that the lighting ratio does not exceed one that will fit the subject pleasingly. In other words, for negative films, the degree of tonal difference between the highlights and shadows is more a matter of artistic taste than a necessity of photographic recording.

Processing

You can, if you wish, process color slide and color negative films yourself. But aside from purely hobby or educational considerations, it is best by far, from a quality standpoint, to have your films developed by a professional laboratory. They have the volume, the sensitometric equipment, and

the expertise to do a consistently good job. Go the commercial lab route; send your exposed films in for normal processing.

You probably know that some films —negative or positive, color or black-and-white—can be forced-processed to higher-than-rated film speeds. However, these words should really read, "higher than recommended." Film manufacturers, conscious of quality, have established interrelated speed and processing recommendations to yield optimum results. "More speed," or more film density, results from prolonged development. But let's look further. Prolonged development means larger, coarser grain.

Do you really want grainier pictures, particularly in facial close-ups? The problem becomes complex when color emulsions are involved. Accurate, pleasing color reproduction is possible only when the three primary sensitivity curves are on top of each other, and this has the best chance of occurring when the manufacturer's processing recommendations are followed.

What happens when you force-develop color films? Because each of the three emulsion layers in a color film has different response and development characteristics, forced development, more often than not, increases the "spread" between these layers—resulting in what the technicians call "contrast mismatch." In other words, color distortions—departures from normal—result. Whether you can accept this depends, of course, on the amount, the nature of the subject, the job requirements, and the degree of viewer tolerance. But you really must ask yourself if you want less-than-optimum color renditions for a little extra film

speed. The choice is yours. Just remember, portraiture is a "sensitive" picture category. The colors must be more accurate than for sunsets or stage photography.

Printing is another matter. Here is a place in picture production where you have a chance to be artistically creative with color, cropping, local density control, and a host of other print-making techniques. For a complete illustrated discussion of these subjects, consult *Bigger and Better Enlarging* (Kodak Publication AG-19), available from photographic dealers or from American Photographic Book Publishing Co., Inc., Garden City, New York 11530.

Density Evaluation

With transparency materials, you know instantly on seeing the processed results, if your exposure was correct or not. The slides are too dark, just right, or too light, and there's little question about what is acceptable.

But how can you tell if you have properly exposed a color negative? Does the overall light-reddish-tan cast affect your judgment? It shouldn't. Look first at the shadow areas—the important details should be clearly differentiated. If they are not, the negative is underexposed. Now look at the highlights—they also should contain detail. If they do not, the negative is overexposed.

If you find the color cast of the negative does affect your judgment, place the negative over a transparency illuminator and view the image through a green filter, such as a Kodak Wratten Filter No. 61. The image will now appear similar to a black-and-white negative, and you can judge whether adequate shadow detail has been obtained.

If you include a gray scale at the edge of a scene, or even better, make a close-up picture of just the gray scale with the same lighting and exposure as the remainder of the roll, you can further evaluate your color negative results. Incidentally, photographic gray scales and an 18 percent gray card suitable for this purpose are included in the Kodak Professional Photoguide (Kodak Publication No. R-28), and the Kodak Color Dataguide (Kodak Publication No. R-19). A well-exposed color negative will differentiate between all successive gray patches. If the negative is *underexposed,* the darker patches (the lightest ones in the negative) will be indistinguishable from each other, indicating that the negative lacks shadow detail. If the negative is *overexposed,* the lighter patches of the gray scale (the darkest ones in the negative) will be the same dark tone, indicating that the negative lacks highlight detail.

Note that from "normal," an underexposure of about 1½ stops will still produce an acceptable print with color negative film. The shadows will have a "smoky" appearance, indicating that the contrast of the print is slightly low, but by-and-large, all but the most critical print viewers would find the quality satisfactory. On the plus density side, an overexposure of about 2 stops more than normal will still yield a good print. At this point and beyond, the highlight tones begin to come together. They lose detail—detail which never can be regained even with corrective printing techniques.

The important thing to note here is that there is more latitude for error on the overexposure side of normal; so when in doubt, it is better to err on the "generous" side.

You can make a precise check on the exposure of a color negative with a Kodak Color Densitometer, Model 1, or a suitable electronic densitometer equipped with a red filter, such as a Kodak Wratten Filter No. 92 or the red filter in a Kodak Densitometer Filter Set MM (certified).

RED FILTER INFORMATION

Depending somewhat on the nature of the subject and lighting, a normally exposed Vericolor II negative read through the red filter should have the approximate densities shown below. These values apply for exposures with recommended light sources and assume correct processing of the negatives.

Reference Area	Red Filter Density
The gray side of the Kodak Neutral Test Card receiving the same illumination as the subject	0.70 to 0.90
The lightest step (the darkest in the negative) of a Kodak Paper Gray Scale receiving the same illumination as the subject	1.15 to 1.35
The highest diffuse density in a normally lighted forehead—	
light complextion	1.00 to 1.30
dark complexion	0.70 to 1.10
(Use as a guide only. The density range from the neutral test card is more accurate.)	

103

Shooting Techniques

The Invisible Camera

The camera is *not* the important element in taking natural pictures of people. The most important element is *you*. And wouldn't it be wonderful, wouldn't you be able to get completely natural pictures if the camera were invisible! Well, that should be your goal. Think of the camera merely as an extension of your fingers; never refer to it when you are taking portraits. This is the way to remove some of the stiff self-consciousness and the I'm-having-my-picture-taken attitude from the subject.

You can do much to make the camera less intimidating. A small roll-film camera is obviously less obtrusive than a large view camera with accordian bellows and film slides that have to be pulled out. A long focal length lens will keep the camera farther away from the subject and make it a smaller object. If the lighting conditions permit you to work without the encumbrance of a tripod fine; this, too, will help to take the onus off the equipment.

Lastly, you can do much to make the subject forget the camera altogether. You must be so completely familiar with all of its adjustments that you shouldn't have to look at it except briefly at the "moment of truth." You must get beyond the mere mechanics of the camera. Don't talk out loud to yourself, as some photographers do, about the camera settings, like, "Let's see, 1/125 sec. should stop that bobbing head." Don't even ask your subjects to look at the lens. No! Have them look at you, if that's where you want to position their *eyes*.

In other words, you must make yourself more attractive to the subject than the camera. You must talk, smile, and be charming and witty.

And you must be ready to *use* your "invisible" camera. Don't be like the photographer who makes a smile-provoking remark and then fiddles with camera adjustments while the subject's great expression comes and goes.

Expression

There is an Oriental philosophy that says, people live most of their business and social life wearing a mask. This is the face they put on to confront the world. It really does not represent the true self or the thoughts and feelings that are reflected only in the true face behind the mask.

When you take a person's picture, can you unmask him? If you can, you'll probably be able to capture a truly great expression.

Like poses, expressions should be interesting, pleasant, relaxed, and natural; not grim, strained, tight, forced, or artificial. Good rapport is essential to evoke a good expression, and conversation is again the key. If you can chat about something of interest to the subject to get his mind off the picture-taking situation, you're halfway there. If, in the print, the subject looks stunned, you've said or done something terribly wrong.

A third person can often be of great help in creating a good expression for the subject, if—and this is a big if—it's the right kind of a third person. A trained assistant who acts as a combination enthusiastic conversationalist and decoy can be invaluable in this respect.

Whoever says the words, you or a partner, should not get caught in the "cheese syndrome." Don't ask your subject to say "cheese," or to "smile" or "frown." Asking for an expression seldom works well; tell an amusing story or stand on your head, if you have to. Finally, anticipate the subject's reaction, if you can, in order to record the peak expression.

Of course the featured illustration (one of the best in the photographer's opinion) wasn't the first one taken. It happened about midway through the rapid shooting session when the photographer moved in for some medium closeups after the long shots had been made.

Shooting Tempo

One way you can recognize a competent photographer is by the rapidity with which he makes his pictures. In this sense, rapidity has nothing to do with shutter speed. Instead, it is the time interval between exposures. And within practical limits, the shorter this interval the better. In other words, there is a proper tempo for taking pictures just as there is a proper tempo for performing a particular piece of music. Don't play "Stars and Stripes Forever" at a funeral-hymn tempo of 20 beats a minute when it should be a snappy 120. Similarly, a photographer should work rapidly, but without appearing to be in a frenzy.

During an average portrait session, how often should a picture be made? Well, as a point of departure, try taking a 36-exposure roll in about 10 minutes. This figures out to be one exposure about every 20 seconds. Too fast you say? Probably not. Let's explain why.

First of all, the cost of 35mm film is negligible when compared with the value of your time and the value of the end artistic result.

Second, it often takes a few clicks of the shutter before your subject really gets used to the sound and starts to relax. Your best pictures are apt to come somewhere in mid-roll, more often than not. Gone should be the days when the photographer rationed only six shots for each

subject—and the subject, knowing this, strained to be at his best for each expensive exposure. Let everybody relax. Let the film flow smoothly through the camera.

Third, a good photographer should be completely and thoroughly familiar with his equipment. The mere mechanics of camera operation should be second nature. The exposure has been pre-established so there shouldn't be any time lost in further thinking in that direction. With the good exposure latitude of the modern color negative films, such as Kodak Vericolor II, you shouldn't have to bracket exposures. The lighting for natural-light portraiture has also been established, so there's no need to adjust studio lights.

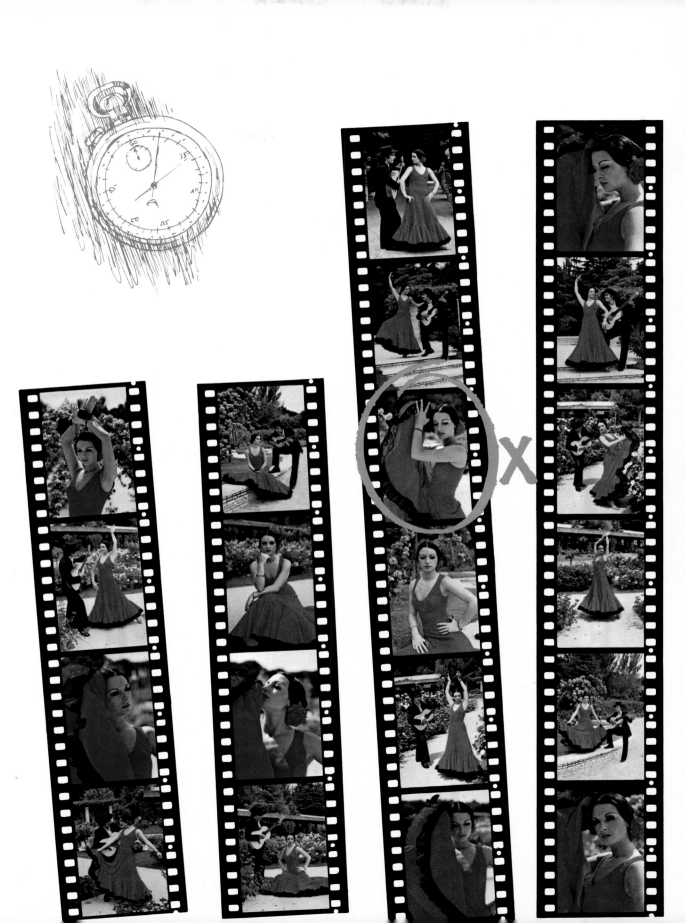

All of this leaves you free to concentrate on capturing proper expressions and natural poses. You can now proceed in rapid succession from one instant to the next.

And this is to your advantage, isn't it? Like a gambler who can hardly wait to throw the dice again in a winning streak, you should try to capture a variety of good expressions while the superb delicate lighting lasts; before the baby gets tired and starts to cry; before the older person becomes weary and starts to sag; before the busy executive's telephone rings and the subject-photographer rapport begins to wane; before the magic of the moment is gone.

Let's dwell on that for a moment.
For most people, it's an exciting,
glamorous thing to be
photographed. It's even more so if
they feel they're in the hands of a
great photographer who will make a
superb, artistic picture of them if
everybody puts forth an extra effort
for just a while. Wouldn't you feel
excited if Michelangelo were going
to paint your portrait? Why
shouldn't you try to make each
person you photograph feel like that?

Then too, you, as the
photographer, should be excited
about creating a fine picture. You
should go into a shooting session
"psyched-up" and you should keep
this enthusiasm until it's over.

And afterward? Do you feel
anything special after exposing the
film? You should. It's an exhilarating
experience to create a great picture,
and you should know if you have
done this at the instant it's done.

Motor Drives

This brings us to the topic of motor drive film transport mechanisms, doesn't it? In a word, terrific! Use a motor drive all the time, for either single shots or bursts. You don't have to take your eye from the viewfinder; you're ready for the next great expression. Besides the advantage of speed, the weight of the motor adds stability to hand-held exposures, which is especially helpful with long-lens photography. A disadvantage is that advancing the film rapidly in a very dry environment may cause static marks on the film.

Sure, a motor drive burns up a lot of film, but consider this: An interesting "frozen" moment, in the midst of a subject's movements or expressions, is sometimes impossible to anticipate. For example, take a young couple in their bathing suits, dashing down the beach through the spray toward you. What would be the best moment to squeeze the shutter? You really can't tell. Here is an ideal place to use a motor drive. "Machine-gun-them-down" as they come. Now you'll have an excellent selection of shots from which to choose.

Let's consider this particular example a bit further. Your motor-drive sequence will be far better if you can rehearse the action beforehand, than if you try to take it on the first attempt. Pick the best camera position, be sure your subjects understand the route they are to take, the desired speed, and whatever bit of action you have invented for them. Then give it a dry run. Any further directions for the subjects? No? Positions everyone! Action! Camera!

Similarly, you can use a motor drive to select the best composition from a burst of a telephoto sequence of a football play, a sequence of a child skipping rope, on a swing, or bouncing on a trampoline, or a sequence of other sports or action activities.

Finally, there is a monetary reason for a rapid exposure tempo. If a client is watching you take the pictures—remember all of your subjects are probably clients too—they can't help but be impressed with your industriousness. If you were an art director or in some other way were a buyer of pictures, what would you think of a photographer who worked slowly? If you were paying top-rate model fees, would you prefer a few proofs or many from which to choose? Would you hire the slow-working photographer again?

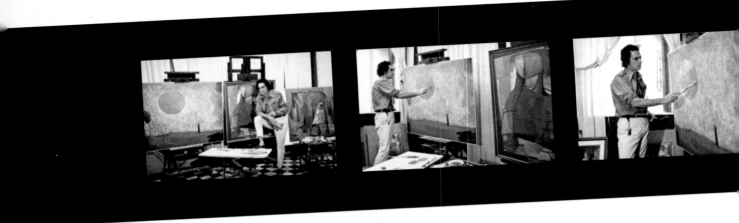

Sequences

For a moment, let's examine our portrait heritage. For centuries, a portrait was something in oils, something expensive, something time-consuming, something prestigious, the privilege of the aristocracy, and a unique experience of one's lifetime. There it sits, a large, stiff, ruffles-and-lace heirloom, like your father's and like your great, great grandfather's. Did you know that Rembrandt once spent a week to paint the handle of a broom?

And now reflect upon how much, how deplorably and unnecessarily much this heritage has influenced recent photographic portraiture. Too often a portrait session results in one best pose, one best print. And there it sits on the piano, staring stiffly at the passersby.

But why should this be true any longer? Much more accurate likenesses and much more accurate colors can be captured in an instant with today's fantastic photographic tools. So why, why, why should there be only *one* good picture resulting from a modern portrait session?

Are you content to see just *one* picture of a wedding? Or *one* of a baby's first birthday party? Or *one* of people at a family reunion? Or *one* of anyone doing anything for that matter?

Let's go back to that reunion and focus just on grandmother. There she is, unpacking the picnic basket, setting the table, supervising the cooking, feeding a granddaughter, eating watermelon, snoozing in a lawn chair while the kids are playing softball. The reunion will be a warm, living, natural sequence that will be enjoyable to keep, and through which to remember the many facets of the event if it's preserved by the many pictures.

You can just as easily invent a similar case for sequential photographic coverage of *any* portrait situation. If you are taking these people pictures for yourself, how much better will be the pages of your memory albums. If you are taking these pictures professionally, it's obvious, isn't it, that the more activities and pose variations you take, the more salable your shooting session results become.

Remember, every time you photograph someone, it is a unique experience.

The 25th wedding anniversary will *never* happen again; nor will *that* graduation, *that* Bar Mitzvah, or *that* award ceremony.

Don't confine posterity to only one peek at these unique situations.

Let's suppose you are taking pictures for a slide show; sequences are going to be the key to your success. You'll produce the best slide show if you keep your audience in mind as you shoot. A series of progressive, time-sequence shots of people doing or making something is far more interesting to view than end-result-only pictures.

Further, you should shoot for the projection system you are going to use for the smoothest screen effects. For example, are you planning a two-projector fade-and-dissolve show? A motor drive is an unsurpassed tool for shooting sequences for this projection system.

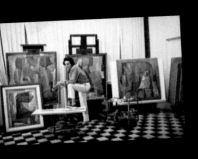

Available Light Considerations

There are occasions when every photographer is called upon to take pictures of people indoors and under existing illumination. Usually, with today's high-speed lenses and fast emulsions, the low light level itself presents no difficult photographic problem. The suggested minimum shutter speed for consistent sharpness with hand-held exposures is 1/30 sec. A tripod plus cable release should let you take consistently low-light-level portraits down to a shutter speed of about ¼ sec. Under these conditions, incidentally, you'll probably find it expedient to make a few more exposures than usual as a safeguard against unexpected subject movement.

Exposure Determination

For general interiors, just expose as your camera meter tells you. Most meters are "center-weighted" and this is all to the good since the reflectance of the person's face—usually located in the center area of the scene—is what should be the prime exposure-determination factor. Don't forget: Base your exposure on the facial highlights if you are using a reversal (transparency) film, and base your exposure on the facial shadows if you are using a negative film.

If there is uneven lighting, however, such as a direct light source that is included in the scene, take care it doesn't deceive your meter, causing underexposure. Let's give three common examples so that you can be aware of these "exposure traps."

1. The subject is sitting next to an illuminated table lamp, which is part of the surroundings.

2. The subject has a large window area behind him.

3. The subject is medium distance from the camera, and the scene includes illuminated fluorescent ceiling fixtures in part of the picture area.

These situations can cause underexposure ranging from ½–1½ stops, depending on the degree of the light-source "interference." The remedy is simple, once you are alerted to the danger. With needle-matching exposure meters—or any hand-held meter for that matter—walk up to the subject, take a meter reading close to his face, and then use that camera setting, even though the more distant camera position calls for less exposure. If your camera employs an automatic meter system, you can, with some cameras, override it. With others, you can assign a *lower* ASA to your film in order to cause the camera to properly expose the subject's face.

Exposure Bracketing

If you are at all unsure about the accuracy of your exposure determination, by all means bracket the exposures. This means giving less-than-normal, normal, and more-than-normal exposures for each picture situation. For reversal films, the increments should be in ½ stops. For color negative films with their considerably greater exposure latitude, the bracket can be in full stops. But let's hastily add that bracketing is a nuisance. *If you are a competent photographer using color negative films, you should not have to bracket exposures.*

The phrase "available light," in photographic jargon, really means dim light. This generally includes the low light levels found in offices, homes, theaters, night street scenes, nightclubs, and other situations where the lighting was not intended for photography. In most of these cases, the principal problem is to expose the film adequately. Wide open lens apertures, fairly slow shutter speeds, high-speed film, and bracketed exposures provide the answers. In theatrical or nightclub scenes, such as these where there is colored light, don't worry about color correction filters, just shoot and let the colors record as they will.

Filters for Available Light

It is, primarily, in available light shooting of people that you encounter filtration problems. Why? First of all, a person's face must be considered a sensitive or critical subject, to be reproduced accurately. You can, for example, tolerate a warm balance of a room interior, but include a fairly dominant subject's face in this scene, and the rendering of the flesh tones becomes unacceptable. In other words, you should strive for normal color balance in all of your people pictures (Here, of course, we are not considering stage lighting or intentionally bizarre effects.)

Given the existing illumination, the way to control the color rendition is with conversion or light-balancing filters. There are so many film-filter-illumination combinations for available light shooting that it is impractical to list them all here. If this information is desired, consult the color temperature balance dial in the Kodak Professional Photoguide (Kodak Publication No. R-28).

One of the most frequently encountered color-balancing problems occurs with fluorescent illumination. There are several kinds of fluorescent tubes, and if you are not sure which kind you are using for an available light shot, try to find out. Ask, or stand on a chair and read the fine print on the end of the tube. Most kinds, even though they look "white," have a discontinuous spectrum. They are considerably deficient in red emission when compared with daylight or electronic flash, therefore unfiltered color

pictures will have an objectionable greenish cast. But put the recommended filter in front of the camera lens, and for all practical purposes, the resultant color balance will be satisfactory.

This brings up a very interesting color-balance problem. All capable photographers will agree that this is the right way, in fact, the only way, to shoot transparency films, such as Ektachrome, under fluorescent illumination. However, when it comes to shooting color negative films, such as Vericolor II, under the same conditions, even capable photographers are a house divided. Some say not to use filters because of the speed loss (and the usual exposure factor in this case is in the neighborhood of one stop). Proper color balance, they say, can be restored when the negative is printed.

STARTING FILTERS AND EXPOSURE INCREASES FOR FLUORESCENT ILLUMINATION

FILM TYPE	TYPE FLUORESCENT TUBE					
	Daylight	White	Warm White	Warm White Deluxe	Cool White	Cool White Deluxe
Daylight Type Ektachrome and Type S Color Negative	40m+30Y +1 stop	20C+30M +1 stop	40C+40M +1⅓ stop	60C+30M +1⅔ stop	30M +⅔ stop	30C+20M +1 stop
Daylight Type Kodachrome (KM25 and KR64)	50M+30Y +1 stop	20C+30M +1 stop	30C+30M +1⅓ stop	60C+30M +2 stops	40M +⅔ stop	30C+20M +1 stop

Fluorescent light exposures, if unfiltered, look like this with daylight-balance film. If it's slide film, the excessive greenishness renders the slide useless in most cases. If it's color negative film, the prints can be somewhat corrected during the printing process. With either film type, the proper filter combination should be used to avoid the green cast.

If you took the same scene with the proper filters, it would look about like this. Be sure to consult the table at the left for the recommended filtration with your film.

This is only a partial truth. *The BEST color rendition will be obtained by filtering the camera exposure even when using color negative materials.* Without delving too deeply into the sensitometry of the matter, an unfiltered color negative exposed to fluorescent light contains a red record layer that is underexposed by about two stops. The color rendition of the middle tones of this layer isn't affected as much as the shadows and highlights, which find themselves on different gradients or contrasts of the characteristic curve as compared with the blue and green record layers. Thus the lack of a filter has introduced non-curve conformities into the reproduction, which can *never* be readjusted in the printing process. The result of the best readjustment attempts could be normal middle tones, yes. But the readjustment would also give reddish shadows and cyan highlights. Don't put blue-green shirts on your available fluorescent light executive portraits. Take the one stop speed loss and use the filter.

There is another practical advantage to filtering color negative exposures to obtain normal color balance. When color negatives are printed at a laboratory (proofed or enlarged) the printer-operator customarily expects that they will all be of daylight balance (for which the film was manufactured). Electronic flash and blue flash lamps are so close to daylight in balance so that these negatives essentially print the same. Unfiltered fluorescent light pictures often get caught in this balance trap, and the first time around, come out terribly green. It costs more to reprint them with a more acceptable balance. It also takes more time to do it.

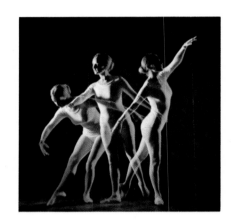

MULTIPLE EXPOSURE. Successful multiple exposures are the result of careful planning. You must leave medium-to-dark shadow areas to record a sufficient amount of the second image. One of the easiest double compositions is a line-lighted close-up profile and a smaller front-lighted image positioned in the dark area of the first image. Certain electronic flash units can be modified to emit multiple bursts of light—handy for motion analysis of a golfer or a dancer against a dark background.

Special Effects

Once in a blue moon, a very different photograph will be needed for an eye-catching display, an unusual advertisement, or for your own creative satisfaction. Imagine how you could impress the viewers of your portfolio with a section of startling special-effect pictures.

There are limitless ways of deviating from straight photographic procedures to produce different or unusual effects. Some of these are camera techniques, others are the result of darkroom manipulation. The Kodak book *Creative Darkroom Techniques* (AG-18), available from AMPHOTO, bookstores, and photographic dealers, covers many of these techniques.

For your interest and amazement here are a few of the things that can be done.

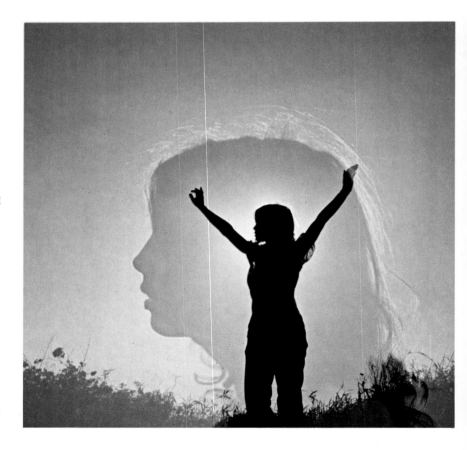

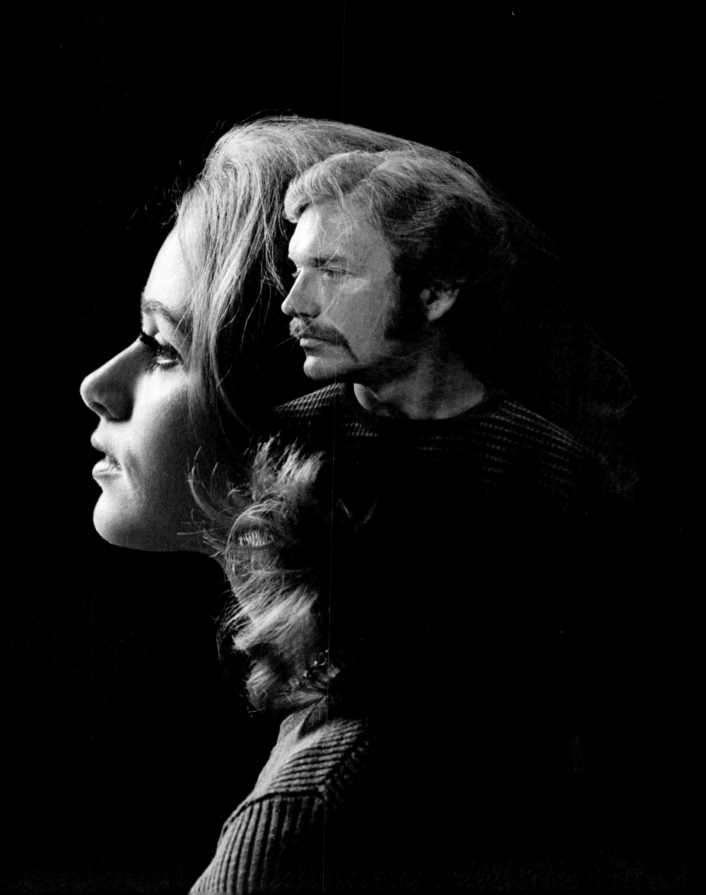

INFRARED. Kodak Ektachrome Infrared
Film can provide unusual false-color
effects. The film is sensitive to green, red,
and infrared illumination, which produce
yellow, magenta, and cyan images
respectively. The colors are spectacular,
but they are often unpredictable. Red
becomes green, green foliage becomes red,
and faces become greenish with yellow
lips. You'll need a deep-yellow filter, such
as a No. 12 or No. 15. Also, since infrared
rays do not focus in the same plane as
visible light rays, you should front-focus
slightly, or at least stop down as much as
possible to ensure sharp images.

120

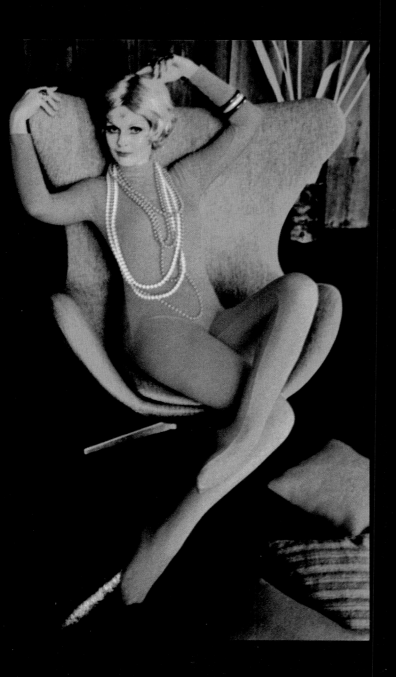

STAR ATTACHMENT. An attachment that will turn point sources of light into stars has very little application in general portraiture. Yet, you should know that with this attachment you can create an occasional different effect. A heavy blue filter was used in combination with the star attachment for the unusual bride picture.

IMAGE MULTIPLIER. How many times would you like to see yourself be married? The interesting image-multiplying effect was created by using a special optical multiplier over the camera lens. There are a variety of such attachments available that can multiply an image three to five times in various configurations. These attachments can even be used in combination for additional effects. If you have a camera with a reflex finder, you can see and evaluate the effect before you shoot.

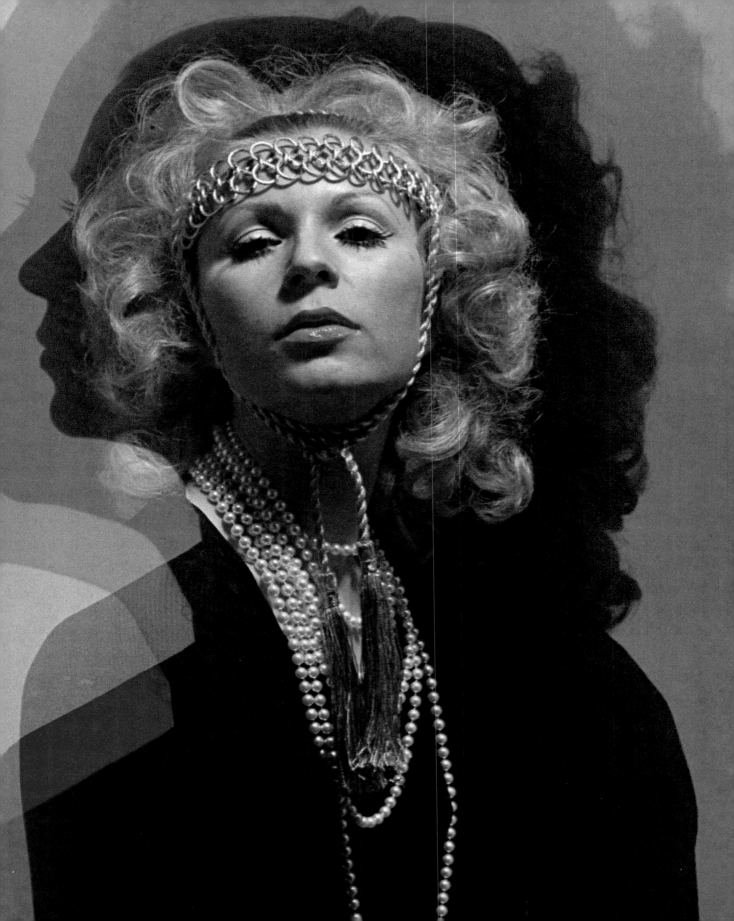

◀ This picture was made by photographing the girl in silhouette through blue, green, and red filters in front of a white wall. The camera was moved in closer to the girl after the first and second exposures. Then she was photographed with conventional lighting without a filter so that the image was positioned in the dark area of the silhouettes. Four different exposures were made on the same frame of film.

MATTE BOX. This creative device and some of the effects it can produce are described in the Lens Attachment Chapter. Matte boxes are commercially available for 2¼'' × 2¼'' cameras and can be adapted for use on 35mm cameras. Imagination plus careful planning and execution are the keys to successful matte-box shots. In this shot, the stained-glass window was photographed in a church, but the couple was taken under controlled studio lighting conditions.

POSTERIZATION. Weird and wonderful colors are available through a limitless variety of posterization, or "derivation," techniques. You can start with either a black-and-white negative or a color negative. You can then make high-contrast film positives and from these, make high-contrast film negatives. Kodalith Ortho Film 4556, Type 3 (Estar Thick Base) can be used for both of these steps. These negatives can be printed successively, in register, through deep-colored filters onto color paper. A word of warning, however: Posterized prints of clowns and gymnasts will look better than posterized prints of babies and grandmothers. The brown, tone-line derivation was made with three different negatives of the same person. They were sandwiched together to get the desired interaction of the lines. These tone-line negatives were reversed into a selection of densities and printed onto color paper.

COLORED LIGHT. For dramatic or theatrical effects, you can place large sheets of colored theatrical gels in front of your portrait lights. You will find that spot lights are easier to use than large floods. Try crosslighting with strong complimentary colors. Where the colors overlap on the subject, a third color will be created. For example, red and green light together will produce yellow.

Al Gilbert

The Shooting Sessions

Take some top-notch people photographers, add creative writers, editors, producers, mix well, and what do you have? Some very inspirational sessions on how to take good pictures of people.

The writer said to the photographer: Hey, tell you what I want you to do as you take these pictures. I want you to think out loud; vocalize every thought you have about the lens you're using, why you refocus every shot, your directions to the model, why you shoot from the angle and distance you're using, how and where you position the sharpness zone. Let's hear your thoughts about the lighting—its direction, its brightness, its color quality, the highlight-to-shadow ratios. Let's hear every single thought you have while you're shooting. I don't care at all if you think

it's important, just say it and keep talking. I'll make tape recordings and put the relevant thoughts into these shooting sessions.

Don Maggio

Steve Schlosser

Don Nibbelink

Mention all techniques or procedural hints that will help show other photographers how you take such terrific natural pictures. It's my job to sift, to edit, and to organize your thoughts into readable, useful copy. Think yon do it?

And the photographer replied: Why not? Let's do this for all types of people situations: kids, babies, old folks, people at work, brides, groups, and a boy and girl in love. Let's do them as location situations—sort of environmental portraiture. Okay?

You seem enthusiastic, but aren't these just routine assignments for you? Just a job, sort of ho-humish?

Hey, these should be great picture-taking opportunities! Today's subjects don't include a millionaire, a celebrity, and it's not an important news event, but we don't care. So it's a gentleman farmer on his tractor, a wedding, some senior citizens, and a baby. What interesting creative opportunities! We feel sorry for the photographer who couldn't approach routine assignments like these enthusiastically. Sure, they earn their daily bread. Sure, they do a craftsmanlike job for each customer. But we don't want to take just good pictures—we want to take superb ones! Think how pleased the baby's mother will be. And the farmer, he'll grin from ear to ear when he sees these pictures.

Maybe these pictures will be *so* good we can enter them in salons or competitions. Maybe they'll be important social documents some day.

That's the excitement of being a really good photographer!

That's the challenge!

Joe and Henry Leichtner

Wait, you're ready to leave right now on assignment, what are your thoughts at this moment?

Let's see now. Is everything packed? Go over the checklist: Two camera bodies, wide-angle, normal, long focus, and our favorite portrait lens to use anytime if there's shooting room; twin electronic flash units fully charged, umbrella reflector, tripod, magenta and blue filters if there's fluorescent available light shooting, plenty of Vericolor II film, spare exposure meter to use as a check against the camera meters.

Ah, yes, here's the sunshade—just no sense taking a chance with lens flare indoors or out. Lens cleaning tissue, long cable release, a couple of lightweight folding aluminum light stands, a couple of candy bars, model releases, and some of my favorite toilet tissue. All set!

So come now with master photographers and "listen" as they cope with typical people picture situations. "Listen" to their words to their subjects, which they'll say either for reasons of pose control or for maintaining rapport. Their words will be in type like this.

Listen also to their thoughts concerning photography as they occur during a shooting session or as they reflect on matters of technique. Their thoughts to themselves will be in type like this, set off in parentheses.

When a client or interviewer takes part in a discussion, their words will be set in type like this.

Neil Montanus

Note: All of the how-they-did-it illustrations on the following pages—the ones showing the photographers in action with their subjects—were taken with a 28mm lens on a 35mm camera. These are excellent examples of wide-angle photography at work.

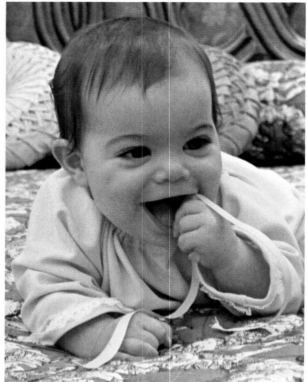

The Baby

You know, I'm glad you're coming along for this series of baby pictures. You want to find out how it's done, I realize, but you can also help me carry in these heavy cases of equipment.

Such a lot of equipment for such a tiny baby—how come?

Well, I'll explain as we drive.

There are several approaches to baby photography. One is to plunk the baby into a playpen, or otherwise confine it, attract its attention and then flash away. I'd guess that 99.9 percent of all baby pictures are taken like this.

And you know a better way?

At least I know a way I like better. It's more work and more time consuming, but it gives me the chance to take a variety of far more natural pictures.

Okay, I'm listening.

Well, first of all, yesterday I looked over the entire house, upstairs and down, to find out what I thought would be the best location. Actually, I've picked two—a large upstairs master bedroom and the dining room. The bedroom has soft, light-toned wall-to-wall carpet for the baby to creep around on, a bay window that lets in plenty of light for accurate focusing, and a white ceiling that I'm going to use for bounce lighting.

You'll probably use the walls for bounce too, won't you, so you have some sidewise direction to the light?

It's not necessary, especially with my three-light bounce. The whole room becomes a tent of light. Sure, most of it comes from the ceiling. But you see, the trick of using this light effectively is to get down low yourself, just above the baby's level, then wait to shoot when it—actually it's a she—looks up so the top light illuminates her face properly.

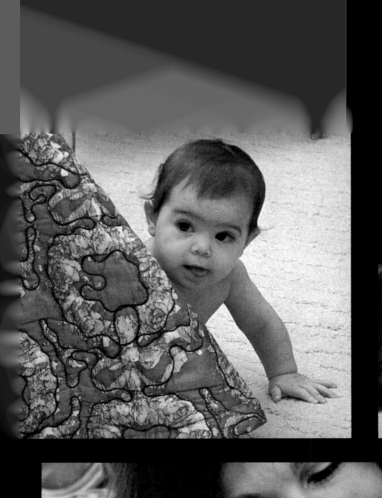

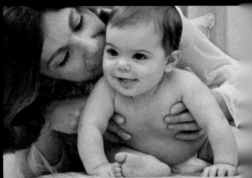
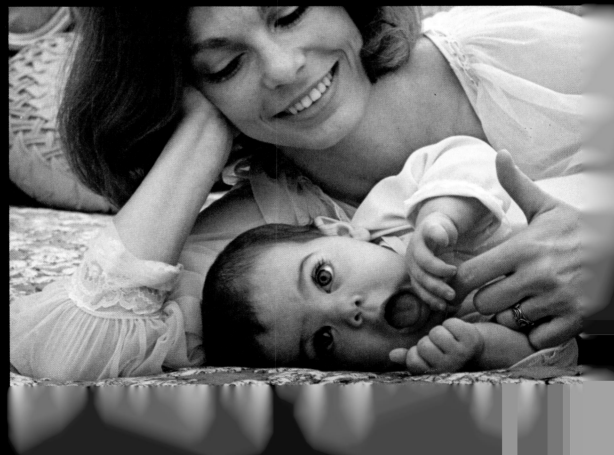

Is that what's in these heavy cases that you want me to lug upstairs—your electronic flash units?

Right. There's a large AC power pack, three flash units that all work off the same pack, three light stands, plus my usual tripod, cameras, lenses, and related paraphernalia.

I heard you say the room had a bay window—why don't you just use all that wonderful soft window light for the pictures? Wouldn't that be a lot easier?

For adults and controllable young children, yes it would. But this is a tiny, active, and uncontrollable baby. We want to let her loose in her natural surroundings. I have to set up the lights to illuminate a fairly large shooting area, not just one spot. So anywhere in one entire end of the room the lighting will be

good, it'll be even, and I can use the same exposure wherever the baby wants to wander.

Besides, the flash has a duration of only 1/1000 sec., which will freeze any movement. Plus, this unit puts out so much light, I'll be shooting, I'll guess, at $f/11$, which will give me a good zone of sharpness—just the thing for a baby who's moving about.

Here we are, and right on time, ten o'clock.

You think the baby would mind if we were late?

The baby might not, but I would. Consider this: The father has gone to work, the other children are in school, and this is the time this mother plays with, bathes, and feeds the baby. Babies get tired, of course, and if this one is good for about an hour and a half of shooting, I'll be

happy. After that, babies often get cranky or go to sleep. We have to schedule this to start at the right time.

I noticed you brought a tripod—you're not going to use it are you?

As a matter of fact, I am. But it's just for my large roll-film camera, which is fitted with an instant-picture type back. I want to make a preliminary test with this outfit to check on lighting distribution and exposure before I get serious with my 35mm camera. The tripod simply keeps the test-shot camera in the same position in case I want to move the lights around and try the checking procedure again.

But you're right; for the actual shooting, a tripod would be a nuisance. I want to be really free to move around.

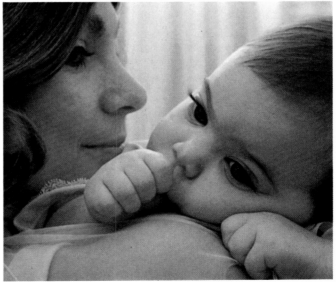

Good morning, Mrs. Sanford. How is our star Donna Jean today?

Let's start by including you in several of the pictures so Donna Jean won't have to adapt suddenly to a new situation all by herself. Then, if we see that she doesn't mind the stranger or the lights, we can try some individual shots. So, if you'll put that pink dressing gown on Donna and the pastel blue one we picked out yesterday for you, we'll be set up and ready when you are.

All of the pictures in this chapter were taken at the same exposure. This was possible because the three-light bounce system evenly illuminated the room.

What lens will you be using?

Looks like an 85mm for the entire session. I can't use anything longer for the size of this room, and it still will put me quite-a-ways away from the baby while still retaining the fairly close-up image sizes I want.

Mrs. Sanford, you and Donna look lovely together. I'd like to have you play with your daughter, just as if I weren't here. Love her, hold her up, play peek-a-boo with her, let her crawl around that leg of the bed. I'll be shooting when I like the arrangement or see a good expression. I'm going to take some close ups of her feet and hands. Wouldn't it be good if you could get her to chew on her toes? All right, everything's set. Let's take pictures.

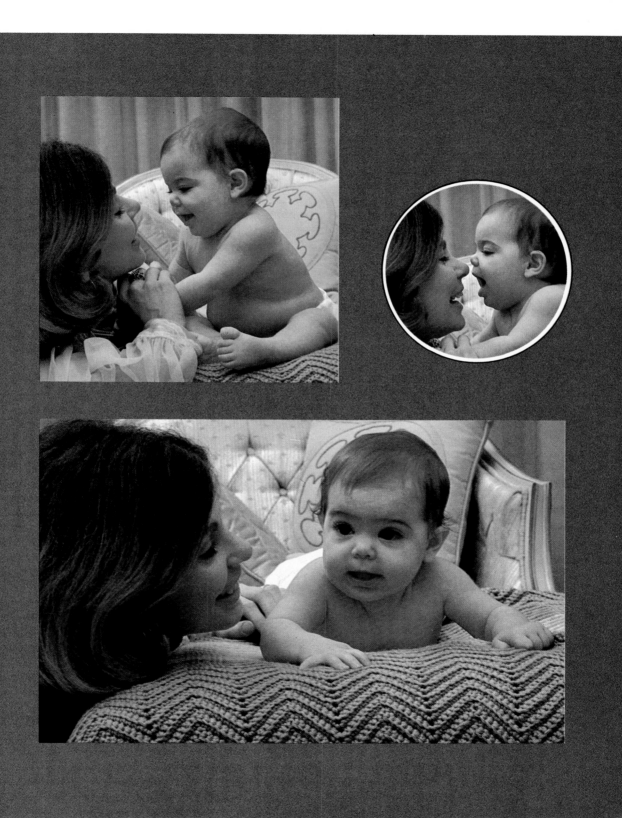

Well, it's been nearly an hour; looks like Donna would go for a bottle break. Let's move downstairs to that long dining room. We'll set the high chair up at one end. Mrs. Sanford, you can be feeding the cereal to her.

Lights all set up? Everything ready? Donna's asleep!

See if you can't set her in the high chair without awakening her. Good—she's out like a light!

We'll just take a few 105mm shots of her asleep like this—it's too good an opportunity to miss—and then we'll tiptoe out.

Thanks so very much, Mrs. Sanford. You and Donna helped me take some great pictures today. And you'll see them soon. Goodbye.

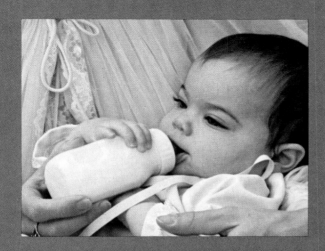

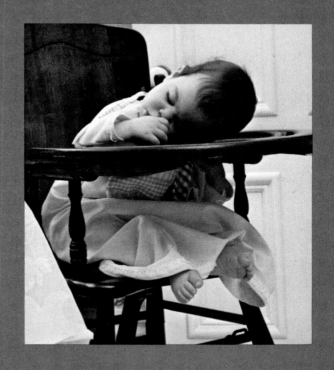

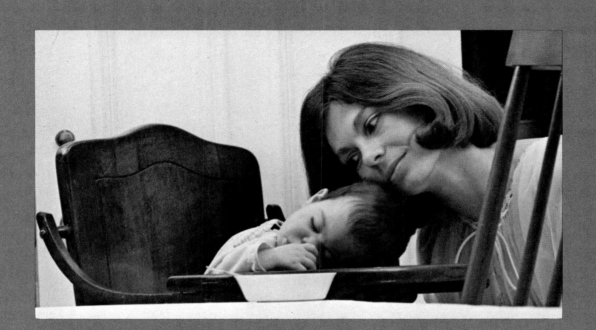

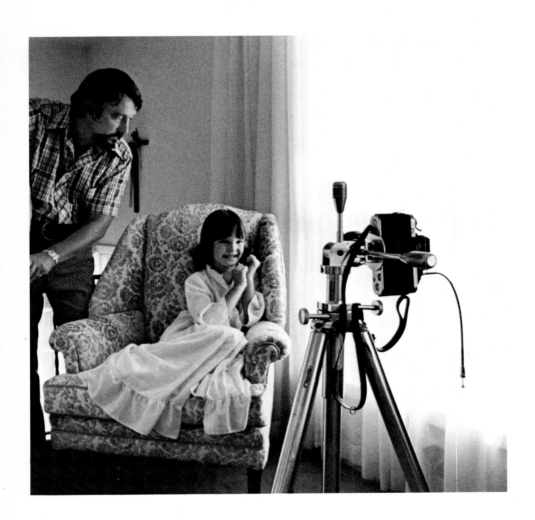

The Child

Hello, Kim. What we're going to do, you and I, is make a picture of your pretty pink nightgown against this blue and white chair. *(The blue and pink pastel colors make a terrific combination with the off-white of the chair and walls. Good thing I stopped by last week, talked with her mother, and picked out her clothes—actually, a pink dressing robe—for this picture. That saved a lot of the shooting session time.)*

In the center of these soft colors, we're going to show a little girl with a sweet little face, with a sort of serious little expression. Your hair is all done pretty—there's a nice light coming through the window—it's

soft on your face—and we'll make you look just like the beautiful little girl you are. *(This mid-afternoon reflected sky light, coming through that large window, reminds me of the great lighting possible in the north skylight studios of the old-time photographers. The drapes on the window are a very sheer material—they soften the light just like a studio light diffuser. If necessary, I can open them wider for a little lighting contrast control.)*

I think if we leave the top of the nightie neck just a little looser, it'll look nicer. Now what we want you to do is sort of cuddle up in that chair and make believe you're nice and comfy. Just get in the corner of the chair and sort of snuggle up. *(It's great to find a suitable home-shooting location like this. Kids feel far more relaxed at home than in a strange studio.)*

Can you hold your hands up a little bit? Yes, just like that. Not too cute, you know. . . .

These bangs are a little long here in front. Maybe we can push them over this way a bit—that's better. Try putting your hands over by your chin—like that. Kim, now what we're going to try to do is take a lot of different pictures of different expressions on your face. Some you can smile, some you can look sad, some you can look serious, but the main thing is that we're trying to take a real pretty picture of a real pretty girl. *(Now let me move this big reflector over on the shadow side to boost some fill back into her face.)*

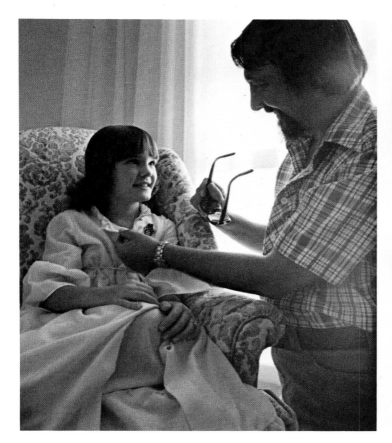

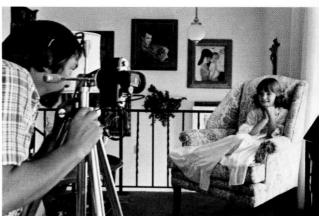

Kimberly, we're going to use the light from this reflector so we can get some light on the shadow side of your face—see? Okay.

(This sure is an ugly chunk of white cardboard, but it does the job. It's big enough to fold into a big L, so it'll stand up by itself. Must improvise without an assistant—I won't have to pay the cardboard a salary. Back to the viewfinder, just be sure the reflector doesn't show in the scene. Boy, we got all kinds of goodies here.)

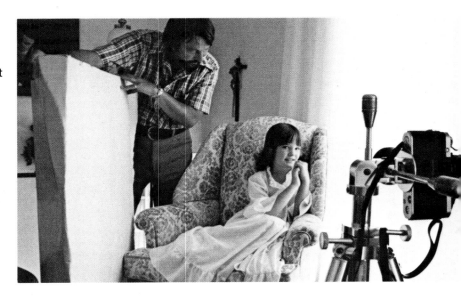

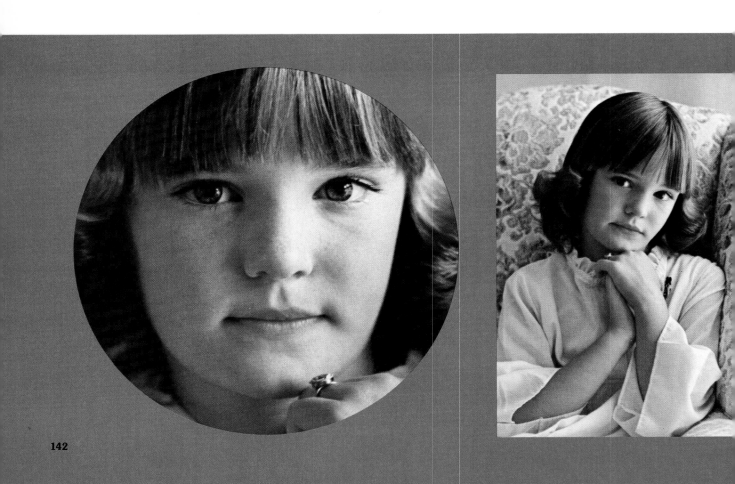

Okay, now, Kim . . . *(Doesn't matter if she really understands this.)* . . . we're going to shoot at a very slow shutter speed. That means you'll have to hold very still when I tell you I'm going to take a picture. *(I'll use the lens wide open at f/2.8. With this 105mm, the background will be a little soft but that's just what I want. I'll be focusing right on her eyes or lips and the sharpness will be right there. I'll tilt the camera up into a vertical position—fits the vertical feeling of the vertical chair lines, clothes lines, and arm position—good.)*

Kim, let's check everything before we really start—okay? You're beautiful, you're just super, just a nice serious expression now. . . . Remember, we're shooting at a slow shutter speed, which means that you can't move suddenly. And you should hold your eyes still—don't blink them—that's real good. Hold it—click—click—click. *(A lot of kids blink, but this seldom wastes much film for me; the trick is to shoot immediately after they blink!)*

Kimmie, now just turn your head over this way, turn your face toward my hand. That's just right. . . . *(I've finally learned to direct subjects with my hands. It avoids that old problem of who's left and who's right. It's especially helpful with children as a clear posing*

direction.) Hold it!—click— that's fine. Hold it—click. Now put your hands up to your face, sweetheart. That's it—click. Now look over here, Kimmie. Hold it—click.

(Try to remember to let your models know when you're going to take the picture. Say "hold it," or "here we go," or something. Helps to prevent a last-minute pose shift or expression sag.) That's super, Kimmie, tilt your chin up a bit. Hold it—click. Now push your hair back just a little bit on this side—here, let me help you. (Sometimes you have to get away from the camera and go up to the model. If they can't easily or quickly follow your directions, it's best to save time and do it yourself.)*

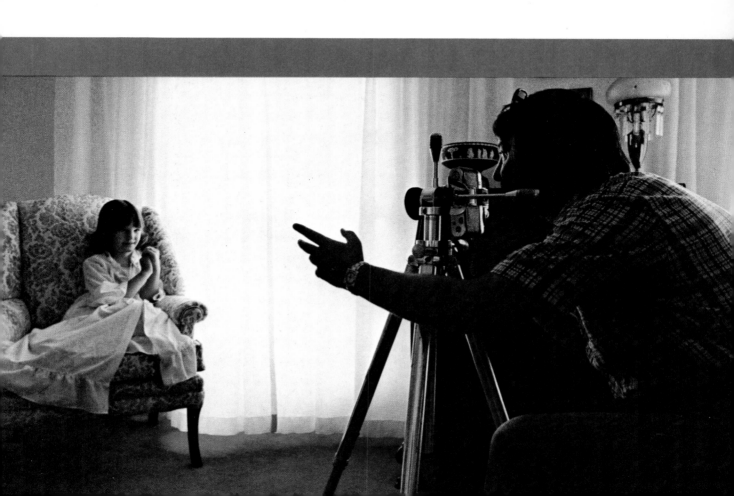

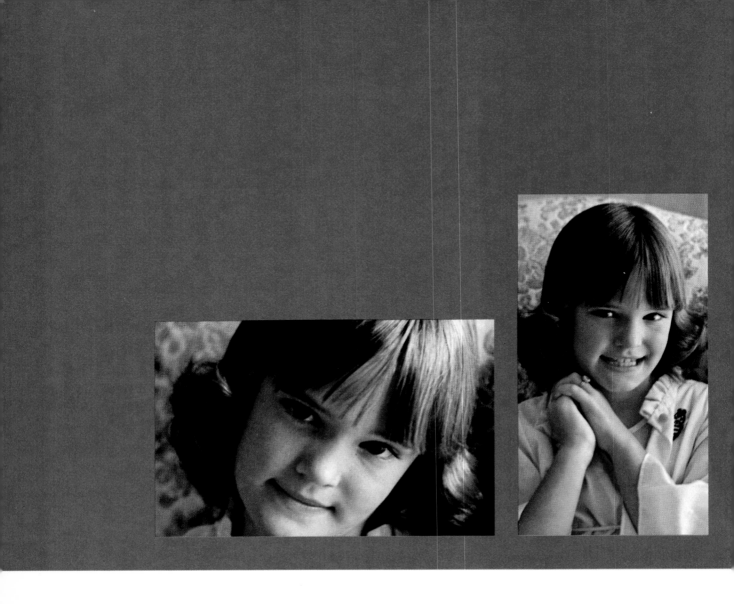

Okay, hold it right there—click—that's beautiful—click. Okay, honey, here we go again—click—click. *(When you're taking pictures, especially of young children, tell them how nice they look! You have to establish a good rapport. You're trying to communicate with them; tell them they're doing a good job. Give them credit. Put them at ease.)*

Okay, sweetheart, just turn your face a little more toward my hand. That's too much, back a little, there! Hold it—click. *(Check the focus! Check the focus! I guess you'd call me a "follow focuser." I refocus just before taking every shot. I've just got to make sure the eyes are always crisp. There's always a chance that when you advance the film you could hit the tripod*

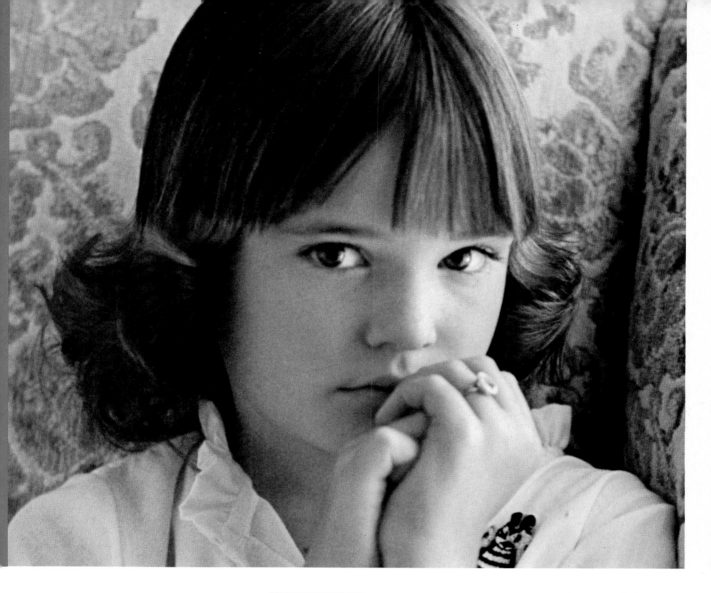

and move it slightly forward or backward. Why not refocus every time? It only takes a second. Besides, I'm waiting for that just-right expression for the next exposure. You should continuously be checking everything. Like that little. . . .) Kimmie, can you fix that one little lock of hair—it's in your eye. There, hold it—click.

Now don't move while I come in for a closer picture of your face. *(Always take the long shots first, then move in for closeups. Gives your models much more of a chance to get used to the camera this way. Recheck the composition. I'd guess about 70 percent of my pictures never have to be cropped—very much— that is. I try to compose correctly right in the viewfinder.)*

Kim, just relax for a moment while I change the lighting. *(Away with the reflector. I'll turn on this table lamp and move it to about five feet from the shadow side of her face. The white shade diffuses the light and matches the evenness of the diffuse window light.)*

Why did I do that, Kim? Well, we want to have a choice of nice lighting effects. This lamp gives off a warm yellowish light compared to the daylight. So we're going to give the shadow side of your face a little extra golden glow. . . . *(Besides, it puts a little extra highlight sheen on her hair. Got to be careful not to have it too close—don't want to overwhelm the main light. Just want to create a subtle, warm-fill effect.)*

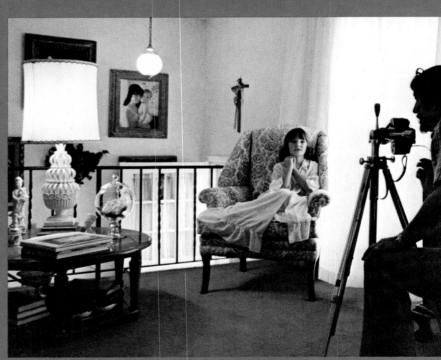

To vary the lighting, the large white cardboard reflector was removed and the tungsten room lights were turned on to provide the fill illumination. This is a deliberate mixing of the bluish main light from the window and the yellowish tungsten fill lights to warm up the shadows. Artistic! Creative! Interesting!

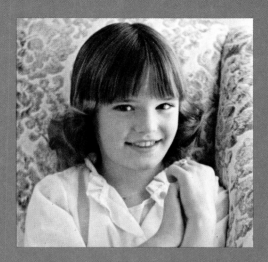

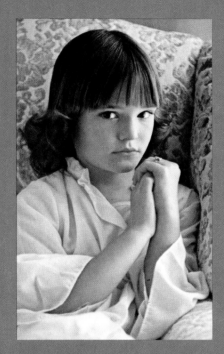

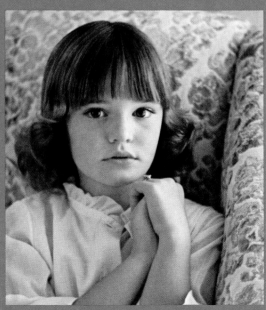

Kim, now look out the window for a
minute, turn more toward the
window. That's it—hold it—click.
*(Kim is now in profile. This adds
to the variety. There'll be so many
good shots in this 36-exposure
roll, her mother won't be able to
choose any best one. She'll
probably buy the lot!)*

In window-lighted profiles where the
window itself is included as a part of the
scene, it's normal to utilize a rather high
lighting ratio, often about 6 to 1. Be wary
of basing the exposure on the deep shadow
side of the face since this would overexpose
the important highlighted portion. Also,
when taking profiles, try to avoid the
half-profile half-front view of the face in
which the farther eye and cheek line are
partially cut by the bridge of the nose.

The Single Girl

Hello, Toni? This is Don speaking. Say, you know the picture you wanted to take to give your boyfriend? Well, I have a spare hour this morning; I could take it for you right now if you're free.

Of course I know it's raining and cold outside. No problem! You wear a comfortable pants suit, bring two or three springtime blouses, and meet me in an hour at the conservatory.

That's right, the big greenhouse building on Reservoir Avenue that's run by the city parks department. Inside it's spring and the flowers are blooming—you'll see.

(It couldn't be a better day for her portrait. Overcast completely, yet there'll be a nice directional quality to the light inside the greenhouse. It'll be soft backlighting if I face her away from a side wall and soft front lighting if she faces toward the wall. Great! Every photographer who has any sort of a greenhouse available as a shooting location is a fortunate fellow.)

Hi! Glad you could make it on such short notice. Put your coat and umbrella over here in the corner.

Now isn't this a great place for pictures? I beat you here, so I spent the few moments picking out some likely spots—all I need is you to complete the pictures. *(What a place for a 135mm lens for a head-and-shoulders shot! Large image size and I'll be able to keep the depth of field real shallow by shooting wide open—f/2.8. The background will be so out-of-focus, no one will ever believe it wasn't shot outdoors in a garden.)*

First, let me take out a couple of pots of these daffodils. Now I want you to tiptoe in there and squat down so that your face will be close to the flowers—careful—there. That looks great! Hold it—click—click.

Lift your chin up just a trifle—fine—click.

(Got to be real careful with an area like this, which is top-lighted so as not to let her face fall into shadow too much. Just that bit of an upward tipping fixed it.)

I'm glad you wore the pants suit; a skirt would have wiped off nine flower blossoms already. Not a toothy smile, just a pleasant expression—think about your boyfriend—click.—Very good. Now turn your face away from the camera a little more. Good—click— click. *(That helps relieve that slight tendency she has toward a squarish jaw line.)*

Now let's move to another spot over in the cactus wing. *(She's been in that cramped position long enough. Longer, and the strain might begin to show in her expression. So far, it has been relaxed and good.)*

This time I want you to stand facing the outside wall, but turn your head back toward me. Your legs need to be farther apart than that—that's better. The reason is that this lowers your head without your doing any bending. You make a good composition with those cactus plants in the background. Another item: Put your hands on your hips with your elbows extended out from your sides. I'm not including that much of you—it's only a tight head and shoulders—but it's going to give a much nicer triangular-shaped base to the picture if you stand that way.

Toni, give your body a little more S-curve twist. No, that's not what I mean. Watch me do it. That's still not it. You come over here and be me, and I'll be you. Look in the viewfinder. See the position now? Okay, lets trade places again and let's try it now. *(That's strange, I thought I transported the film for the next shot. I did! That rascal took a picture of me when I was showing her the pose! I'll get even sometime, Toni, just wait. But I'm really glad she did it—shows she's relaxed and having fun with this shooting session.)*

Here we go for a real. . . . Fine— that's it—click. *(A demonstration is sometimes the quickest way to explain a subtle pose. This is all to the good; it helps give any subject an enthusiasm for the mood and composition you're trying to create.)*

Toni, move over here where I can frame you between these two cactus plants. Right—click. *(With them right in front of this wide-open 135mm lens, they'll be out-of-focus blurs framing her.)*

Time to change to that darker blouse; and wind this pretty green scarf around your neck. *(That darker blouse is going to be better. I could see the white one catching quite a bit of the top light, making it the brightest area in the picture. Really, it was too bright. It'll probably detract from her face. I should have caught that subject contrast error the first thing. Guess I was too excited by the pictorial opportunities of a pretty girl and all these flowers when it's still winter outside.)*

Yes, that's a better outfit from a photographic standpoint. You see, I tried to play white against white for a delicate high-key effect, letting your auburn hair provide the main color for the scene. But I really think we can keep the attention on your face better with the darker blouse. Let's try this: Put your fingers up to your chin. How would you feel if your boyfriend told you he had to leave on a six-week trip? Hold it—click. *(The hands up to the face surely called for a pensive expression, and apparently that remark did the job. I noticed her hands were catching more of the top lighting than her face, but not so much that it can't be printed in later, if that's the shot that gets enlarged.)*

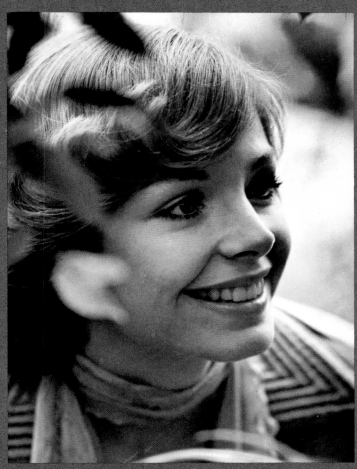

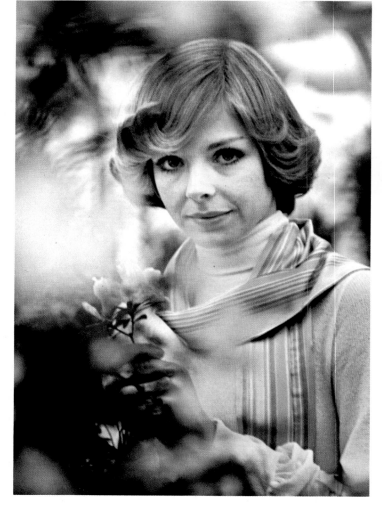

Let's go back into the other room where I saw a bed of red tulips. Maybe we can use. . . . There—like that—click. *(Wait a minute. Even though the tulips are only out-of-focus areas of red in the background, I think they may call attention away from her face.)*

Toni, don't move. Let me take a couple of these tulip plants away so they won't be distracting. There—better—hold it—click. *(And it is better too. Funny, but sometimes you don't see these things right away. You have to work with a subject like this to really find the most compatible arrangement of light and colors and everything.)*

Notice the difference between the $f/2$ depth of field above and the $f/8$ depth of field below. Which do you prefer?

Okay, that should give you plenty of real good shots to choose from. While you're putting on your coat, I'll take just a moment to finish this roll on a few flower closeups. *(Who could resist taking blooms like these while it's still winter outdoors! And it's good close-up practice. You know, if I were going to do an album of pictures using a greenhouse setting like this, I'd make it a real point of including solo blossoms like this. What a beautiful way of dressing up an album double spread, or of enhancing a layout in a book. If a series of these pictures were ever to be published, they'd be great.)*

I did get even with her!

The Boy and Girl

Good morning, Jean! Good morning, Claudio! Have you two had breakfast yet? Eight o'clock is pretty early to arrive at a photographer's studio for an engagement picture session.

I'm glad to see you wore the informal "now" clothes we talked about. Claudio, your blue shirt and Jean's candy-striped blouse will make a good color combination. *(Wish I had had a chance, actually, to see these clothes first—I'd have preferred more muted tones. But I won't mention that to them; I will just make the best of it.)*

Well, let's hop in the car and be on our way. This park I told you about, with the big pine trees, is about twenty minutes away. By the time we get set up it'll be nine o'clock— just when the sun starts splashing pools of light into the woods. We'll have a chance to take some nice, sunny backlighted shots and some with soft shadow lighting.

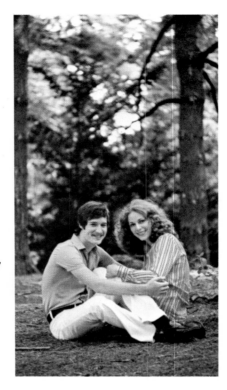

Claudio, I understand you're interested in photography, is that right? Good! Tell you what we'll do—I'll explain about the lighting as we progress with the shooting because I'm sure you'll find it interesting. Right?

To start, I'm not bringing reflectors. Nor will I use fill-in flash, even though the sun is shining brightly. You see, you asked for a modern engagement picture. To me, this means the two of you at some distance from the camera. Imagine this: There you are, just the two of you alone in the woods, almost as though it were the whole world; perhaps you're walking hand in hand down a little path or standing in a patch of sunlight. The point is, you'll be so far from the camera to create this lovely composition, that a

reflector, which has to be close to do any good, would be in the picture.

Fill-in flash? Well, again, you'll be too far from the camera for fill-in flash to reach you with any effect. These two lighting-contrast reducers are only for closeups! At your 25- to 40-foot distance, the bright sun will pick you up with a lovely highlighting effect.

So remember, Claudio, bright sunlighting can be used effectively for people pictures outdoors, if the subjects are far enough away. And especially if you position your subjects so that they are backlighted—like we're going to do. *(I won't bother to tell him that if I used fill-in flash, it would terribly overlight and overexpose any grass or bushes in the foreground of the pictures.)*

All this doesn't mean we can't take close ups. Not at all. We'll just move you into the shade where the lighting is wonderfully soft *(and where you won't squint)* and we'll adjust the exposure accordingly.

I'll tell you what I'll do so you can see the lighting difference yourself. I'll take one close-up picture of you and Jean in the sunlight—mind you, it'll hurt me to do it—but you'll see the terrible, contrasty lighting effect.

What's wrong with this picture? It's the visually overpowering background at the left. The solution is to shoot from farther left or move in closer.

I call it "hatchet lighting" because of the way it chops up a face. But just you wait and compare this with a good close up made in the shade.

Ah, here we are. Everybody out and head for that grove of beautiful old evergreens over there.

(Looks like a 105mm lens will be the only one I'll use. It'll be excellent for the close ups and still put me far enough away from them so I'll have a good selection of foreground foilage to shoot through. A 135mm lens would put me too far away, especially where I'll use them as figures in the landscape.)

See that little path that seems to end in the clearing by the big trees? That's the beautiful spot I was telling you about. Isn't it lovely? And you'll be a part of the whole scene. We'll start by taking the long shots first, and then we'll take some closeups.

(This way, they'll get used to the camera, without self-consciousness creeping into their expressions, which is so much more important in the close-ups than the long shots.)

Go over by that grandfather pine tree. Both of you sit down in the shade in front of it. Jean, turn your back toward Claudio and look off into the distance—that's right. Claudio, look at your bride-to-be. Hold it—click. That's just fine. Claudio, get up on one knee and put your left hand on Jean's shoulder. Now both of you look over here at me. Fine—hold it—click. *(Oops! That left background looks awfully bright to me; I'd better shoot more to my left to exclude most of that sunlighted area. I must watch the exposure. Mustn't let those bright patches of sunlight overly influence the meter. I'll take a close-up reading of the shadow side of their faces.)*

Stand up now and we'll try a few shots—looking at each other, holding hands, looking at me—just be yourselves. You don't have to freeze. Relax, and slowly go from one position to another. That's it—fine—click—click—click. *(And it is too. My shutter speed of 1/250 sec. will freeze any slow subject motion—especially since they are so far away, which further reduces their relative image speed at the film plane.)*

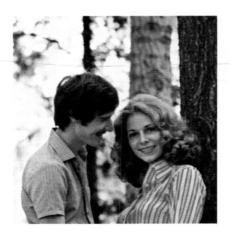

Photographers call it "crossed eyeballs" when the eyes of the subject are not looking at the same place.

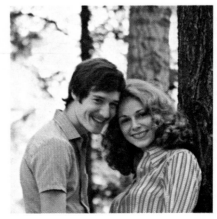

Ah, better! If there is any question as to which version would please the subjects best, take both.

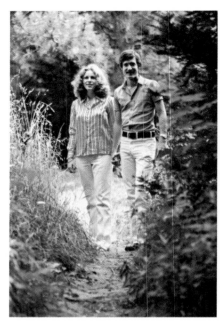 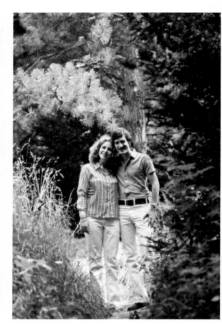

Let's try something a little different. Come down this path toward me. I'll catch you as you cross that little patch of sunlight. Walk slowly, don't stop. You'll look far more natural than if you try to pose as if you were walking. Start toward me now. Fine—click—click.

Okay, let's do that again—just the same way.

(Hard to tell which shot will result in the best arm and leg positions—best to have several to choose from.)

Back up and walk toward me once again. This is really a great picture idea. Put your heads a little closer together as you come. ***(This time I'll get them with a diffuser over the lens. The backlighting at this spot will look terrific with the highlights diffused.)***

Come on—you're looking good—click. ***(That's it, that's it! That's the shot everyone is going to like best! That's a 16″ × 20″ shot if I ever saw one in my viewfinder!)***

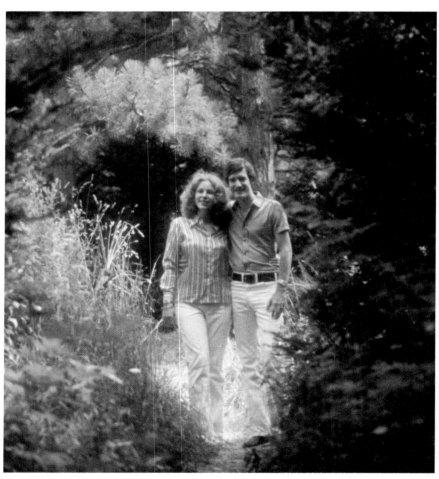

162

Okay, kids, that'll do it for the long shots. That last one was great, by the way. How did it feel to help create such a beautiful photograph?

Let's move over into this open shady area for a few closeups. You know, the kind the newspaper will want to run for your engagement announcement.

That wraps us up. You'll have a good variety of shots to choose from.

Wait, wait! I almost forgot to take that hatchet lighting shot I promised to do. Back into that patch of sunlight. Heads together. Now turn a little more to the right until you feel the sun on your face. Hold it right there—click. Got it. Let's go home.

(Was that last shot wasted film? Not on your life! They'll appreciate the good ones even more when they compare them with the poor one.)

Newspapers usually crop the ears off portraits, so for engagement-type pictures that are to be published, it's best to include closeups. Also, portraits made under soft light are best for newspaper reproduction.

Hatchet lighting! So called because of the way the contrasty sunlight cuts up faces. The same lighting ratio would be far more acceptable for a distant shot taken with a diffusion attachment.

The Wedding

Al, let's suppose I'm going to be married. I call you up and ask if you can photograph my wedding. Take it from there. What happens from there on, from a photographic standpoint?

All right. If you had called me, you and your bride-to-be would be invited to my studio for a planning conference.

The planning conference in the Gilbert Studio often includes a preliminary shooting session. An intentionally contrasty lighting ratio is used with black-and-white film. Resultant proofs may indicate that changes in makeup and hair style are necessary, that a lower-than-normal camera angle would be more flattering, or that one side of the subject's face is more photogenic than the other. Photographer and subject become better acquainted and the rapport improves for the actual bridal picture session.

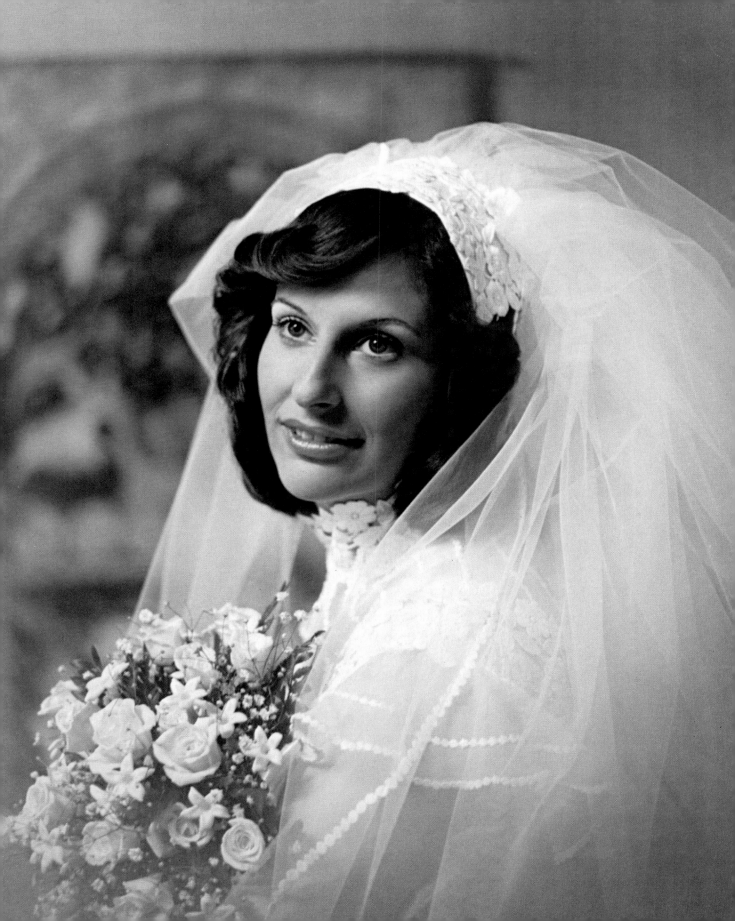

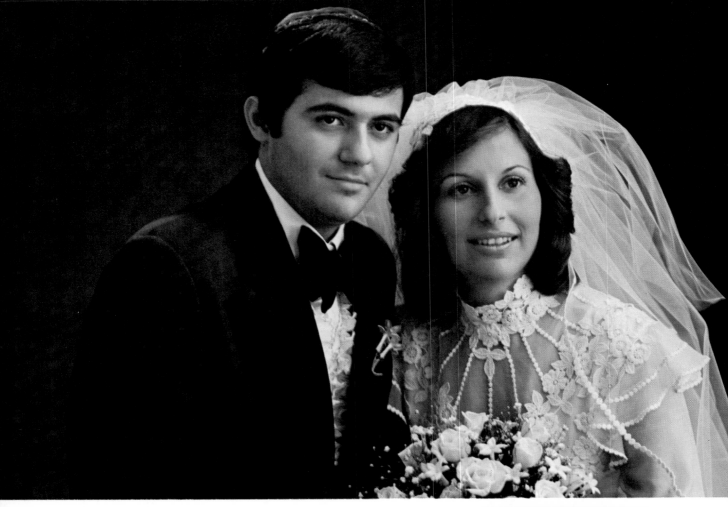

The situation is this: It's Sunday afternoon, the place is the anteroom of a large synagogue in Toronto. The sunlight is streaming strongly through several tall, frosted-glass windows. Al regards this as an ideal location studio. The window light is excellent. It's high, directional, and diffused by the frosted glass. The only modification of the existing light needed is to add some light to the shadows. There are three ways to do this: with flash-fill, with a reflector on the shadow side of the faces, or with a translucent scrim placed between the subjects and the window. Al tries both of these last two techniques for this bride-and-groom portrait.

First, look at the circular closeup of the hands holding the wedding ring with the out-of-focus stained-glass window background. Actually, this is the result of the two camera exposures you see at the left and eventual double printing in the darkroom. The "window" was made from colored pieces of plastic cut and taped together in a random pattern. It was intentionally photographed as an out-of-focus image.

I would then go through the three types of coverages that we do here.

And they are?

First, there is the contrived type of picture. By this I mean the double exposures and the trick shots—some photographers call them "fantasies."

You mean the matte-box shots where the bride and groom are dancing in the middle of their wedding invitation or are in the center of a brandy snifter?

Yes, only we prefer to do these effects in the darkroom as double exposures on a single sheet of paper from two different negatives.

Other ideas along these lines are the garter shot and the shot of the bride and groom with heads together looking closely at engagement ring on the bride's finger. Well, people don't just stand and look at a ring with their heads together—so to me that's a contrived situation.

I have a whole album of these kinds of pictures. I don't like them myself, but if that's what the people want, that's what I'm going to take for them.

Al can assess the shooting possibilities of a new location and select the areas he thinks will serve him best in about five minutes. Is there a suitable chair? Is it too high, wrong color, right shape? What furniture will have to be moved? Which lamps, paintings, or objets d'art would make good props? Can the drapes and curtains be pulled back to get the exposure up to 1/8 sec.?

As a matter of interest, about how many people express a desire for that kind of thing?

About 20 percent.

Now about another 20 percent want absolute candid coverage. You know—Don't pose me—Don't touch me—Be as unobtrusive as possible.

You mean, just with the camera as your observer's eyes to pick up the feeling of the wedding?

Yes, and it's a tough way to go and do it right because now you're supposed to come back with photographs that show happiness. And it takes more than a photojournalist type of photographer to come up with pictures that show the scene as the bride imagines it is.

Exposure determination is different for location photography than it is under controlled studio conditions. In the studio, with color negative film, you should base the exposure on the shadows and then add the highlight illumination to give form and shape to the face. But here, in these window-light pictures in a home, the main light producing the highlights—the window—is already established. Al's system is to base his exposure on the highlighted areas of the face with half the rated ASA and then boost the shadow illumination with a very weak electronic flash. This flash unit has a two watt-second rating and is actually intended to be used only as a fill light.

What about the third sort of coverage?

This is the one I like to get personally involved with because this is the one where you can develop a real sensitivity for the scene. It's hard to explain, but I try to photograph a moment or a feeling between two people. In a way, I'm actually eavesdropping. If there is love there, I can get it. If there is no love, I can't put it down of film. You know, I can sense this feeling in my first meeting with the couple once they choose the type of photographic coverage they want.

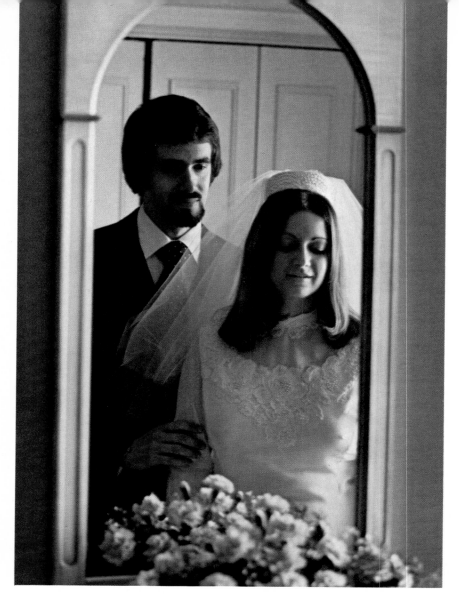

You're saying that 60 percent of the couples choose the uncontrived type of photography, hoping you can capture the mood or sensitivity they deeply feel?

Right. I like to start with an engagement picture. I tell them to dress exactly as they would if they were going for a stroll in the park. We go out about sunset, when the sun is beginning to drop. With a long focal length lens, usually 250mm on a 2¼-square camera, I'll stand off at about 15 feet, then when they are standing close to each other and I can feel a reaction between them, I start shooting. Revolving around them, I keep shooting. Sometimes I don't even see one of the faces, but it doesn't matter, the feeling is there.

The hallway mirror made an excellent prop for an unusual picture. The main illumination was daylight through the opened front door and the intensity was controlled by the amount the door was opened. Weak fill-in flash added just a touch of shadow illumination so the lighting would look natural but not be too contrasty. Don't make the mistake of focusing on the mirror itself for a shot like this—focus on the *mirror image*. In this case, the image is about four feet farther from the camera than the mirror itself.

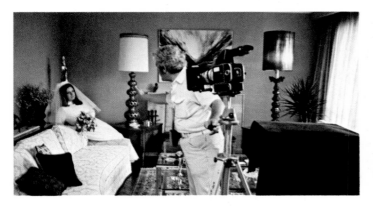

In this case, no fill-in flash from the wink light is needed because the soft illumination from the window covers both sides of the face. Notice, however, that the face is turned slightly away from the window to create a flattering narrow placement of the main light. Notice also the partial use of a vignetter to help obscure the busy detail of the flowers and the background.

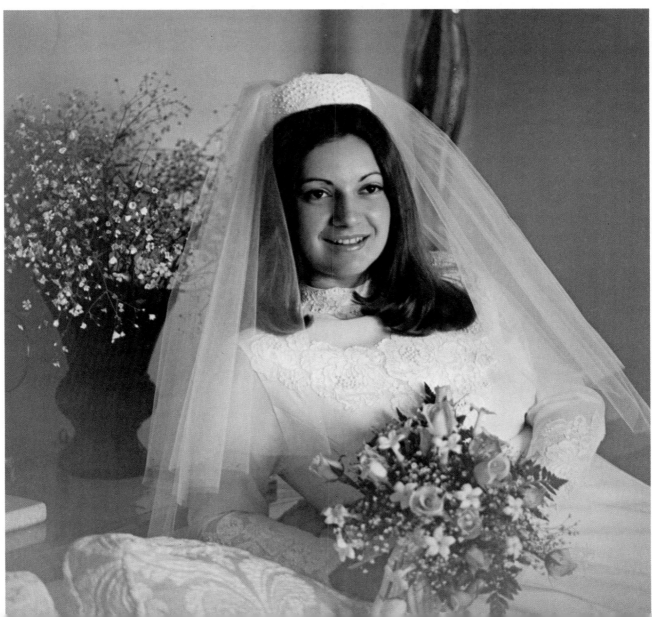

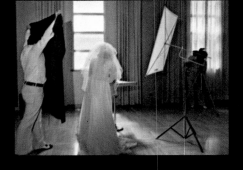

You want a black background and there isn't any? The problem is easily solved if you remembered to bring along a large black cloth which can be held up by an assistant in back of the subject.

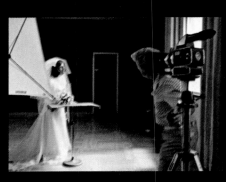

Don't overlook the adjustable-height posing table which is an essential part of any good location photographer's equipment. See the forward look or "driv to the bride's pose in the arch-cropped picture below? The posing table made it possible.

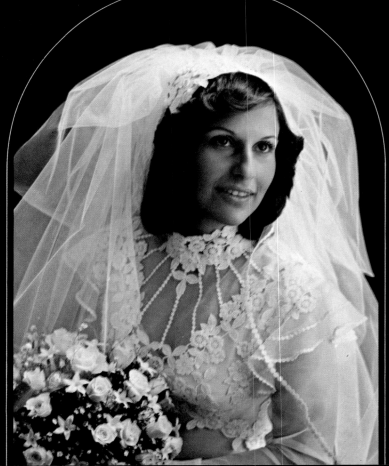

By this time I know the kind of people they are. I know the type of photography they like. And this is a great clue as to how to cover the wedding itself.

I'd go over to the house an hour before the wedding. I'd do window-light photography of the bride. I'd photograph the bride and her mother, the bride and her father, and even the grandparents. Offbeat, but sensitive wedding photography.

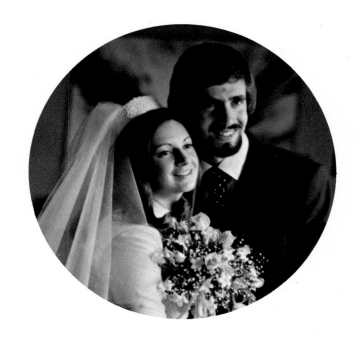

How many rolls of film are exposed on a location job like this? Don't count! The point is, stop shooting when you have adequate coverage and are confident you have a superb version of each situation. These are all motor drive exposures. Using a motor drive frees the photographer of one more mechanical detail and enables him to concentrate on the important matters of lighting, pose, and expression.

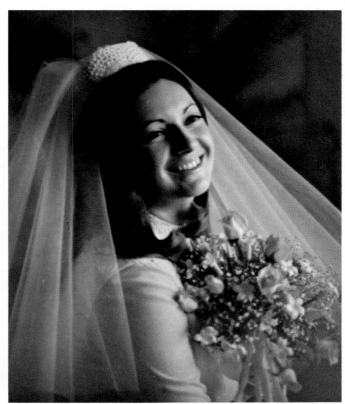

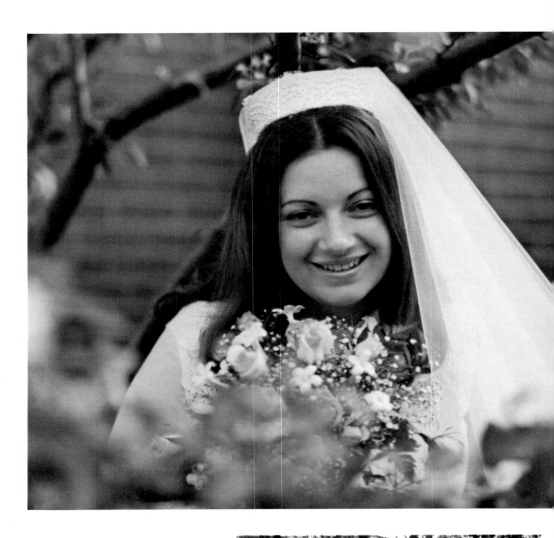

On a warm day, take the inside pictures first and the outside pictures last. Outdoors, even in the shade, a reflector can be used to advantage to help control the lighting distribution. On a sunny day, a highly efficient reflector like this would be useful in providing fill-in illumination for a group of people since it could be used at a considerable distance away. Notice that a matte acetate vignetter was used to partially blur busy foreground details. Vignetters must be used artistically, not unthinkingly. Watch the effect carefully in the viewfinder and at the *f*/stop you will be using to take the picture.

Let's see if I can sum it up for you. If you feel the bride and groom want a sensitive interpretation, you should be sensitive to this mood and take the most beautifully sensitive pictures you can.

Right. And if they're not, any photographer who can technically make correct flash exposures can do the job. I'm glad I can do it both ways.

See the foreground, the middle distance area, and the background? It's taken indoors of course, but it's an excellent three-plane photograph duplicating the three-plane effect of a natural outdoor setting. An assistant provides a little needed control over the foliage.

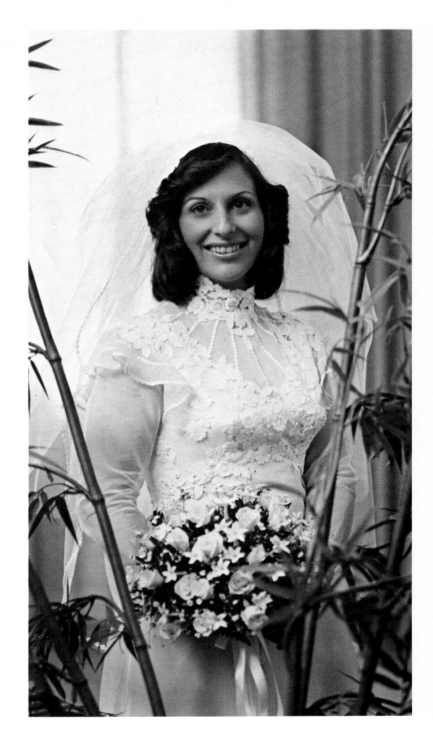

And so they got married! On the previous 12 pages you didn't see all the awesome permutations of—"this is the father of the groom having his picture taken with the mother of the bride"—and on and on. No, you can easily imagine those kinds of photographs for yourself. What you saw were the unusual and artistic location pictures that are rarely taken of wedding principals. The pictures represent skillful lighting control and creative adaptability to existing locations. True, no wedding coverage would be complete without its set of candids of the ceremony and reception. But is this merely routine available light or flash-on-the-camera photography, where all one has to do is get the exposure technically right? NO! The good photographer has to direct the people, control the action, invent the poses, elicit the good expressions, and have an excellent sense of timing to know the best moment to take the picture. Look at these candids carefully and you'll realize a very capable photographer took them.

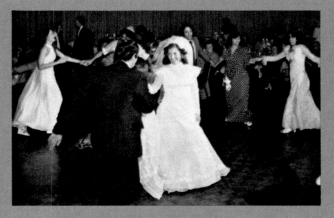

The Family

Neil, you're renowned for your people pictures—especially for family groups. What advice would you have for recording this rather difficult photographic subject?

In the first place, I'm going to disagree that families are difficult to do. Sure, I've seen loads of pictures that really are terrible.

You mean with people all lined up like a firing squad and staring at the camera?

Right. The main idea I have to offer is to suggest some bit of action where the people can just be themselves.

Then you just stand back and shoot candidly?

No, no. Not at all. Call it controlled or directed action. Understand, I'm an advocate of picturing people as they really are. I love to have the opportunity to photograph an interesting, real, alive family, preferably outdoors having fun, playing games, barbecuing, gardening, even doing yard chores. But shoot it candidly? No, because you'd be "shotgunning" and wasting time and film. Suggest the action, watch it progress, then when you see an excellent composition or a fascinating moment, slow it down, or stop it, or repeat it, if need be. And, of course, shoot when everything looks just right to you.

There are, of course, dozens of excellent picture-taking situations in every family gathering.

To say nothing of the obvious family activities around the holidays, such as unwrapping Christmas presents and carving the Thanksgiving turkey.

Seasonal and party picture ideas are obvious; let's not spend any time with them now.

Tell you what let's do—why don't you come along with me right now. I'm on my way to the Frank Deblase farm. Frank and Angela have asked their son and daughter-in-law and two grandchildren out for the day. They've asked me to come along to take some family pictures.

Count me in. What equipment are you going to use?

Ah, this is easy, normal focal length lens photography. I won't use any telephoto lenses because a family group occupies a fairly large target area. I won't use a wide-angle because I'm not after weird angles or extreme depth of field. A normal lens will be just fine for this purpose. Of course, I'm including a medium telephoto just in case I take some individual portraits.

I'm taking an electronic flash along too. I expect that a lot of their activities will take place outdoors, and since it's a bright, sunny spring day, I'll surely need fill-in flash to soften the lighting contrast on these outdoors faces.

Besides, suppose they want an indoor shot. With wiggly grandchildren, you'll surely need the action-stopping feature of electronic flash, won't you?

Absolutely. So, let's see what kind of family activity pictures we can come up with. Let's go.

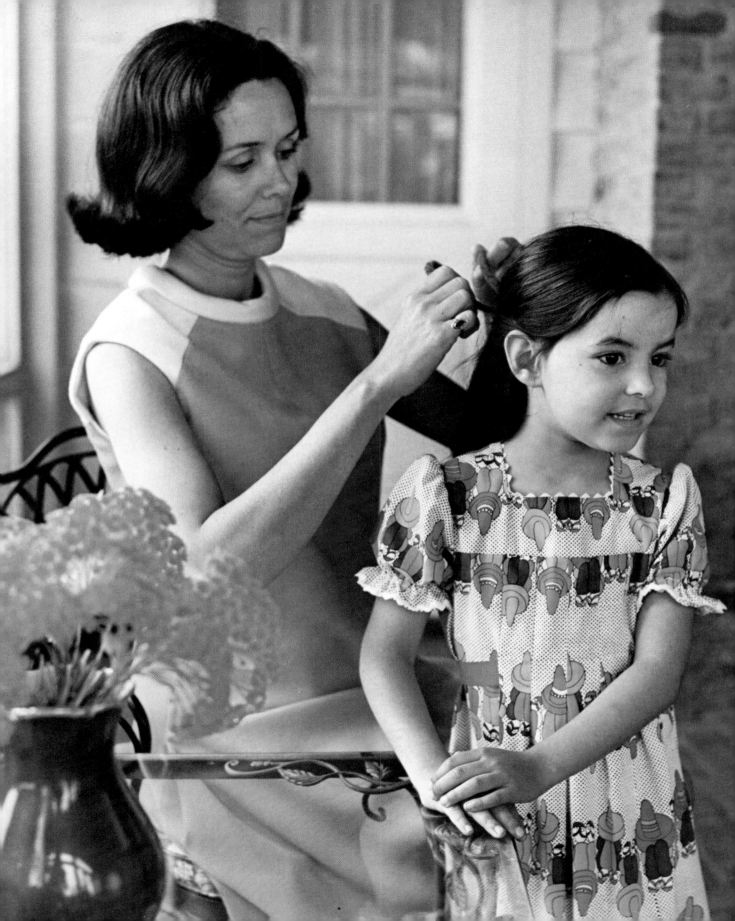

Witness the evolution of a good family group picture: First, Neil intentionally took the classic-mistake shot. He was back too far—the group came out too small, you really can't see the people's faces, and you wonder if the picture is of the family or the house. Next, Neil moved in closer for a tighter composition. Better, isn't it? But it still has compositional faults. Everybody is lined up stiffly like a squad of soldiers. Then, at last, the group is arranged far more artistically—the subjects' heads are at different levels. Note the use of fill-in flash to lighten the otherwise harsh shadows. The flash was tilted up slightly so as not to overlight the foreground.

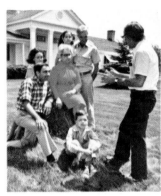

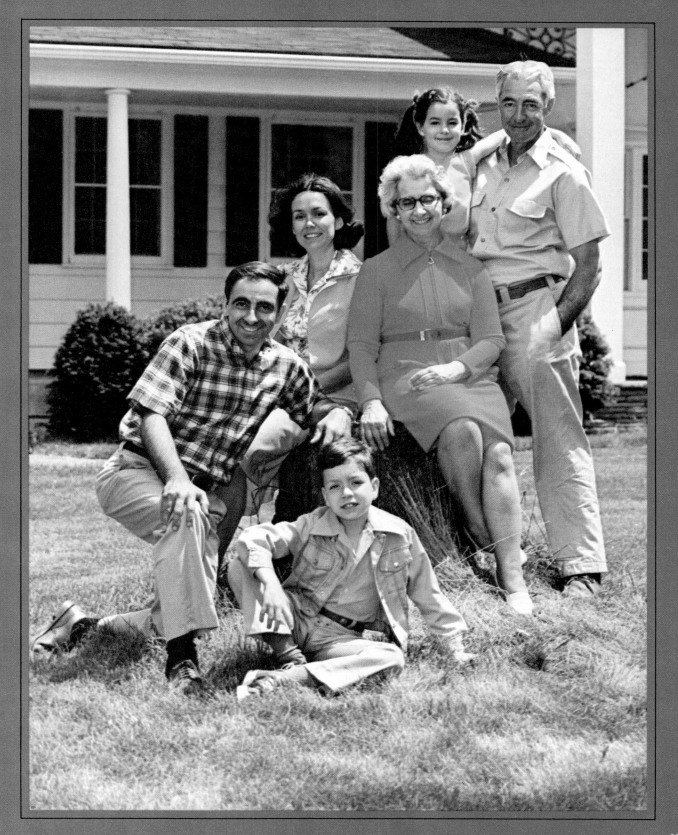

Neil has switched to a 150mm lens for the 2¼'' × 2¼'' camera for good perspective on these tightly framed closeups. Fill-in flash would have overlighted the foreground foliage, so a white cardboard reflector is used to soften the shadows. Although it may not look it, the position of that reflector is quite critical. It must be aimed exactly, and if it is too far away, it will not fill in the shadows sufficiently. The effect the reflector has must be evaluated from the camera position.

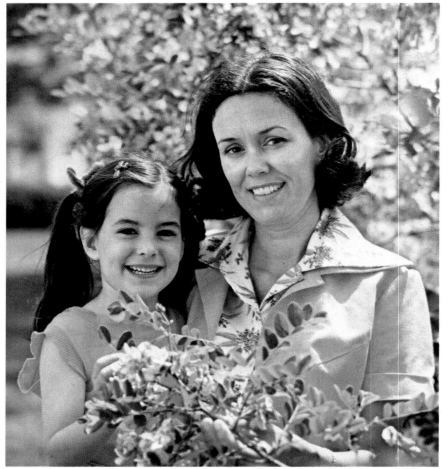

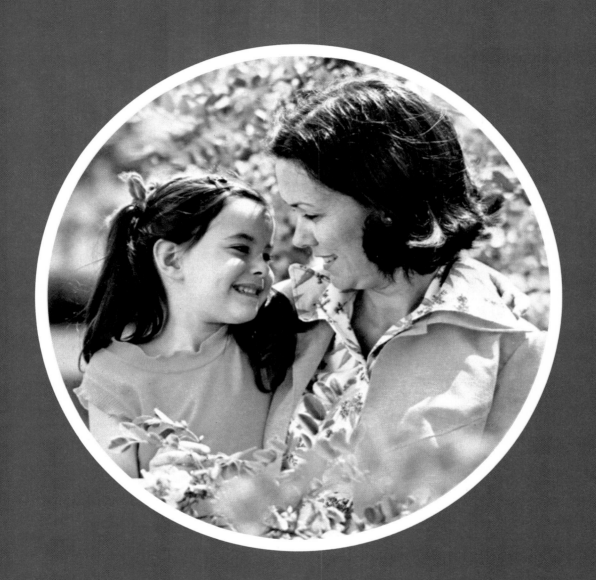

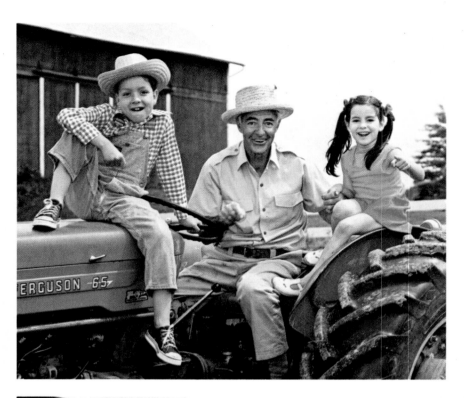

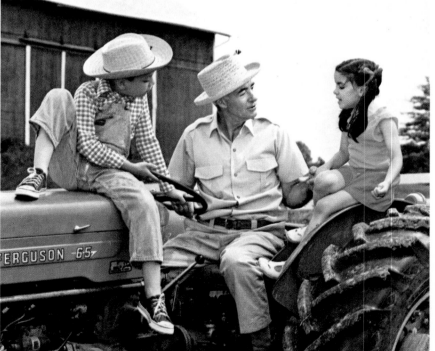

To look at the photographer, or not to look at the photographer, that is the question. If the subjects are doing something together, such as making something, demonstrating something, or examining an object that can be the center of compositional interest, then generally, they should not look at the camera. However, if there is no center of interest, and if it's a fairly close-up picture, then it's natural for the subjects to look toward the camera. In this latter case, good expressions become especially important.

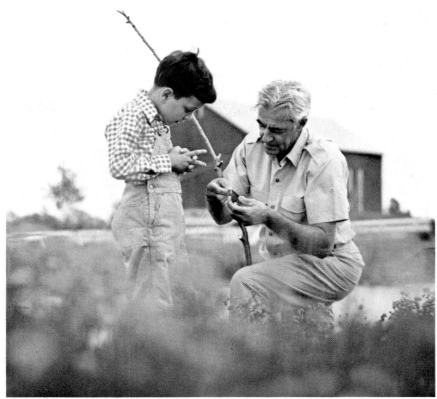

Perhaps the most neglected aspect of family picture-taking is sequence shooting. Pretend that these fishing pictures are color slides. Cover them up right now so that you look at them only one at a time and in sequence. Imagine the effect on your slide-show audience when they view the last triumphant, holding-the-trophy-aloft shot—that's the kind of sequence shooting that people enjoy.

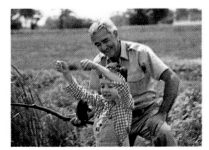

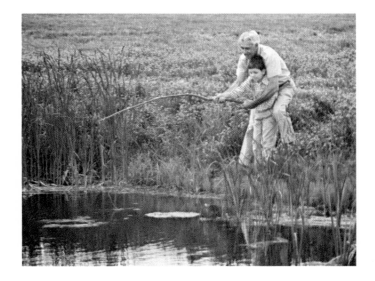

Which of these two pictures do you prefer? It took less than a minute to compose and shoot the one at the left, but about fifteen minutes for the one at the right. For the action shot, first there was selection of the location and three rehearsals. The camera, on a tripod, was prefocused at the exact clump of grass where the exposures were made. It took six downhill trips (and six exposures) before the dogs were lined up correctly, the subjects looked forward and not down, and Grandpa's hat tilted back enough so it wouldn't shade his face. The important thing is that the *subjects* liked the action version far better than the static picture.

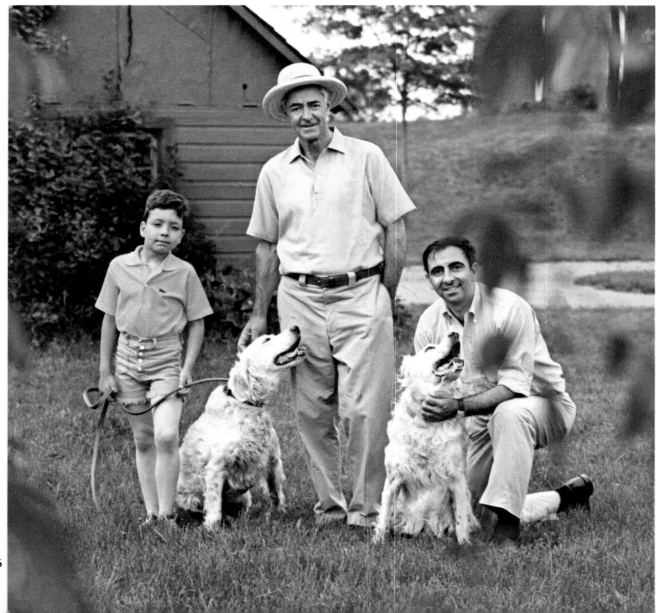

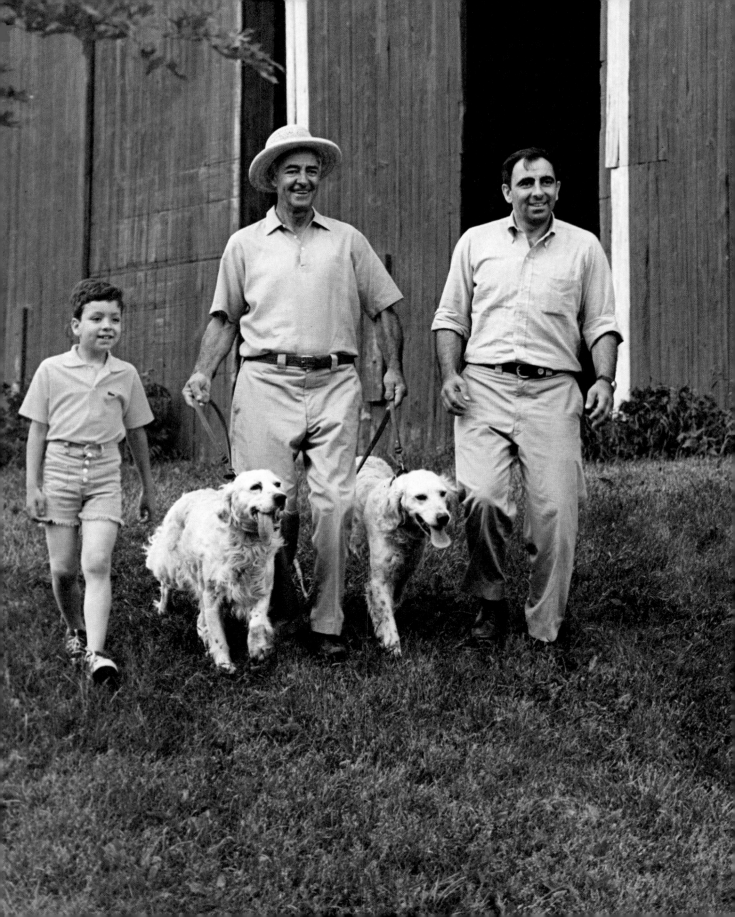

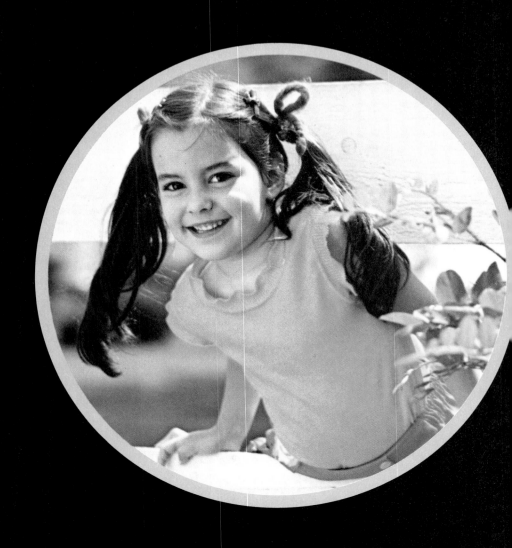

The 2′ × 4′ reflector is lightweight "foam board." It keeps its stiffness, which is important, and is still easy to carry. A reflector this size fills in a relatively small area and thus is useful only for closeups. Larger reflectors are a problem on a windy day.

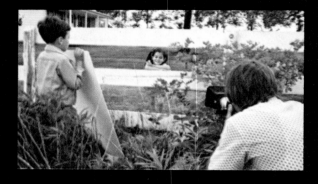

Neil is using a shutter speed of 1/250 sec. for two reasons: First, he needs this speed when hand-holding a 150mm lens to insure against camera movement; second, the correct aperture for this setting is f/5.6, which gives him an artistically shallow depth of field at this close shooting distance.

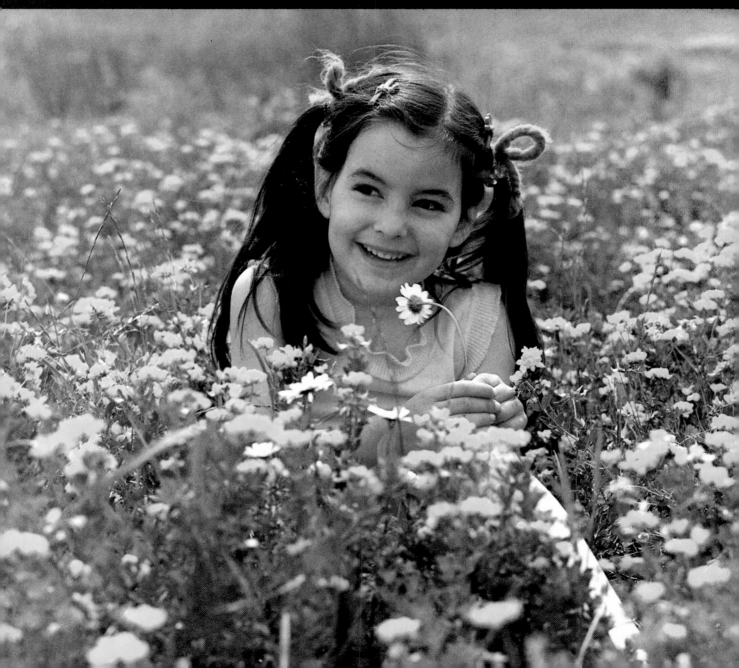

How many reflectors in this scene? The answer is two—the cardboard and the white house. Outdoors you must do all you can to reduce the normal harsh lighting contrast of direct sunlight. Natural reflectors, such as the side of a white house (*not* a brightly colored one), can be part of the solution.

For an interesting group of family pictures like these, try to introduce as much variety as you can. Change the location, the action, the camera angles, the groupings, the clothing. Bold and solid colors for blouses, dresses, and shirts are better for simplified compositions than are fine patterns and prints.

Groups

Troop 817

Okay, Scouts! Everybody over here! Your troop picture is next on this cook-out program. Say, tell me, what's the number of this troop? I heard it 15 times but I've forgotten. Now wait until I say NOW, then everybody tell me all at once. Ready—wait—wait—NOW!!

(Ouch! Did I have to deafen myself with number 817? But if I start off with easy and fun directives, they're training themselves to obey me without any question, and promptly too. Every photographer who takes group pictures ought to be part Marine drill sergeant—it makes the job so much easier.)

Now who has a good idea for a group picture? *(I have, but let's let them believe they're part of the creative process. Besides, maybe one of them will come up with an idea that beats mine of the crowded picnic table banquet scene.)*

No, that won't work because you'd be too scattered. No, I wouldn't see all your faces equally well. What's that? You over there cooking that big pot of stew on the grill, what did you say? QUIET EVERYONE! Let the cook speak.

You're saying get the gang—I mean

Troop 817—around the grill and give everybody a sniff at what you're cooking?

(What a great idea! It'll unify the composition with a center of interest and give everybody something real natural to do. The expressions should be so good, I'll probably want a few individual faces real closeup.)

Calling all hungry Scouts! All you sniffers, gather around the cook! Wait! You and you, grab that picnic bench and put it on the other side of the grill. There's too many of you at ground level; you're too spread out. Five of you get on that bench and look down at the cook. Cook, you look back at the gang. Now nobody

dare to sneak a look back at me; anybody looks at me and they go without lunch!

Look at the stew now. Everybody get ready for that delicious aroma. Cook, lift the cover off the pot a little. Tip the cover so that they can really peek in. Now all together, EVERYBODY SNIFF—click—click.

Do it again, and this time keep your eyes wide open—SNIFF! Click—click—click.

Hold it right there. Nobody move. Keep sniffing. I'm moving in for some terrific close-ups. I'll want that big expression—click—click. Come on, imagine how good that will taste—click.

And what's the matter with you little girl, don't you like stew? *(She doesn't like stew!)*

193

The Team

A picture for your yearbook of the girl's swim team? Sure, glad to do it—how many girls will there be? About 20? As many as 34 of them? *(My gosh, it's a crowd! I must be sure to take along both the 35mm and the 28mm wide-angle lenses.)*

Can we have the pool all to ourselves for about an hour? Fine. *(There'd be nothing worse than a gang of spectators, a few distracting boyfriends, or some extra kids splashing around in the background.)*

Tell me, most important of all, what is the lighting situation? Is there a skylight? Lots of side windows? Fluorescent or tungsten ceiling fixtures? Can you control the underwater lighting? Do you know where to turn these lights on and off? That's fine—now I know better what equipment and filters to bring with me.

Next, how big is the pool? Are there spectator seats? What color are the walls? What color swimsuits do the girls wear? There's a choice of gray tank suits they use for practice or red-and-white suits for meets? By all means, have them wear the colored ones. And could the coach please wear a different color? Green, for example, to contrast with the red-and-white? That's fine, I'll be over there promptly at two o'clock.

Oh, one last thing. Don't let any of them get in the water before I arrive. Not anyone! I don't want one or two wet heads among the group, and besides, a wet suit may have a slightly different color than a dry

one. We'll take some water shots afterward. Okay, see you at the pool.

(Control, control, control—you never have enough of it for group photography. Hope the word gets through to everyone on the team.)

How do you do, girls. I understand you're the State Sectional Champions. Congratulations!

First of all, I want you all to sit over here on the spectator seats. Divide yourselves up into three equal rows—about ten in each row. I want the smaller girls to be in the first row. That's right. Now everybody squeeze in toward the center—even more—that's right. I want to be able to see each and every one of you. Be sure the girl in front of you isn't obscuring part of your face. You can test this for yourself if you look at me, first with one eye, and then the other. You must be able to see me, and even the tips of my outstretched arms, with each eye. If you can't, move a little until you can.

Okay, girls! Listen! Here's the center of your group. Now I want each of you to turn slightly toward this imaginary center line. That's it. Now you girls on the bottom row—knees together, cross your ankles, and put your feet back underneath you until they're touching the bench. Right.

You, take your hair out of your eyes. Top row—all squeeze together a bit more. That's it. Top and second row—your hands should be behind you. Bottom row—your hands should be folded together in your laps. That's right. Now we're almost ready. Chin up, everybody—chest out—stomach in.

All set? Eyes open wide. Now everyone think of how you felt when you won the championship.

Hold it—click. Once again—click. Again—click. Okay, relax.

(I hate that kind of picture—all the heads in a row like a police lineup. But that's what the yearbook editor wanted—apparently to match another batch of unimaginative pictures. But I'm going to try to improve this and submit the "natural" versions along with the old lineup shot. We'll see which one gets used.)

Okay, girls, tell you what we're going to do now that we've finished your formal portrait. There are a lot of you to crowd into just one picture—really, I'm serious. We can do better if we take a few shots of smaller groups—not more than ten of you at a time. This means I can get closer, your individual faces will be larger in the photograph, and your boyfriends will be able to recognize you. Okay?

Now how many of you on the relay team? All right, the rest of you wait a moment. Relay team, down to the shallow end and take racing dive positions. Coach, you stand about 10 feet from the end corner of the pool to watch the take-off of the number two swimmer.

Tell you what, let's have one girl coming in for a touch and the second girl is ready to take off. Coach, check to see this doesn't happen too soon. The rest of you watch this action. Okay? Let's do it! Click. Do it again—click. Once more to be sure we've got it—click.

Now the next ten of you over to the diving board. Coach, show your star diver the arm positions of a back layout. Do this on the end of the board. The rest of you gals, drape yourselves naturally around the diving board at the edge of the pool. Sit, stand, peek through the platform frame—don't all take the

same position. Now everyone look at the coach, NOT at me, at the coach. Hold it—click—click—click.

Last group in a human pyramid. Let's chalk up that last victory meet score over East Rochester. Now, now, look at me. Each of you hold up your right hand as high as possible, and let's shout together. HIP, HIP—HOORAY! Click. Once more— HIP, HIP—HOORAY! Click.

(Just couldn't help finishing up the last few exposures on the roll on a couple of the team's outstanding stars. They looked great as normal-lens available-light portraits.)

That's it! Thanks, everybody. The pictures will be up on the school bulletin board next Thursday. Bye, now.

(Confusion say: One picture idea is worth a thousand yearbook editors who like lineups!)

People at Work

Welcome to an Art Director's office. Sorry it's messy, but I won't pretend it's ever any better. It's the nature of the business, I guess. Coffee? Well, let me show you the layouts for this ad campaign so you'll have a better idea of the kind of pictures we want.

The main idea here is recruitment. We want to run a series of, sort of, job-career illustrations. These will be run in consecutive months in the trade journals. Then at the conclusion of the campaign, we'll gather together all the different segments and put them into a recruiting booklet for our Corporate Information Department.

Let's thumb through these layouts.

Here are couple of things to note.

First, we've planned the art and the copy for vertical pictures. Then, too, these sketches show we want fairly close-up shots of these people at work. Don't crop too tight on their faces—we want to see some of the surroundings. Also, don't feel you're confined by these sketches—they're just the result of our artist's big imagination. I would like to have you capture the feeling that these people aren't just employees putting in their time. We should see from your pictures that these are

intelligent, educated people who are really dedicated to their jobs. Keep in mind that what they are doing at the moment—even though we want to get an idea of that—is less important than the individual person.

For example, one of these two chaps I'd like to have you start with this morning is a research chemist. From our standpoint, we don't care what particular project he's working on, or the specific chemicals, or the apparatus. We do want to see some of these things, but perhaps it's a look of intent on his face that'll make our point.

The other fellow is a printing department supervisor. He was recently promoted—shows excellent administrative potential. Can you get a feeling of this in your pictures?

Oh, yes, I'd appreciate it if you could give us some variation of poses—one of them might fit the layout and copy a little better than the others.

All set? Let's go out in the plant and I'll introduce you to your subjects.

(Before we even get to the shooting areas, I can see it's going to be available-light photography. I suspected that when I included High Speed Ektachrome film and some color-compensating filters in my gadget bag.)

(Many of these new factories and plants use the cool white deluxe type of fluorescent overhead lighting. Let's see, that calls for a CC30 blue plus a CC20 magenta filter pack to bring the color balance back to normal. I hate to think how green these slides would be if I didn't use any filters at all!)

(Good—no windows in the shooting locales. If there were, this filter pack would give too much correction. If there was bluish daylight contaminating the scene, the slides would take on a magenta cast. I never know exactly what filters to use for a window plus fluorescent light combination! The best bet when in a situation like that is to close the blinds to shut out the daylight, or even better, move the subject away from the lighting influence of the window.)

(Yes, available light is the way to go. It'll look natural and it will show enough of the surroundings to give an idea of the locale. Besides, it's the easiest way! I'd hate to think how much lighting paraphernalia I'd have to lug in here to do any kind of adequate lighting. These are huge rooms, but they're really well lighted anyway. They would almost be impossible to light in some other way. Forget it!)

(Camera on a tripod, exposure about 1/30 sec. at f/2.8. The shallow depth of field will keep just the face sharp—where the viewer's attention should be anyway.

Watch out for this exposure trap when taking available light pictures: If ceiling light fixtures are included in the scene, they can affect meter readings and cause underexposure of faces. Take close-up readings of the facial shadows to avoid the problem.

(First, the chemist. The lab looks too cleaned up.) Excuse me, could you arrange some of these beakers and retorts around on this bench? Please make it look a little more realistic. That's fine. Now, how about giving me a little color to include in the composition? Can you mix up a small yellowish solution and perhaps a bluish one? Potassium ferricyanide and copper sulfate, you say? *(I don't care, really, how you do it. I'm most interested in adding the color otherwise this'll tend to be a monochrome scene. The color will pep it up quite a bit.)*

Good! We'll try several versions of this arrangement. Thanks.

One more thing. Before you put them away, I'd like to make a few extreme close-ups of these tools of your trade—these beakers and flasks. No, I wasn't asked to do this, but maybe they will be of use to the art director when he's finalizing the layout for the page that your picture will be on. It should give him some real attractive layout ideas.

Do not rely on corrective printing techniques to bail you out if you take fluorescent light pictures without the proper light-balancing filters. Consult table on page 116 for suggested filtration.

(Now, the printing department supervisor.)

Jim, on one of these shots I'd like to have you act as though you were giving instructions to someone.

The way to do this and have it look natural is first to demonstrate something with your hands—both of them. Look over here at me when you do this. Let's practice this a bit. How does that machine work? Go ahead, tell me. I really want to know. Use your hands to help describe what goes on. That's right, keep going. What else? What happens next? Hold it right there! Don't move! Your right hand was just a little higher—that's it. Extend your forefinger a little more. Hold it right there and we'll record this scene for posterity—click. *(Good. He didn't close his lips. Closed lips for someone who is supposed to be speaking is like someone on the telephone with closed lips—it's the talking cadaver syndrome! Can't be guilty of that here.)*

Got it! Thanks, Jim. You should take up acting.

199

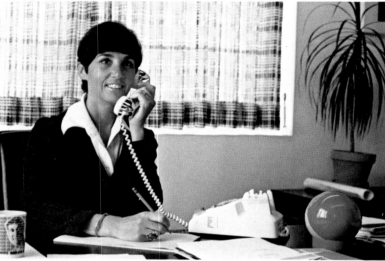

To keep the background from being too light, it was simple to pull the blinds shut. But watch out for this exposure trap if you include the window and take this picture with only available light.

The Executive Office

Good afternoon, Mrs. Schlosser. May I call you Nancy? I'm pleased to have this opportunity to photograph a real corporation president in her office. Tell me, Nancy, while I'm unpacking and setting up, how did you happen to get started in the advertising business?

You don't mind if I move this typewriter off your desk, do you? Typewriters say secretaries, not company presidents. Also, may I move these plants around a bit? I'd like to take some pictures with the plants in the foreground. They'll be out of focus *(I'll see to that with a fairly wide lens opening),* but they'll add a nice touch to the composition. We want to emphasize the aspect of femininity, and since male executives all too often don't have plants in their offices, this idea will help a lot.

Your white phone with the silver cap will help say the same thing. I'll want to try a picture of you using it.

What an attractive desk! We must try to include those unusual supports. Are they wooden gears?

I understand that a steel company is one of your clients. Is that right? *(Boy! Is this different from photographing the man in his office! No pipe in the hand, no feet on the desk for an informal shot. But I must be careful not to make it all look too fluffy. Perhaps I should include an attaché case.)*

Actually, Steve used a weak flash plus a long (1/15 sec.) shutter speed for a combination of available light and flash illumination.

Nancy, do you often push your glasses up on your forehead like that? You do? I like to keep my pictures as natural and as believable as possible. If you think it's a good idea to take some like that, let's do it. Let's do it even if you don't know whether or not you'll use the picture. You can always make up your mind about this after you see the results.

Let's try an at-the-desk shot of your partner. There're some interesting objects on her desk. Those colorful pencils and pens can be used as out-of-focus foreground framers.

(What an interesting assignment! No pink rosebuds and sweetness here! But why not? We'll just tell it like it is.)

People in Motion

Stopping the Action

I've heard that a little subject unsharpness adds to the feeling of movement in a picture. Would you say this is true?

Myself, I like to see action-type subjects wire sharp or else really blurred. No halfway measures allowed. But now you've opened up the whole subject of how to photograph people in motion.

All right, let's hear your views on it.

First of all, it's comforting to know that you don't have to tell people to stand still in order to take a sharp picture of them. In fact, often you can take a better picture of them if they don't.

Angel in flight or blithe spirit soaring? Blurred or frozen? The choice can be yours with the selection of a slow or a fast shutter speed. Camera should be on a tripod for slow speeds if a sharp background is desired.

 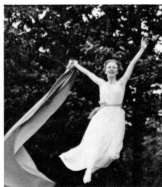

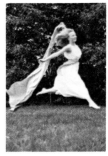 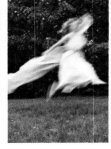 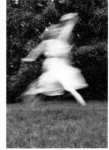

| 1/125 sec. | 1/30 sec. | 1/8 sec. | 1/4 sec. |

For example?

For example, it's almost impossible to pose someone walking naturally. Far better to direct the person to walk slowly and pick the appropriate shutter speed to stop or freeze the action. And obviously for play or sports activities, the same principle applies.

Couldn't I just use electronic flash with its instantaneous stopping ability?

Indoors, or at night, there would be no problem in freezing motion if you use electronic flash. The duration of the flash varies with the type of unit. The small battery-operated portable units have a flash duration of 1/500 sec. to 1/2000 sec.; the larger studio-type units can vary anywhere from 1/500 sec. to 1/10,000 sec.

Incidentally, be sure not to use a shutter speed faster than recommended by the camera manufacturer, in order to ensure synchronization. With most focal-plane shutters on interchangeable lens 35mm cameras, this maximum shutter speed is 1/125 sec. A slower shutter speed will control the amount of ambient light that is admitted to the film; it has nothing to do with the amount of flash received by the film. A faster shutter speed will result in an exposure of only one end of the film because the shutter curtain will not be fully opened when the high-speed flash occurs. Outdoors, when photographing people in motion, don't use electronic flash.

Why not?

Because you'll get a double exposure—one for the short flash and the other for the daylight. You should know the minimum shutter speed that will give you satisfactory action-stopping results. This will depend on the subject's speed, his distance from the camera, and the direction of the motion.

Frozen motion calls for the highest possible shutter speed. Preferably it also calls for rehearsing the action and prefocusing your camera to the distance where the peak of action will occur. Excellent action pictures usually are not the result of a single lucky shot; the best are often selected from a sequence.

How would I ever know what the camera settings really need to be?

Check the following table for the specific shutter speed needed. I keep this table taped to the underside of the cover of my gadget bag where I can consult it when I want to.

If the lens is a telephoto of about twice the normal focal length, use the next faster shutter speed to achieve the same degree of action stopping. If the lens is a wide-angle lens of about half the normal focal length, use the next slower shutter speed than is given in the table.

But these values assume a stationary camera. Can I help the action-stopping ability of any shutter speed—and even that of electronic flash—if I pan the camera with the direction of the moving subject during the moment of exposure?

Yes. Also, you can help the apparent action-stopping ability of any given shutter speed by choosing the exact moment to shoot—the peak of the action. A pole vaulter at the top of the bar, a child at the peak of his swing, a diver at the height of his dive are examples.

SHUTTER SPEED TABLE (for lenses of normal focal length)					
SUBJECT SPEED (MPH)	TYPE OF MOTION	DISTANCE FROM CAMERA (IN FEET)	DIRECTION OF MOTION		
			← OR →	← OR →	← OR →
5	Slow walk	12	1/500	1/250	1/125
	hand work	25	1/250	1/125	1/60
	people sitting	50	1/125	1/60	1/30
	or standing	100	1/60	1/30	1/15
10	Fast walk	12	1/1000	1/500	1/250
	children playing	25	1/500	1/250	1/125
		50	1/250	1/125	1/60
		100	1/125	1/60	1/30
25	Running sports	12	1/2000	1/1000	1/500
	very active play	25	1/1000	1/500	1/250
		50	1/500	1/250	1/125
		100	1/250	1/125	1/60

You can tell the camera was panned with the motion of the subject because the background is blurred. Experiment with various slow shutter speeds to learn how to control the degree of blur.

Blurring the Action

But suppose you don't use an action-stopping shutter speed. Is the picture ruined?

Well, if you blur it enough, and you are lucky besides, you may have created a pictorial masterpiece!

Witness the impressionistic pictures on these pages.

Terrific, aren't they!

They were all produced by intentionally using slow shutter speeds, and more or less panning the camera with the moving subject. You can tell that the camera was moving by the blur of the background.

How slow should the shutter speed be to produce effects like this?

For fast-moving subjects, like a motorcycle or a galloping horse, 1/30 sec. would be about right. For a swimmer or a tango dancer in a nightclub act, try about 1/4 sec. It's really best if you can bracket the motion with a range of slow shutter speeds since it is virtually impossible to predict the degree of blur that will give the most artistic results. If the subject isn't blurred enough, your picture will look like a technical error. If the subject is blurred too much, it will be an indistinguishable nothing. You'll just have to experiment.

And be lucky!

Blur is an excellent way to induce a feeling of motion in a still photograph. The two outdoor pictures were taken at 1/30 sec. by panning the camera. The dancers were taken at 1/4 sec. with a stationary camera. Notice the highlights apparently blur more than the shadows.

205

Dark Faces

Is there anything special about photographing people with dark faces?

Well, if you are talking about snapshots, no there isn't. But if you are fussy about the ultimate of photographic quality, then yes, there is.

Of course I'm interested in quality—you'd better explain.

First, lighting. There is, obviously, a wide range of dark facial tones, all the way from a light tan to almost black. Interrelated to these skin tones is a range of sheen from matte to glistening. This varies, as you know, from one person to the next.

Really, the only combination of facial characteristics that calls for any special attention is a moist dark skin. In this case, very diffuse lighting will help to keep the facial tones from assuming a high subject contrast— higher than may be pleasing in view of modern portraiture's soft lighting trend.

The reason this skin condition can cause a photographic problem is that the bits of moisture are extremely reflective. Undiffused light is mirrored off these tiny areas, just as bright sunlight bounces off a smooth lake. Consider, also, that each of these peaks of specular reflectivity is surrounded by dark skin, creating a very high contrast situation. Diffuse lighting counteracts this problem by lessening the highlight intensity and increasing the illumination in the dark areas, thus bringing these two closer together in tone.

Shade lighting would be excellent, in other words?

Right. Indoors, use window light plus reflector. Or use several umbrella bounce lights in a studio.

Anything special regarding exposure?

Not really. Just be careful to avoid underexposure for black skin with color negative films. Take a close-up meter reading of the face with a reflected-light meter and there will be no printing problem.

Say, I did think of something else to pass along to fellow people photographers. If there is the opportunity to talk about clothing before taking dark-skinned people, try to advise the subject against white shirts or blouses. Somber, muted, or even pastel-colored garments would be much easier to encompass within the film's contrast range.

The main thing, however, is the diffuse lighting?

Right. But there is an interesting exception to this diffuse lighting.

Well?

Well, if you wanted to produce an outstanding character study—an exhibition-type close-up portrait— you couldn't do better than to choose a person with a moist dark skin and use undiffused dramatic lighting with about a 6-to-1 ratio.

Sounds like you'd probably win prizes with that shot.

Maybe, but I probably couldn't sell it to the subject!

Older People

How would you photograph older people? Any special problems? Any special recommendations?

Nothing extra special, but I do have a couple of suggestions.

And these are. . . .

The first is to use diffuse lighting; the softer the better. So, practically, this means bounce, or at least umbrella reflectors if it's flash; window light plus reflectors indoors; and outdoors, a completely overcast day or shade if the sun is shining.

The corollary of this is that direct flash indoors or direct sun outdoors are low on your list?

Not low, lowest. Sunlight makes people squint. But undiffused light is especially hard on older people because it really emphasizes facial wrinkles, pockets under the eyes, sagging jowls, and other features no one wants to show. On the other hand, diffuse light illuminates the tiny valleys of these facial contours, minimizing them greatly.

What is your other recommendation?

Again, no different than for anyone else, but it seems important to me to invent something interesting for these oldsters to do. The list is endless: grandmother cooking or reading a letter by the window; grandfather showing a grandson anything at all. You name it, and there's a picture they'll like, as will the rest of the family. Check into their hobbies for picture ideas too.

Tell you what we can do: I'll dig some senior citizen shots out of my files and we'll go through them for the photographic details that are involved, right?

A clothing conference before the shooting session is usually beneficial. In addition, you may find an excellent shooting location like this next to a very large window. Do you like the dark red dress?

Or do you prefer this lighter-toned dress? Don't you think it is better suited for the entire composition? Doesn't it help separate the subject from the background better?

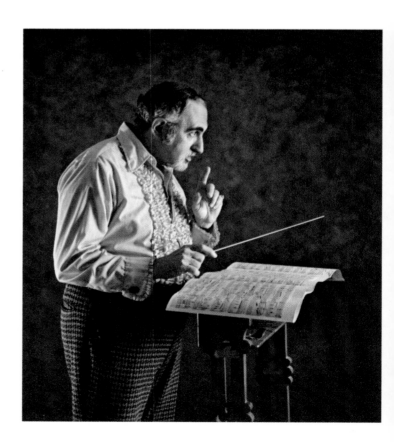

Occupations form a good clue on which to base a shooting session. A planning session can reveal an interesting costume or prop possibilities, which in turn may suggest the mood of the lighting and even an appropriate expression.

Professional Models

What's different about photographing a professional model?

As compared with someone who is not accustomed to being photographed, you mean? What's it like?

Yes, what would you tell her?

Wait, wait. The shoe would be on the other foot. It's what you don't have to say that makes the big difference. You're more of a team, working together, with the model and the photographer each knowing what's expected and how to achieve the desired results. Let me review some of these things.

For example, take body position. If the model didn't know what would make the most appealing photograph, you'd have to go up to her and show her how to put all her weight on her right leg and turn her left leg toward the camera. You'd have to tell her to turn a hip toward the camera instead of standing with her stomach flat toward you. An amateur subject usually doesn't know which is the best—the most ideal—side of her face. And amateurs don't know how to emote.

In these cases, you have to work. You have to tell her how to stand. Since time is money, you're wasting

The photographer works for the client, the model works for the photographer. The key word is—WORK—not glamour or fun and games. "Now, Monique, let me show you how I want you to wear that hat. . . ."

both if you try to use an amateur to do a professional's job.

Fascinating! Got any other for-instances?

I could go on and on. If a girl who is a professional model is a trifle heavy in the thighs, she realizes it and—say, it's a bathing suit shot—she'll get up on her toes a bit. This makes her legs look much more slender. You can't show me an amateur model who'll do that without being told.

Then there's the matter of the animated face. Let's say that you want to take some pictures of a man fishing. It's part of an ad layout for an outboard motor company. Well, if you can get a man with a jovial face, a man with lots of expression, a man who is used to acting and posing, then when that guy is out in the rowboat and you say to him, "Okay, be happy you caught this fish," that guy has got a bagful of beautiful expressions. Imagine how different it would be if you picked someone who had never modeled before. He'd be afraid of the camera and he wouldn't know how to smile.

You see, professional models actually practice expressions in a mirror. They really train themselves in this way. They stand in front of a mirror and see which expression best fits the mood they are trying to portray.

Further, they are experts in makeup, and although I can do a creditable job in this department, I'm frankly glad when I don't have to. After all, the model knows her face better than I do. My main concern is to not let makeup get overdone. It must be natural looking for today's mode.

You might say that a professional model has poise, good expressions, stage presence, and gracefulness. A good model is imaginative from a picture-idea and pose standpoint, and is relaxed in front of a camera. Good models give you all the things you'd probably have to evoke from nonprofessional subjects.

Just don't forget to have her sign that model release!

Right!

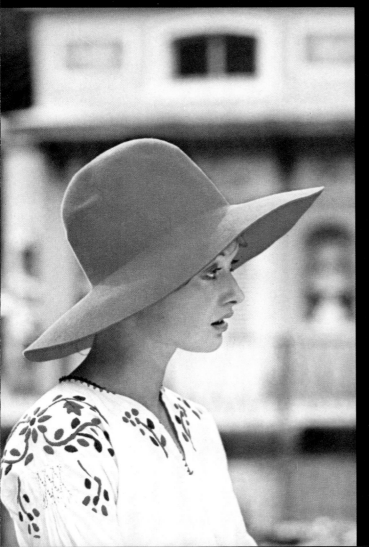

Soft shadow lighting provides most of the illumination—especially necessary because of the broad-brimmed hat. But see the sunlight just ticking her nose? A lighting mistake? Not at all. Most intentional to provide a different bit of lighting accent.

Carefully supervised eye makeup to emphasize those big eyes. Supervised costume and hair style. Supervised expression and pose. Result: satisfied client.

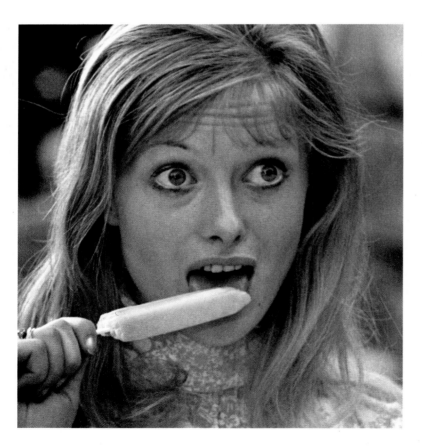

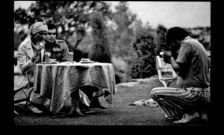
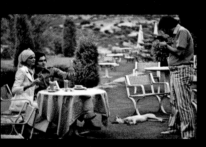

Situation: The right day, time, place, and models. Object: sports wear ad campaign. Problem: Pictures must fit the ad layouts. Technique: Subject control is probably the single biggest key to success. Requirements: Advertising agency people must have a large selection of shots from which to choose.

One of the mistakes not to make in a professional model situation like this is to use a normal focal length lens. Or, even worse, a wide-angle lens which would probably create an unattractive size relationship between the horse and the people. A 135mm lens on a 35mm camera would be a good choice. Note the leave-nothing-to-chance degree of model pose control and the use of the soft shadow lighting.

People on Your Travels

I've asked you, Don, in particular to comment about picturing people on your travels because you are the most widely traveled person I know—and maybe the most widely traveled expert photographer I know. How many countries have you been to?

Sorry to disappoint you, but I've lost count. I've visited all of Europe, all of South America, most of the Middle East, the Orient, a few of the Iron Curtain countries, and I've been from the top to the bottom of Africa, with lots of skips in between.

So if you had to boil it down, what would be your suggestions for someone about to venture forth upon the world with good people pictures in mind?

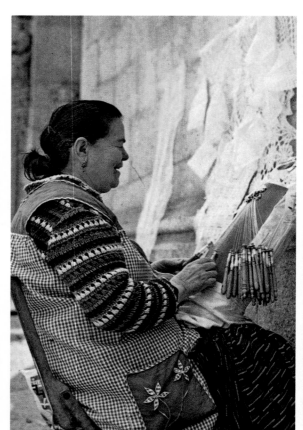

Think of your audience as you shoot travel pictures. Take the long shot, then move in for the interesting closeups so your audience can also have a complete, satisfying look at what you saw.

The candid shot of the Dance of the Conquistadores illustrates many of the shortcomings of candid photography. Especially poor is the subject-background separation. The individual pictures were subsequently posed and taken from a low camera angle to use the sky as the background.

You've said it right there—good people pictures. I'll bet everyone has groaned or slept through Europe as seen via an unending series of slides shot through train windows or taken at bus rest stops. How great it would be to see Europe, or any other place for that matter, as reflected in close ups of interesting faces and pictures of people doing interesting things. Good shots of people just being themselves.

So please get right down to the hows of picturing people as you travel.

Of course. There are two approaches—candid and controlled—and both have their place.

You can snap timidly from afar, stealing the images as it were, preferably using a long focal length lens—not less than 135mm for a 35mm camera. Sometimes this works.

What do you mean, sometimes?

Well, this will work just fine on the streets of Tokyo, for instance. The people are universally polite and are very much camera-oriented. They won't mind your attempts at candid portraiture.

All you have to do is ask with a smile. Even if someone doesn't understand your language, the idea of permission for a picture is easily communicated. Don't forget—SMILE.

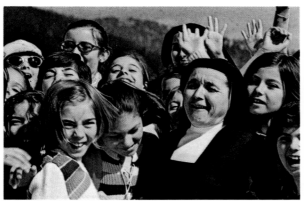

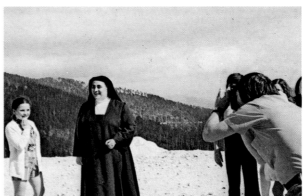

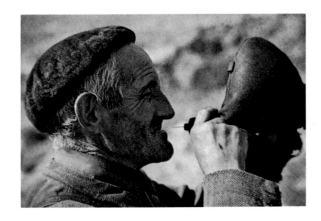

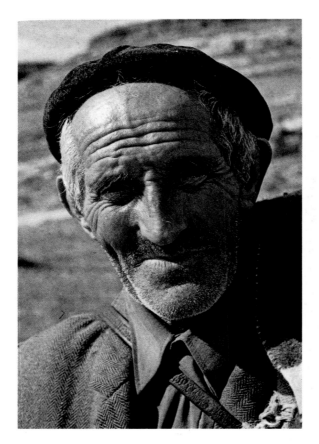

Here's the situation: You're driving
through Spain and on the outskirts of
Segovia you chance across this shepherd
and his dog. Are you going to take one
snap timidly, from afar, or are you going to
stop and make friends with this wonderful
old man? And then will you tell his story
with one picture or with many from which
you can select the best ones for sharing
when you're home?

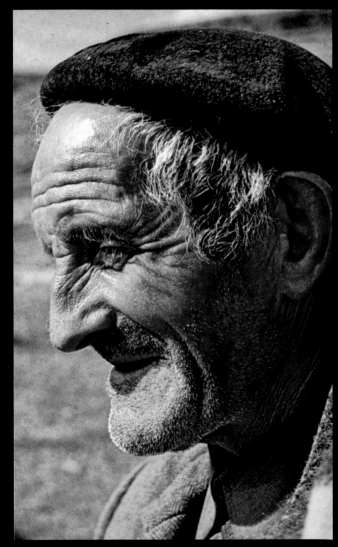

Another terrific place for candid people pictures is in open-air markets. The flea market in Paris is such a place. Much better are the many open-air markets throughout Central America. Fascinating! Hundreds, sometimes thousands, of colorfully dressed people jam into a concentrated area, buying and selling, bargaining and bickering—you'll see literally a hundred pictures for every one you'll be able to take.

You should try, however, to get a representative coverage that will give your friends and neighbors back home a good idea of what the market was really like.

Are you saying I should keep my future audiences in mind as I shoot?

Absolutely! To implement this idea, you should first get an overall, or long shot, of the entire market. Back off in a corner of the market area and use a wide-angle lens to include as much as possible. More often than not, you can take this audience-orientation shot from a high vantage point, such as from the steps, or even the bell tower of the nearby church, or from a second-story window or balcony of an adjacent building. But even from your vantage point, don't shoot indiscriminately. Wait for a good crowd pattern, or for someone in brightly colored clothing to fill up an empty space in the foreground.

Then what?

Now move closer. If you can find an across-the-street vantage point, perhaps from a second-story window, and use a telephoto lens. This combination will keep you shooting and shooting and shooting. It will be especially helpful if you have a zoom lens in the 80mm—200mm range. A lens like this will not only give you a variety of image

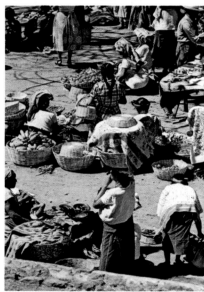

sizes, from a fixed shooting position, but it will also help you to compose with far better frame-filling compositions that would be possible with a lens of a fixed focal length. This candid technique is particularly productive at a market entrance through which crowds of colorfully attired folks are continuously passing.

Camera ready? Now prefocus on some spot where you are sure your subjects will pass. Try to push the shutter release only when the subject's face is in sunlight. These distant shots usually need the brilliance of sunlight. Faces are so small that you shouldn't worry about contrasty facial lighting. Use the highest possible shutter speed—you'll be dealing with moving subjects and hand-holding a long lens—both calling for a faster shutter speed.

You've got me feeling like I'm right there!

Good! Now move even closer. Take off the telephoto lens and substitute a normal lens, or even a wide-angle. Move down into the crowd and rub elbows. Preset your camera for, say, 9 feet and set the shutter speed at 1/125 sec. and the lens diaphragm for the prevailing light. You are now free of mechanical camera manipulations; all you have to do is aim, shoot, and transport the film. Walk up to an estimated 9 feet from your subject and shoot only during an unposed moment when the opportunity presents itself.

I'm shooting, I'm shooting!

With this type of medium close up candid photography, take far more pictures than you actually need. It's inevitable that many are not going to be satisfactory from one standpoint or another. Usually, it's those frustrating things you can't control that spoil the shot: someone jostles you at the moment you make the exposure, or else someone steps in front of your camera, or else the subject suddenly looks up at you. Obviously, it's nice to have a selection of poses and actions from which to choose.

Something tells me I'm going to get some great shots, but there's going to be a lot more in the wastebasket that nobody will see.

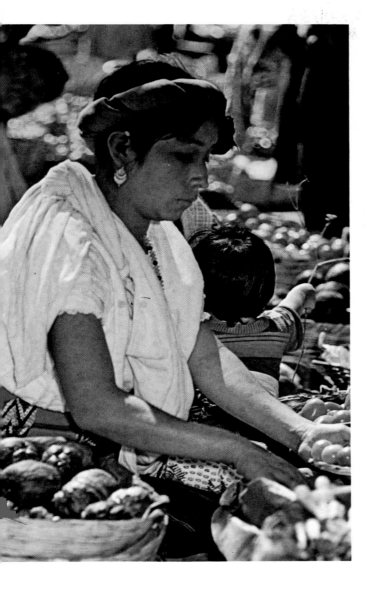

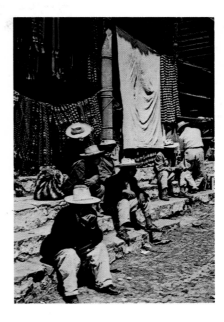

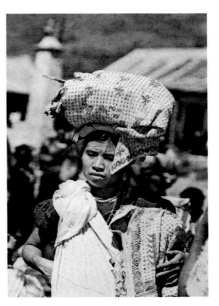

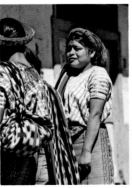

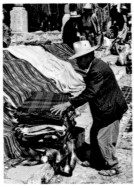

You'll have to hold yourself back to keep from taking too many pictures in a colorful market place, such as this one in Guatemala. Give your audience the complete scene with long and wide-angle shots first, then move down for closeups.

Of course you should take flash along on your travels—you'll miss a lot of good pictures if you don't. Flash for indoor shots, to be sure, but consider using it also for lessening harsh lighting contrasts outdoors, like this.

Should I take flash along on my travels?

Many of those people-doing-interesting-things shots will benefit from flash fill. The hard-sunlight-only portraits will too often cause squinting subjects and terribly black shadows under hat brims. Be sure to paste essential fill-flash information right on your camera. Consult the table in the location-lighting section of this book.

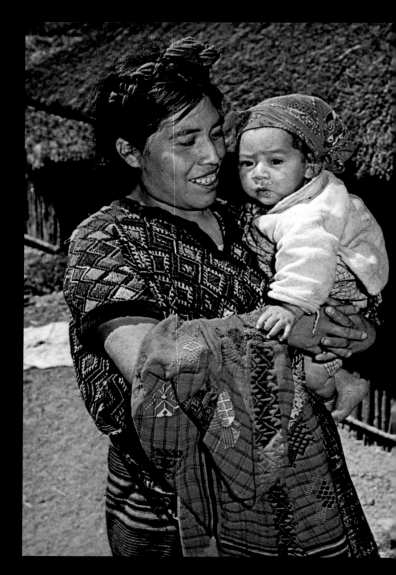

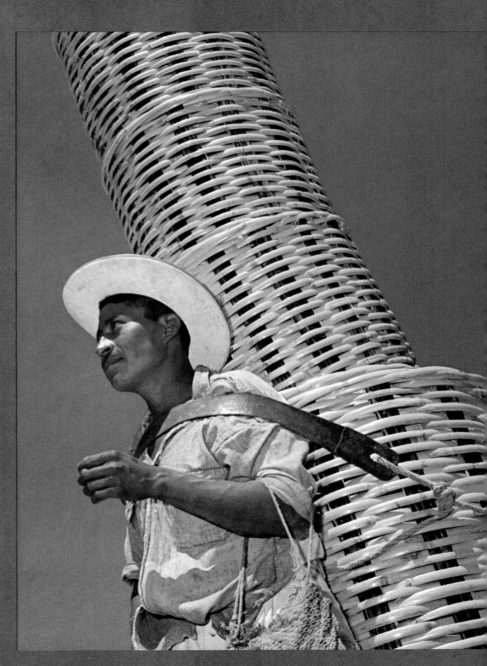

Sometimes you'll have to stoop to conquer!
That small dark, round object in the
foreground above, is a south view of the
photographer, facing north, as he took the
fill-in flash picture at the right.

These are the Indians on the San Blas
Islands off the coast of Panama. They're
very willing to pose for a fee, but be sure to
negotiate the amount before you take even
one picture.

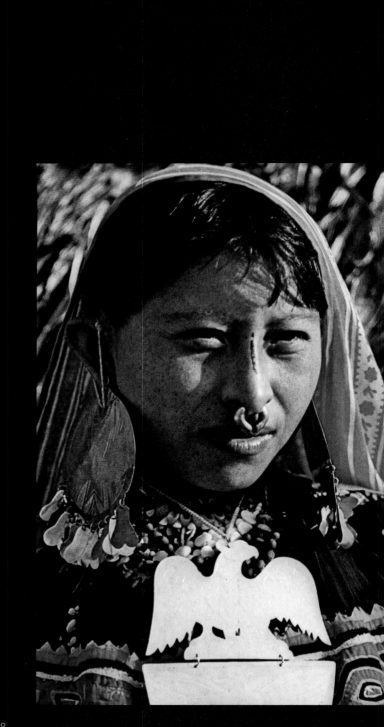

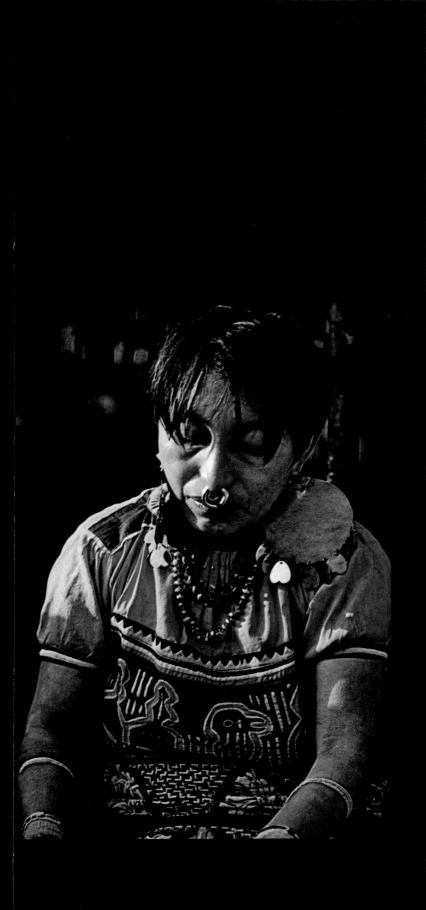

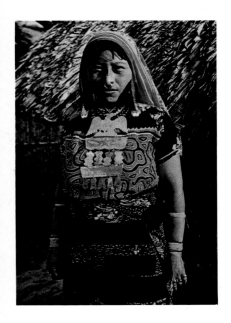

Don't always think of only head and shoulder or tightly-cropped faces for your travel people pictures—try to show something of their surroundings, their activities and their possessions. The evening silhouette effect of the boat scene below was achieved by deliberately underexposing a sunny back-lighted scene by two *f*/stops.

231

I'm all set, I guess, for candid photography in a friendly place like Bali, but what about a not-so- friendly place?

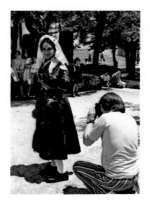

There are, of course, many countries where you are best advised not to try it. Some people believe the camera is stealing their soul, others furiously resent the camera's invasion of their privacy. Don't forget that in these situations you are outnumbered! What, then, for picturing strangers? The answer lies in *control.*

Ask the subject if you can take his picture. Deal with your subject in an honest man-to-man way. *Ask first* and you'll get a lot more cooperation with your picture-taking. Sure, you're bound to run into some refusals, but there will always be some sympathetic individual just a few steps further on who will be willing to let you take his or her picture. Don't be afraid to pantomime if there is a language problem. Sign language plus a big smile will go a long way. A modest model fee—paid *after* the pictures are taken—may be appropriate.

How large is modest, anyway?

Ask the desk man at your hotel or your guide for advice on these matters.

But let's not leave the matter there. After I have the subject's consent to shoot, how am I going to control the situation?

To answer this question properly, you should separate your people pictures into two categories: the closeup—and this really means head-and-shoulders shots to tightly framed ones of just the face—and the middle-distance shot, which shows people being themselves during an interesting moment in their lives—hopefully, *not staring at the camera.*

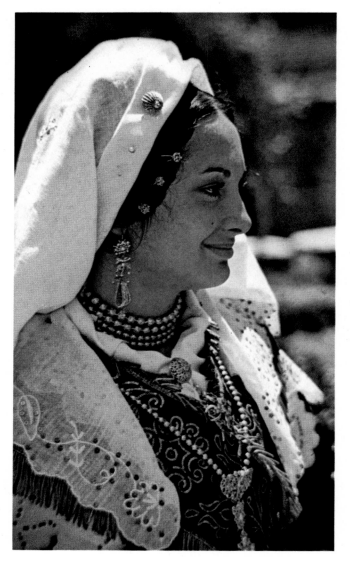

It was just an old Spanish costume. But adorning such a pretty girl, who could resist taking a whole series of shots. You wouldn't take just one and leave, would you? No, the details of the dress, the shawl, the earrings, all deserve a separate close-up picture. And, of course, a few variations of that charming face are called for.

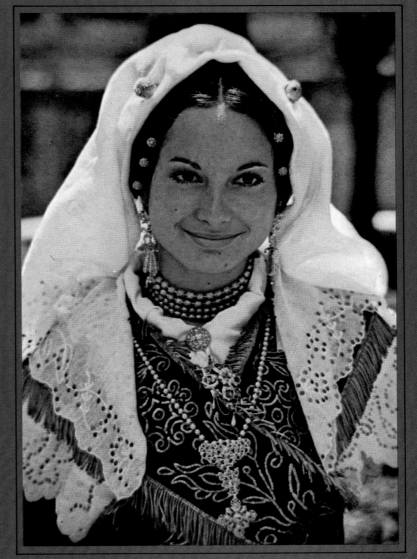

In other words, my job is to invent a pose that looks unposed?

It's not all that difficult. Just don't let that weaver look up from her loom toward the camera. Keep that painter's attention focused on his canvas. Have that vendor sort or arrange his wares. Be sure that potter watches his wheel. It's only human that he will try to glance in your direction as you fiddle with a bag full of strange gadgets, so tell him to look away just before you shoot. *Control* the situation if you call yourself a photographer. Anyone can push the button on a camera, but if you want really good people-on-your-travels pictures, you'll have to assert yourself.

You'll be able to take better travel pictures if you can communicate clearly with your subjects.

Wait! I can't remember ten words from my high school Spanish. What about the language barrier?

Poof! Let's not admit the problem exists! Can't you manage even a few basic control phrases in the local language? If you can't, you'll have to improvise! Pantomime! Do you want good pictures or don't you? Really now, suppose you couldn't speak one word of the local language and you wanted the cooperation of, say, a shoe-shine boy on the streets of Istanbul—how would you manage? How?

Well, I guess I'd walk up to him and smile. Then I'd point to my camera and to him and to my shoes. I'd say, "Okay?" with a question in my voice. Everybody knows "Okay." He'd probably get the idea, wouldn't he?

You can bet on it—I can see your shoe-shine pictures already! Yes, you'll do all right. Just pretend you're playing a game of international charades.

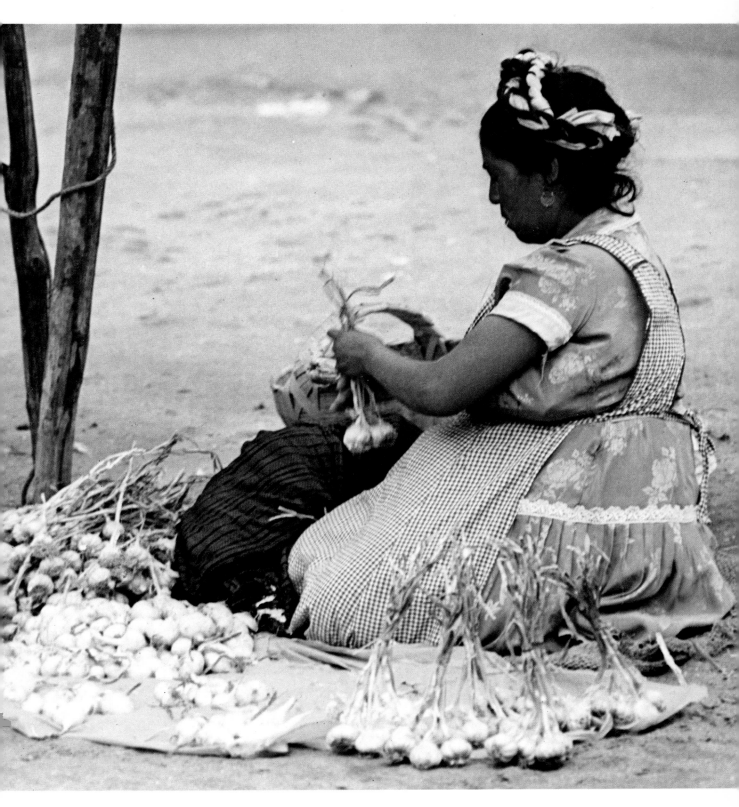

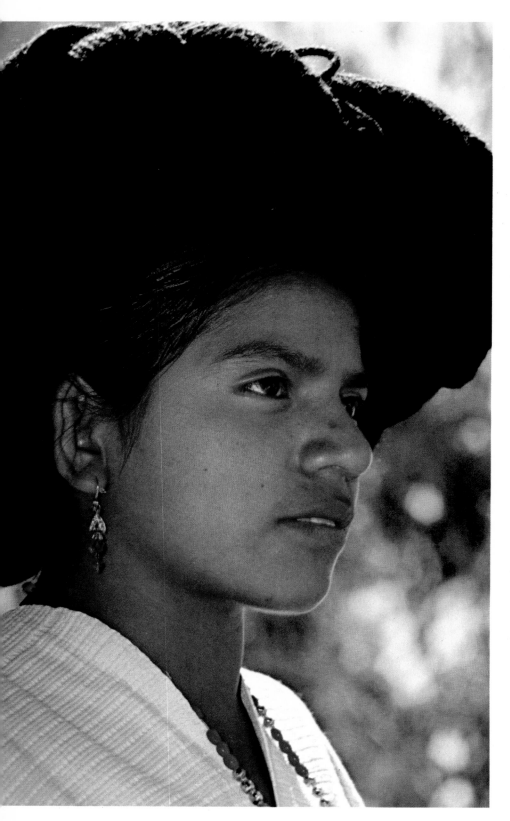

Controlled situation. Shade lighting. A Zapotec woman from the village of Yalalag in the Oaxacan highlands.

Any final suggestions?

You wouldn't make the mistake, would you, of taking only one picture of any given travel-portrait situation? No, you're a competent photographer and you realize that the first picture may not—and probably will not—be the best one. Shoot the long shot. Shoot another from a different angle. Another. Move in for a middle-distance shot. Now, how about that tightly cropped portrait? Probably in this case it's natural for your subject to look at the camera. But again, you shouldn't take just one closeup. Make sure you have an adequate selection of good positions and expressions. Do it just as if it were a professional portrait taken at your leisure at home. Are you able to evoke an interesting expression? A smile, a wink, or a grimace? How dull a dead pan look is. Your models will *freeze* and stare blankly at the camera *unless you motivate them.*

Finally, remember this about making good travel portraits. *There is no such thing as a good, introverted, dignified photographer.* Be a director of photography—not a camera operator.

The best people pictures on your travels will probably be taken in the countryside, not in the cities. Why is it that country people are more friendly than city people? It's anyone's guess, but it's true all over the world. And when you do find an interesting situation in your travels, such as this colorful procession in Guatemala, you'll be remiss if you don't give it adequate photographic coverage!

The large frame in front of the lens is to hold vignetting screens. Note how Henry views his subject from as close to the lens position as possible to be sure to appraise the scene as the camera will record it.

The Studio

Good morning, Henry. Good morning, Joe. Glad to be able to catch both you busy photographers in at the same time. Tell me, what accounts for the success of your father-son studio? It's been going for about 48 years, hasn't it? Why are you chaps so much in demand?

(Joe) If I had to boil it down to one sentence, I guess it would be that we try to make pictures that people like.

All people are different. How do you know what sort of pictures they'll like?

(Joe) We always sit down and chat with people before we really get swinging with a camera.
(Henry) Yes, we have low-key planning sessions that are quite personal from the client's standpoint. Let me relate this to weddings. Before we go out on a wedding job, the planning

conferences give our clients a feeling of confidence in our photographic ability. They relax and they know you better as a result of these talks.

It's that business of rapport, isn't it?

(Joe) Right. You have to relate to the people. Generally, I photograph the younger clients and my father will photograph the older ones. By just talking their language, you can put people at ease and help them relax—relax naturally. You know, it's easier for my father to photograph older people because he's likely to have more things in common with them.

Like grandchildren, or something?

(Henry) Yes, grandchildren and a number of other things. Like going through the Depression, or having similar views on politics, or buying condominiums.

(Joe) And I talk to our younger clients about contemporary movies and things they are concerned with.

These rapport-building planning sessions sound like a great idea—do all good professional photographers have them?

(Henry) Most do. But we really stress them. Here's another reason why. If Joe or I are scheduled solid, I'll have an associate spend an hour talking with the clients, seeing what they like and don't like. We'll find out if they like a contemporary treatment— complete with double exposure and special effects—or a more conservative approach. Then on the day of the wedding, we'll be able to go out there and do our job efficiently. We'll know what the right thing is.

(Joe) You know, we have certain clients who come to us and want the traditional stuff. You know, stiff-looking portrait, very very formal. But as much as we suggest some informal, natural photographs, they insist on having it the way their parents had it done.

And their grandparents too, I imagine.

(Henry) Right. You just can't get them away from that.

Is there any answer for a customer like that?

(Joe) We try to get them outside as much as possible, because they tend to be more relaxed. But we can formalize the pose outside too, if we know that's what they're going to like.

What is your own preference in taking pictures? Would you rather do it in the studio or outside?

(Joe) If we had 300 days a year of good weather in Rochester, I would love to take all our clients outside. But we don't, of course, we have about three!

So let's talk about your studio lighting techniques. I understand you recently switched over from directional lighting units to umbrellas. Why the change?

(Joe) Well, the lighting effect is softer and more in keeping with the times. But there are additional reasons—you don't have to feather your lights anymore and it's an easier system to work with. My father used raw strobe lighting for many years, but his technique was so good that he could just feather the light and approach the softness of umbrella lighting. But as I said, it's easy with the umbrellas.

(Henry) A slightly new wrinkle for us is to use barndoors on the umbrellas. It's just another control. With them, you can keep the light off the background and let its tone go a little deeper.

Tell me more about the use of umbrella lights.

(Henry) Generally, we use them as we would directional lights. We can get crosslighting and backlighting effects if we wish, but the main difference is that the light is softer—more diffused.

(Joe) We establish the general light level—on which our $f/16$ exposure is based—with a large main-light umbrella positioned high and about halfway between the camera and the subject. It's high enough so that the subject's shadow falls low behind him on the background where it can't be seen.

(Henry) Sometimes with people who have deep-set eyes, if the main light is too high or too close, we get little pocket shadow areas under their eyebrows. In this case we just lower the main light a little. Even so, we don't get any subject-shadow on the background.

I notice you have two backlights aimed at the subject position—when do you use these?

(Joe) We use both of them together about 75 percent of the time. They really help to separate the subject from the background. They're both equipped with barndoors so we can shield this backlight from flaring into the camera lens.

(Henry) We also use a modeling light. This is the fourth umbrella light. It's aimed directly down on the subject's face, from about a 45-degree angle, and positioned to give form and shape to the planes of the subject's face.

(Joe) We generally position this light on the far side of the face so that it results in narrow sidelighting. This lighting is the most flattering for the majority of people.

(Henry) With a real thin-faced person, though, we position this light a little closer to the camera in order to broaden the face a little bit.

(Joe) When this light is directly in front of a person's face it casts a nose shadow directly underneath, and in line with, the nose. We have to watch that.

Tell me about lighting ratios. What do you aim for? How do you establish them?

(Joe) Well, we don't pin them down. We don't want to always be confined to a one-to-three ratio, for example. We'll use whatever is most flattering for the subject. With elderly women, it's quite a low ratio. For something more dramatic, like male character studies that my father still loves to do, the ratio will be high. But keep in mind that the trend today is toward soft lighting.

(Henry) And a good thing about umbrellas is that you can get either soft lighting or crisp lighting. If I want slightly brighter highlights on a character-study shot, I put a tiny touch of cold cream down the subject's nose and on his cheekbones.

Let's have a critique session on some of your pictures. I'd like you to tell me why you think they're good. Comment about the lighting, the composition, the color, the pose, the expression, and anything else that'll help me recognize the many attributes of good portraiture. Okay?

(Joe) Here is a picture that resulted by and large from a planning conference. We learned she was interested in horses, rode a lot, and had the riding clothes and accessories which we used as a theme for the picture. She wanted a "different" picture, and again, it's one of the most commented-upon pictures on our studio reception room walls. This is my style, it's almost monochromatic. I do this so the people will stand out. Generally, we use a painted background. We paint them ourselves using subdued browns and greens, but sometimes we add a touch of autumn colors.

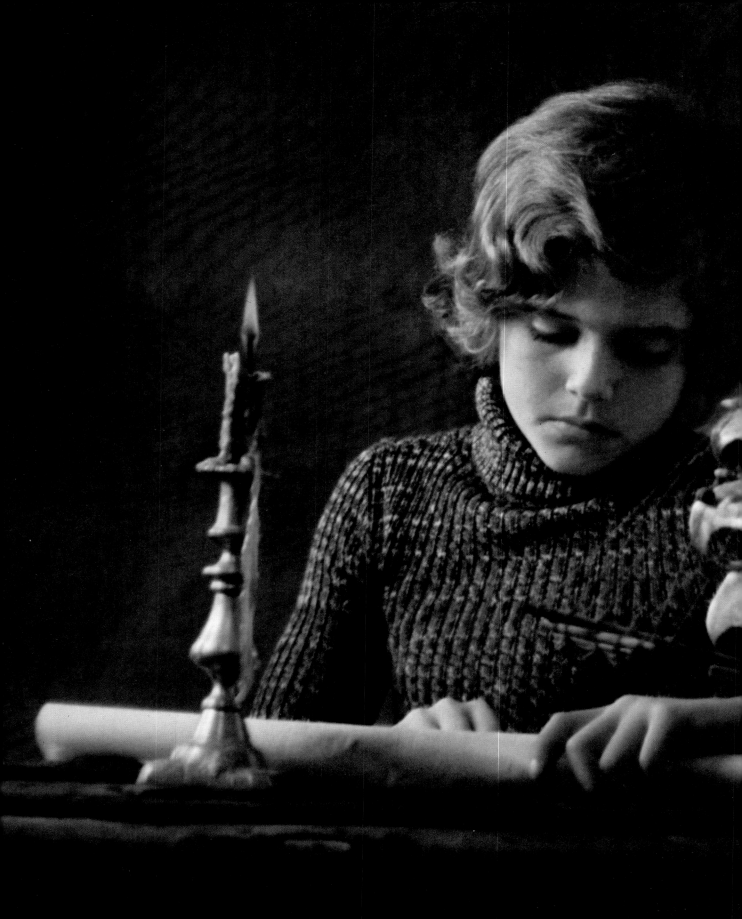

(Joe) This is a simple two-umbrella shot. Notice what a subtle blending from light to dark areas there is—that's what umbrellas can easily do for you. Another interesting thing about the lighting concerns the background. Of course this is just a piece of brown paneling, but the point is, with umbrella lighting you have to start with a darker-toned background than you might expect, or else it'll go a bit too light. You see, the umbrella not being a point source of light like a direct spot, for example, has a more gradual falloff of light intensity. Another solution to this same problem would be to use the background a bit farther from the subject, but with small backgrounds you can't always do this. Exposure was 1/125 sec.; a slower shutter speed would have flared the candle flame excessively.

(Joe) I prefer very soft colors in combination with very soft light. It not only is a trend in portraiture, it's an artistic way to feature a person's face. This model was a relative, not a client, and she seemed ideal for the wood-nymph theme I wanted to try. It was an overcast day that made it—no reflectors, no fill-in flash—just the natural soft lighting. I used a wide aperture to obtain a shallow depth of field to help obscure the background detail. Then, as a final softening touch, we printed it with differential sharpness by taking the rear element off our old enlarging lens. That leaves the center sharp, but blurs the image gradually toward the edges. Anyone can do nearly the same thing by smearing oil on the edges of a sheet of plastic held under the enlarging lens.

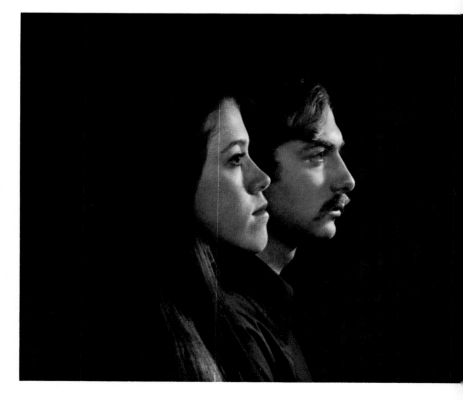

(Henry) Guess I'll comment about the depth-of-field problem here. Note both subjects are sharp even though they are not in the same plane. My old blunderbuss of a view camera didn't have a swinging lens board and I didn't want to swing the back to solve the problem. Swinging the back would have enlarged and distorted one of the heads. So I stopped my 9-inch lens down to ƒ/32 and moved in five direct electronic flash units of 100 watt-seconds each. Power! That was the answer then when we used direct flash. But today, with weaker umbrella lighting, I'd have had to either swing the back or use a smaller image for increased depth of field and then enlarged the image more in printing.

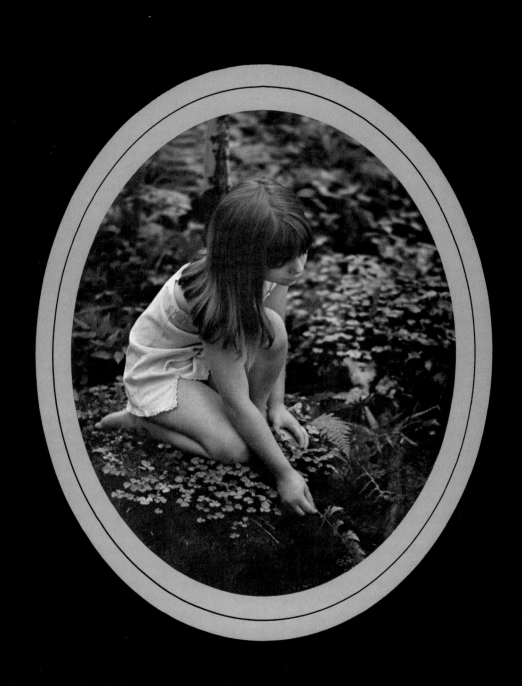

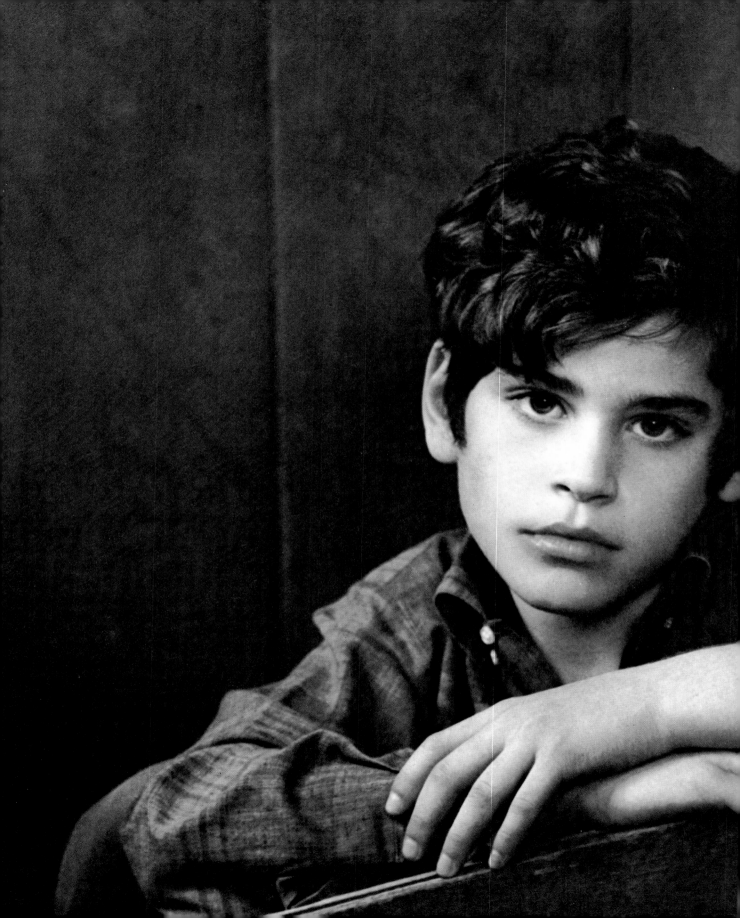

(Joe) Often we take pictures just because
we want to—not assignment pictures.
Why? To satisfy some inner creative urge, I
imagine. Or perhaps simply to practice
photography like a musician practices at
home. He can't always and only be playing
concerts for money, and we have to keep
our skills sharp too. But you know, this
kind of photography has broadened our
studio's business. We have these
"different" photographs on display to show
our versatility to our clientele, and often as
not, someone will come in, look around,
and say, "I'd like to have my son
photographed just like that."

247

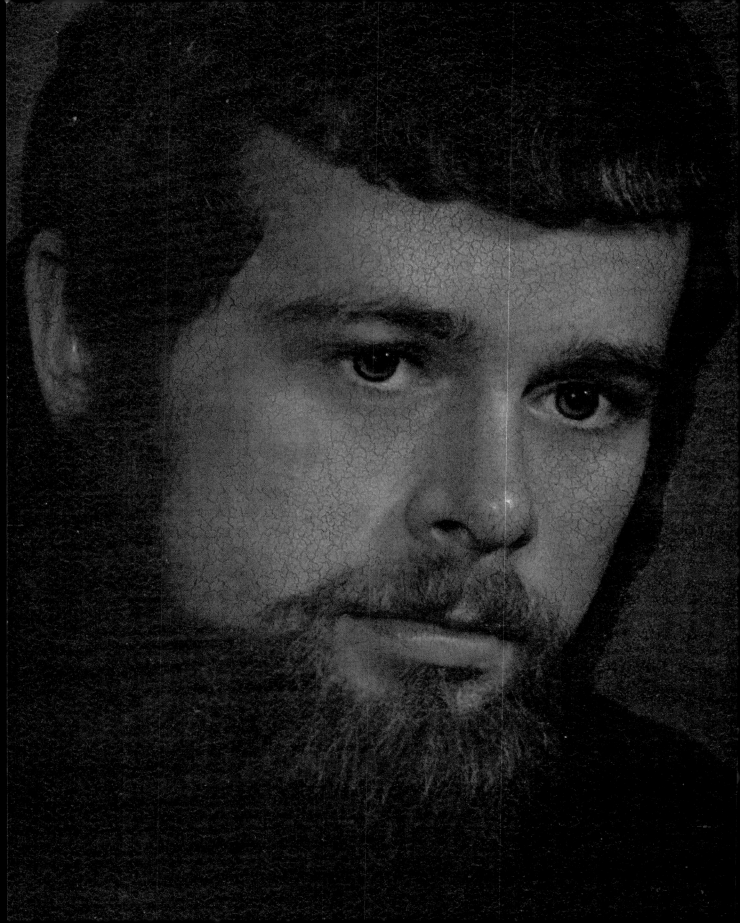

(Joe) When this young bearded man came in for his portrait, he reminded me a little of the way monks looked a couple of centuries ago. So right then I decided to try to carry through with an old-masters style of portraiture. I kept the lighting soft, used brown tones, and vignetted the bottom portion of the scene. Much of the "old painting" appearance comes from the unusual print-finishing technique. The print was "aged" by covering it with a weak wash of yellow-brown dye, some of which was wiped off the highlights. Then the print was coated with a clear lacquer, followed by a special lacquer coating that checked or reticulated the previous coat. It all worked here, but this sure wouldn't do for the typical client.

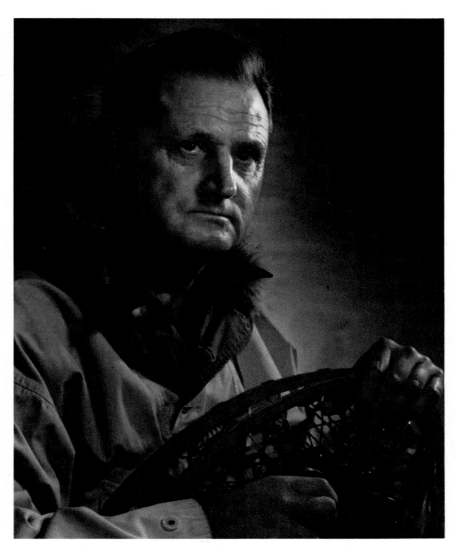

(Henry) As Joe told you, I still love to take male character studies with my five-light wrap-around system. It's called "wrap-around" because there are four lights illuminating the subject from different angles and a fifth on the background. When one light starts to fall off, its job is taken over by the next light, and so on around the subject. The four lights that go around the subject are actually the high, 45-degree main light, the diffused fill light aimed from near the camera, and two back- or crosslights from each side and behind the subject. These last two light up the subject's hair and separate him from the background. There's a touch of cold cream on the subject's forehead and nose to give a highlight within a highlight. Specular reflections like this add a bit of extra lighting quality brilliance in my opinion.

249

(Henry) Joe has been converting me—I like to take pictures outside too. This picture gets so much favorable comment from our customers, I took it outdoors. I found out an interesting thing about using shade lighting—you can see it here. That profile highlight is *not* sunlight—it's directional skylight. And I use a 4′ × 5′ white cloth reflector on a frame to lighten the shadows and create the highlight. Many photographers think a reflector is only for softening bright sunny effects, but you can use one in the shade as well.

(Henry) Where did the diffusion come from? Easy. I simply hung a large translucent sheet of plastic between the camera and the subject. I had to experiment a little to achieve the right artistic degree of blur. The closer the model was to the scrim, the sharper her image became, and vice versa. In this shot, the plastic sheet was about midway between the girl and the camera. Stronger-than-normal crosslighting helped to delineate the figure and to separate it from the background. We limited the props and kept them sufficiently out of focus so as not to detract.

(Henry) Dogs are people—according to some dog owners. Anyway, dogs and other pets are photographed the same way people are, from a lighting standpoint that is. This is the same five-light wrap-around lighting technique I'd use for any subject. Wish you could have seen me take this shot. Joe had a hammerlock around the back end of both dogs to immobilize them. The owner was at the right, talking to them to keep them looking in the same direction. I was using my right hand to chuck them under the muzzle so they'd keep their tongues in. My left hand? That's the one I took the picture with!

(Joe) I'm a great believer in props whenever they are sympathetic to the composition. You always have to be careful, though, not to let the prop steal the show away from the subject's face. I try to keep the light off the prop to subdue it. And if it still looks too prominent in the proof print, I darken it even more during printing. By the way, this is another easy-to-do two-umbrella picture with a rather high lighting ratio and a short main light position from the right. It has my favorite somber tones in it. If you think I helped him select the brown shirt for the picture—you're right.

The Value of Critique

The shooting is over. The films have been processed and proofed. At this point you have a valuable opportunity to become a better photographer. You should study the pictures you have taken to see how they might have been improved.

Want some specifics? Let's say that you have just received a batch of lab-made prints from a 36-exposure roll shooting session. Sit down at a desk with a bright table lamp on it and *rapidly* go through the pile as if the proofs were a deck of playing cards and you had thirty seconds to find an elusive ace of spades.

Put aside any print that strikes you as really ōutstanding. Then recheck these few. Why did you put each one aside? The reason was probably *pictorial impact*.

Any others that belong among these "keepers?" Any that should be taken out of this first-choice pile?

Now, at a leisurely pace, recheck each print with a small pair of black L-shaped croppers. See anything to change your selection because of cropping?

But the practice with these particular prints should not end here. Look at them again next week, next month. It's practically guaranteed that you'll see tiny new distractions (things that could have been improved upon) on the subsequent viewings that you didn't see when you were still flushed with the creative excitement of the shooting session.

What you are doing, of course, is training your eye—improving your compositional judgment, helping yourself to take better pictures next time.

What would you do differently next time? Think about the lighting, expression, color balance, camera angle, and general subject arrangement.

A helpful step to be critically introspective is to try to regard the pictures as though some *other* photographer had taken them. Now what do you think of them? Did this "other photographer" leave a wisp of hair out of place on the model's forehead? A raveling there on a dark lapel? Should "he" have lowered the horizon line? Was "his" reflector too close, overfilling the shadow side of the face?

Realize that in any portrait you take, the perceiving viewer can tell nearly as much about you as the subject. Is the subject staring unimaginatively at the camera? It isn't the subject who was unimaginative—it was you! If the subject is posed inartistically, illuminated unskillfully, or has a dour expression, it's your fault, not his.

No photographer has reached his ultimate capability. The path to improvement is practice. You cannot go forward unless you experiment. Of course you'll make mistakes. So experiment on your own time and not when your pictures must count.

But let's look on the positive side. A terrific, natural shot heaps glory on your head, doesn't it?

What will the people who see the pictures you take think of you?

Remember, fine photography is an art form that can be as expressive of its owner's personality as an original piece of artwork or sculpture.

INDEX

Angle, camera, 80
Aperture, high speed, 88
Aperture, lens, 90
Aptitude, photographic, 27
Arms, posing, 79
ASA Speed, 100
Attachments, lens, 92
Attitude, photographic, 27
Available light considerations, 114
 Exposure bracketing, 115
 Exposure determination, 114
 Filters for available light, 116

Baby, 132
Background hot-spot control, 74
Backgrounds, 73
Backlighting, 50
Black strip, 74
Blinking, avoidance of, 143
Blurring action, 202
Bounce lighting, 55
Boy and girl, 160
Bracketing, exposure, 115
Brightness range, 43
Broad lighting, 66

Camera angle, 80
Candid approach, 226
Child, 140
Client, 37, 214
Color balancing, 116
Colored light, 128
Color use, 69
Composition, 68
 Backgrounds, 73
 Background hot-spot control, 74
 Camera angle, 80
 Color use, 69
 Foregrounds, 72
 Groups, 85
 Image placement, 76
 Picture shape, 70
 Posing, 78
 Practicing, 34
 Props, 80
 Two persons, 84
Critical focusing, 143
Critique, value of, 253

Dark faces, 206
Darkroom manipulation, 118
Density evaluation, 103
Depth of field, 34
Diffuse lighting, 62, 64
Diffusers, 92
Dimensional planes, 29
Distortion, perspective, 89
Double exposure, 118

Earth tones, 69
Electronic flash, 52, 64
En Rapport, 36
Environmental portraiture, 30
Exposure
 Bracketing, 115
 Determination, 101, 114
 Latitude, 103
 Level, 103
Exposure meters, 45
Expression, 104
Eye catchlights, 66
Eye photography, 32

f/stops, 90
Facial lighting target, 40
Family, 178
Feet, posing, 78

Fill-in flash, 52
Fill light, 67
Film and exposure, 100
 Density, evaluation, 103
 Exposure determination, 101
 Film selection, 100
 Negative vs. positive, 102
 Processing, 102
Filters
 Available light, 116
 Color compensating, 116
 Neutral density, 99
 Polarizing, 99
 Skylight, 99
Flash
 Fill-in, 52
 Single, 54
 Two-light, 58
Fluorescent illumination, 116
Focal length, 86
Focusing, 90
Forced processing, 102
Foregrounds, 72

Gray scale, 101
Groups, 85, 192
Guide numbers, 52

Hands, posing, 79
Hazy-day lighting, 46
High key, 69
Highlight, 66
High speed aperture, 88
Hot-spot control, 74
Hotspotting, 55

Image magnification, 86
Image placement, 76
Image multiplier, 122
Incident meters, 45
Infrared, 120
Interaction, two subjects, 84
Inventive eye photography, 35
Invisible camera, 104

Kodak, Neutral Test Card, 101
Kodak, Vericolor II Professional
 Film, 100

Lens attachments, 92
Lens design, 86
Lens selection for portraiture, 86
Light, nature of, 38
Lighting
 Available light, 114
 Brightness range, 45
 Broad, 66
 Colored light, 128
 Contrast, 45
 Errors, 66
 Facial target, 40
 Fill-in flash, 52
 Fill light placement, 67
 Location, 54
 Narrow, 66
 Outdoors, 46
 Practicing, 33
 Ratios, 43
 Reflectors, 51
 Rule of Thirds, 76
 Short, 66
 Single flash, 54
 Special effects, 118
 Specularity, 45
 Studio, 64
 Studying effects, 35, 253
 Subtractive, 46

Sunlighting, 46, 48
Two-flash, 58
Umbrella, 60, 64
Window, 62
Location lighting, 54
 Available lighting, 114
 Single flash, 54
 Two-light flash, 58
 Umbrella lighting, 60
Long lenses, 86
Low key, 69

Magnification, image, 86
Main light, 66
Matte box, 96, 125
Meters, exposure, 45
Models, 214
Motor drives, 110
Multiple exposure, 118

Narrow lighting, 66
Natural results, 16, 27
Nature of light, 38
Negative vs. positive, 102
Neutral Density Filter, Kodak, 99
Neutral Test Card, Kodak, 101
Normal lens, 88
Normal exposure, 103
North light, 62

Older people, 210
Optical tricks, 74
Outdoor lighting, 46
Overexposure, 103

People at work, 196
People in motion, 202
People on your travels, 220
 Candid approach, 226
 Controlled approach, 234
Perspective control, 86
Perspective distortion, 89
Picture shape, 70
Polarizing filter, 99
Portrait lighting, 38
 Ideal conditions outdoors, 46
 Location lighting, 54
 Studio lighting, 238
 Sunlighting, 48
Posing, 78
Posterization, 127
Power of rapport, 36
Practicing lighting, 33
Processing, 102
Processing, forced, 102
Professional models, 214
Professional portrait techniques,
 64, 238
Profile, 149
Props, 82

Rapport, 36
Ratio, lighting, 43
Reflected-light meter, 45
Reflectors, 51
Reproduction curve, 101

Saturation, 38
Shade, 49
Shadows, 66
Shape, picture, 70
Sharpness, 90
Sequences, 112
Single flash, 54
Shooting Sessions, 130
 The Baby, 132
 The Boy and Girl, 160

The Child, 140
Dark Faces, 206
The Family, 178
Groups, 192
Older People, 210
People at Work, 196
People in Motion, 202
People on Your Travels, 220
Professional Models, 214
The Single Girl, 150
The Studio, 238
Weddings, 164
Shooting Techniques
 Available light considerations,
 114
 Expression, 104
 Invisible camera, 104
 Motor drives, 110
 Sequences, 112
Shooting tempo, 106
Short lighting, 66
Shutter speeds, 202, 204
Sidelighting, 58
Single flash, 54
Single girl, 150
Skylight, 62
Skylight filter, 99
Slave unit, 58
Special effects, 118
 Colored light, 128
 Image multiplier, 122
 Infrared, 120
 Matte box, 125
 Multiple exposure, 118
 Posterization, 127
 Star attachment, 122
Spot meters, 45
Star attachment, 122
Stopping action, 202
Studio lighting, 64
 Fill light placement, 67
 Main light placement, 66
 Umbrellas, 64, 238
Studying lighting effects, 33
Subtractive lighting, 46
Sunlighting, 46, 48
Sun position, 48

Tempo, shooting, 106
Three-dimensional style, 29, 90
Today, 12
Tomorrow, 16
Tomorrow's pictures today, 26
Tungsten illumination, 116
Two-light flash, 58
Two persons, 84

Ultraviolet filter, 99
Umbrella lighting, 60, 64, 238
Underexposure, 103
Using the lenses, 90

Vericolor II Film, Type S,
 Kodak, 100
Viewfinder, 34
Vignetter, 95

Wedding photography, 164
Wide-angle lens, 88
Wink light, 53
Window lighting, 62

X-synchronization, 52

Yesterday, 12
Young children, 140

Zone of sharpness, 75, 90